LESSONS in DSLR WORKFLOW

with LIGHTROOM and PHOTOSHOP

JERRY COURVOISIER

Lessons in DSLR Workflow with Lightroom and Photoshop
Jerry Courvoisier

Peachpit Press
1249 Eighth Street
Berkeley, CA 94710
510/524-2178
510/524-2221 (fax)

Find us on the Web at: www.peachpit.com
To report errors, please send a note to errata@peachpit.com
Peachpit Press is a division of Pearson Education.

Acquisitions Editor: Ted Waitt
Project Editor: Susan Rimerman
Production Editor: Lisa Brazieal
Development Editor: Corbin Collins
Technical Editor: Michael Clark
Cover Design: Charlene Charles-Will
Interior Design & Composition: Kim Scott, Bumpy Design
Indexer: Karin Arrigoni

ISBN-13: 978-0-321-55423-9

ISBN-10: 0-321-55423-X

9 8 7 6 5 4 3 2 1

Printed and bound in the United States of America

To my wife, Julie,
for all her support, patience, and inspiration.
I am forever grateful.

Don

Pleasure to have you
in my favo HBR workshop!

All My Best

ACKNOWLEDGMENTS

First I would like to thank my wife, Julie, for being so supportive of my efforts to complete this project. Certainly the "hard yards," as she would say in her Australian accent, were done with her help in allowing me to carve out the time between the house closing in around us, chasing after our 18-month-old son Woody, and fitting in this book project between the family wine book project. She is certainly a special person in my life.

I have been extremely lucky in my job as the director of digital programs at the Santa Fe Photographic Workshops to have met and worked with a great community of industry professionals, talented teachers, photographers, and students. I would need another book just to acknowledge all the wonderful people who have shared their talents and friendship with me. A special thanks goes to Reid Calanan, a true friend, and to the amazing staff at the Santa Fe Workshops who provide that "can do" approach to making the photography workshops a special place here in the high desert of New Mexico.

I would like to throw out a big thank you to the dedicated team at Peachpit: Ted Waitt for pushing the book project forward; Susan Rimerman, the project editor, for her encouragement and keeping us all on track; Corbin Collins, developmental editor/copy editor, for his patient editing and for making sense of my rambling words; Lisa Brazieal, production editor, for the gentle nudges about getting the layout done; Charlene Charles-Will, design manager, for a great book design; Glenn Bisignani, on the marketing side; and my tech editor Michael Clark for his "wait a minute, cowboy, let's rephrase that" approach to curtailing my long-winded explanations.

And finally thanks to all the talented people at Adobe Systems, past and present members of Photoshop and Lightroom teams, who have listened carefully and developed these great products for the photographic community. It's been a pleasure to work with all of you.

Contents

Introduction

I remember a discussion years ago when sitting at a table with industry executives, educators, photographers, and engineers at a photography trade show. Based on my years of experience as the digital programs director for the Santa Fe Photographic Workshops, I was asked to comment on what it was that photographers found difficult and how the process could become more efficient. I certainly didn't have all the answers, but my sense was that we were on the edge of a new era with digital technologies converging and integrating into mainstream photography. What I like to think evolved from that experience was a kind of roadmap, with directions to a destination and a built-in flexibility to suit individual preferences. This book grew from that roadmap.

As a photographer, you will set up a workflow to achieve some sense of order amid the various methods and procedures, one that fits your style and approach to photography.

By *workflow*, as it relates to photography, I mean the sequence of tasks that includes these components:

- Checking camera settings before shooting to increase your potential of capturing the best images for a given scene.
- Recording images on location.
- Transferring images from the camera to the computer.
- Organizing, renaming, and placing image files in folders.
- Reviewing, evaluating, and ranking images by importance.
- Adjusting your images through a development processor or external image-editing program such as Photoshop CS3.
- Sharing your images with clients, friends, and family through the printing process or electronic online communities.
- Archiving and backing up your images for future review.

In the past, many of the steps in such a workflow have been traditionally performed using a variety of disjointed applications to complete the steps of image management, Raw image processing, photo editing, and electronic transfer.

Adobe has been listening to photographers and now provides two premium applications that are complementary and can effectively integrate the process seamlessly: Photoshop Lightroom 2 and Photoshop CS3.

Built for photographers, Adobe Photoshop Lightroom allows you to stay on top of complex and continuously evolving digital photography technology. For many photographers, Lightroom provides all the image organization and processing resources one could want. But for those who need to go further, only Adobe Photoshop's advanced digital darkroom capabilities and sophisticated features are adequate. That's why this book covers both Lightroom 2 and Photoshop CS3, on both Mac and Windows platforms.

If you use Adobe Bridge and Photoshop as your digital darkroom, you should know that, in plain language, Lightroom is the photographer's killer app. It's not just a terrific Raw file converter and image-processing program. It's also great for cataloging, sorting, presenting, printing, and creating Web galleries from your image files. It offers photographers many tools in one elegant interface. Lightroom breaks the mold with a well-designed feature set and a clear organizational structure.

Most importantly, Lightroom allows you, the photographer, the freedom to use your time more productively—that is, capturing images—and spend less time sorting and organizing files.

Understand, though, that Lightroom is not a replacement for Adobe Photoshop. The Photoshop lessons included in the later chapters of this book are certainly the next step when you want to do the heavy lifting of moving pixels, adjusting, compositing, and delving deeper into to the digital darkroom.

This book covers the effective methods and processes you need to get started exploring digital photography *efficiently*. You'll find guidance on how to set up your camera correctly for capture, optimize your methods of exposure, create an effective digital darkroom environment, meet computer hardware requirements, and figure out how to edit and process with Lightroom. Then and only then do we explore some simple foundational Photoshop nuggets to get the very best results from your digital camera images.

Yes, I am a photography devotee and have a passion for photography education. Not a day goes by when my camera is not within reach. You can't take images if your camera's not handy, and I find something visually interesting every day to capture. I hope you enjoy the sample images, culled from my years of experience, that I use throughout the book to illustrate the process of using Lightroom and Photoshop.

I set out on this quest to provide a book that allows you to first understand the concepts and then implement the tools to create a workflow that can stand the test of time. This book was developed out of my experiences

teaching, consulting, and helping people to realize their passion for photography without letting the technology getting in the way. I hope you find it a worthwhile investment in time to walk through the process with me.

The book is divided into four parts:

- "The Gear" covers equipment.
- "Streamlining Your Workflow with Lightroom" is about devising efficient methods of accomplishing your photographic work.
- "Image Processing with Lightroom's Develop Module" goes into of the details of the Develop Module tools for easily improving your images.
- "Adobe Photoshop: The Digital Darkroom" covers taking your images to the next level with Photoshop.

This is certainly *not* the complete user guide to Lightroom or Photoshop, but rather a foundational tool to jump-start your understanding of organizing and developing your images using these programs. The output processes of Slideshow, Printing, and Web are not covered in order to concentrate on the heavy lifting involving image management, Raw image processing, image editing, and image enhancement.

By getting the basics right, you will slip into a comfort zone that allows you to spend more time out there, pursuing your passion for capturing images, and less time parked in front your computer. The learning curve is not as steep as you might think. You'll have half a dozen new adjustments loaded in your paint brush before you know it. You will reach the next level of mastering the art of what used to be the traditional darkroom, but has now become a new realm of creative possibilities.

PART ONE
<hr>

THE GEAR

CHAPTER ONE

The Digital SLR Camera

Digital single-lens reflex (DSLR, or digital SLR) cameras (**FIGURE 1.1**) are the performance standard in today's photography market. Characteristically, DSLR cameras for the most part offer excellent image quality, have large sensors that work well in poor lighting conditions, start up quickly when turned on, and have high-performance autofocus systems, short shutter delay, fast continuous shooting, and greater flexibility and versatility for creative photography.

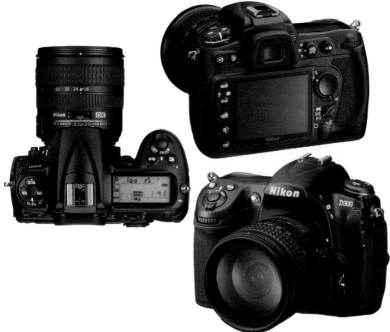

FIGURE 1.1 Three views of a Nikon D300 DSLR. It resembles the style and build of the 35mm film camera with considerably more dials and buttons.

COURTESY OF NIKON USA

DSLR Advantages

It's this flexibility in the tool that allows the photographer to make creative decisions about controlling depth of field for selective focus or shutter speeds in stopping or blurring motion—as opposed to cheaper point-and-shoot digital cameras, which have limited camera shutter speed range and aperture control. Today's DSLRs are powerful and sophisticated pieces of equipment. Today's DSLR camera's onboard computer technology is faster and smarter then the computing power used in some of the early NASA space missions.

Lenses

As with a traditional SLR camera, the DSLR uses a mirror behind the camera lens to direct the light to the viewfinder when composing an image. When the shutter is released, the mirror moves rapidly out of the way, allowing light from the lens to expose the sensor (as film is exposed in a traditional SLR) and briefly blocks out the viewfinder for the exposure to take place. This through-the-lens viewing system, in which you see exactly what the sensor will see, is what allows for greater creative flexibility when capturing images.

For sure, the DSLR is bigger and heavier than a point-and-shoot camera, and the high-end models with one of the more powerful lenses attached may require weight training to hold steady at eye level. But rest assured as the technology continues to develop, DSLRs will get smaller and lighter. The biggest advantage with a DSLR is the great versatility in lenses that can be used. DSLR systems offer a plethora of lens choices, including ultra-wide angles, super-telephotos, and special optics such as close-up macro and perspective-control lenses.

Sensors

Bigger, better sensors produce excellent image quality. Nearly all DSLR sensors (**FIGURE 1.2**) are larger and more expensive then the thumbnail-sized ones in point-and-shoot cameras. For quality, a DSLR sensor beats a typical point-and-shoot sensor hands down. Be aware, though, that *just* having the best image sensor in your DSLR does not ensure image quality. Many factors are involved in creating a quality image. Making intelligent decisions about the correct exposure, using shutter speed and aperture combinations, and choosing the best lens for a specific scene are all excellent examples of factors that influence quality.

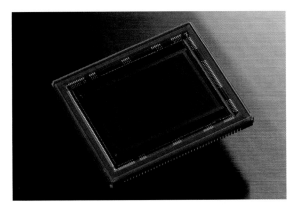

FIGURE 1.2 Image sensor chip for the Nikon D300 camera. This sensor measures 4,288 sensor spots wide x 2,848 high. When you multiply the two dimensions together, the result is a 12.2 megapixel image.

The quality advantage with a larger image sensor is especially evident in low-light conditions, using ISO settings of 400 and higher. *ISO* is a number that represents the sensitivity setting of the digital sensor to light. The lower the ISO, the less sensitive the sensor is, and the more light is required to expose the sensor. For example, for bright and sunny conditions, use a low ISO. When low or poor lighting conditions prevail, choose higher ISO settings so the sensor is more sensitive and can gather more light to take advantage of a faster shutter speed, resulting in less camera shake and motion blur. The larger DSLR sensors gather more light, produce less *noise* (digital version of film grain) and capture a greater *dynamic range* (DR). Greater DR allows more tones

to be reproduced within the correctly exposed image—in effect providing more image detail, from the darkest shadow to the lightest highlight information available. The more tone detail that can be reproduced between the two extremes, the better the DR.

Other Advantages

Most of today's DSLR cameras include the following features to help improve your creativity and photography craft:

- Instant on
- Fast shutters (no shutter lag)
- Shoot 3 to 5 frames per second
- Ultra-smart metering systems
- Instant feedback with image histograms
- Live LCD display
- Raw image capture mode
- Quick autofocus systems
- A broad range of accessories
- Pop-up flash or compatibility with powerful flash attachments
- AC and DC power options
- Wireless transmitters for remote control photography

Now let's look in a little more detail at some of the more important components of DSLRs.

Megapixels

The surface of a DSLR camera sensor chip (refer back to FIGURE 1.2) is divided into a grid of *photosensitive sites*, what I call *sensor spots*, one for each pixel in the final image. The more sensor spots, the better. The *megapixel* number for a DSLR is calculated by multiplying the total number of vertical sensor spots by the number of horizontal sensor spots. In today's cameras, this multiplied number is usually in the millions, and one million pixels is called a megapixel.

But how many megapixels do you really need? Any of the current crop of DSLRs has certainly far more than enough resolution to handle Web site production or newspaper reproduction. For magazine photography and large inkjet printing (13 x 19 inches and larger), 8 megapixels is a good starting point. Commercial and fine art photographers and printers seek maximum detail within in their workflows. For them, a good starting point is 10 megapixels and more.

Let's look at some math (don't worry, just a little simple multiplication). Let's say you would like to produce an 11 x 14-inch print on a photo quality inkjet printer. You would do the following:

1. Figure out the required output resolution. My photo quality inkjet printer generates good-looking images at an image resolution of about 240 pixels per inch (PPI).

2. Multiply the output resolution by the linear dimension of your final print.

 11 inches x 240 PPI = 2,640 pixels for the vertical dimension

 14 inches x 240 PPI = 3,360 pixels for the horizontal dimension

3. Multiply the vertical by horizontal.

 2,640 x 3,360 = 8,870,400 or 8.8 megapixels minimum required resolution

<div style="float:left">

NOTE

The math outlined here is only a suggestion; you can get great large prints even when you increase the dimensions proportionally when reducing the PPI to, say, 180 in Lightroom and Photoshop. If you feel you are limited by the megapixel size of your DSLR, you can decrease the PPI resolution to increase the size for the printing.
</div>

Many photo quality printers today can produce quality results starting at 180 PPI. Let's take the example again of my Nikon D300. The base pixel dimensions are 4,288 wide x 2,848 high. When this image file is opened in Photoshop's Image Size dialog box (**FIGURE 1.3**), the size of the print at a resolution of 240 PPI is 17.867 wide by 11.867 high. When the resolution is reduced to 180 PPI, with the Resample Image box unchecked (off), the new image size increases to 23.822 wide x 15.882 high. The output size fields automatically update to reflect the new print size from the resolution change. (Refer to the Help menu in Photoshop to review all the image size choices available.)

FIGURE 1.3 In the Photoshop Image dialog examples here, note the resolution changes and the corresponding width and height dimensions.

Take in to account that larger prints do require a larger viewing distance. I always chuckle when people view large prints close up, inches from their face. Large prints are meant to be enjoyed from a distance to appreciate the subject, view, or scene.

Speaking of printing, it is becoming increasingly popular today to self-publish photography books through online printing services. This is a great way to share your DSLR images. Self-publishing photo books today is very easy to do, with some showing outstanding quality. With all the choices available from online services—Apple Blurb, My Publisher, Asuka, and Kodak Gallery,

to name a few—it's a good idea to test which suppliers are producing the best quality books. Check out the resource reference at the end of this book for more details on potential sources of photography book publishing.

What Is the Correct Resolution for Digital Slide Shows?

DSLR's have more then enough resolution for projecting through a digital projection system. The question becomes: How many pixels should an image be when creating a slide show from your images on your computer? The answer depends on the output resolution of the projector. Most high-quality LCD projectors have a native resolution of 1024 x 768 pixels. So, creating anything larger will not improve the quality of the resolution of the projected image. An emerging standard is High-Definition TV at 1920 x 1080 pixels.

Memory Storage Cards

Digital memory storage cards are the equivalent of traditional rolls of film in the digital age, but they can record much more then the old standard 36 frames per roll. Today's digital film comes most commonly in the form of high-capacity CompactFlash (CF) or Secure Digital (SD) storage cards. DSLR photographers use them like traditional rolls of film. Once filled up, their images must be downloaded to the computer and deleted from the card, and they can then be reused.

CompactFlash and Secure Digital

All major camera manufacturers use CompactFlash (CF) or Secure Digital (SD storage cards (**FIGURE 1.4**) in almost all of the *prosumer* (serious enthusiast) and professional series DSLR cameras. CF/SD cards are amazingly rugged and durable and have survived my all-thumbs handling and laundry mistakes many times.

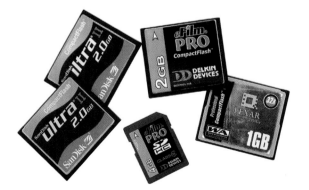

FIGURE 1.4 Memory cards come in a variety of types and sizes to work with specific cameras. The most common ones are CompactFlash and Secure Digital.

Taking pictures at higher quality settings with your DSLR will lead you to discover sooner or later that the amount of memory available on the card that came with the camera (if it comes with one) is not nearly enough. And although downloading photos to your computer can be quick, it's not really as simple as changing a roll of film. If you're not close to your computer, and you want to take more pictures, you have to delete images directly in the camera to make more room on the card.

Size isn't always the remedy, but large-capacity memory cards *are* a big help. Keep in mind that you will most definitely take many times more images using your DSLR camera than you would with traditional film. Having the freedom to explore all the angles and perspectives possible without worrying about film developing costs will have you filling up memory cards like buckets of water at a fire. And why not—the technology has eliminated not just the cost of development but also the inconvenience of driving down to the photo store to drop off the film for processing and driving back to pick it up.

Think about your picture-taking habits and consider buying multiple cards so you can change them frequently. Large-capacity memory cards in the range of 2GB (2,000MB) and up certainly help you shoot longer without having to stop and download pictures to a computer. The number of images you can put on a card depends on the resolution of the images and the file format you choose to capture images (JPEG, Tiff, or Raw).

When my Nikon D300, for example, is set up for shooting in Raw format, a 2GB card holds up to 98 images, and a 4GB card holds 196 images, before I need to change cards or download the photos. I carry four CF cards for added image security and peace of mind. I change out cards and label them before downloading, just like rolls of film.

TIP

I have a system when shooting in the field to identify if a memory card has been "exposed." I carry a card case that holds four memory cards in a convenient fold-out manner. When I open the case, I know by the orientation of the cards which ones are ready to use. Cards with the label facing up are available for shooting. If the card is face down with the back side showing I know that the card already has exposed images to be downloaded. Following this system of memory card storage in the field allows for a smooth transition to placing the next card into the camera without the cumbersome need to review each card to make sure it's ready the one I want to use for the next set of exposures.

Yes, you *can* use higher capacity 8GB cards, and there are even 16GB CF/SD cards. But the convenience of using 2GB and 4GB cards becomes apparent when you start backing up your images to DVDs. Standard DVDs today have a capacity of 4.7GB. So, it's easy to use 2GB and 4GB cards rather then have to split the larger 8GB capacity cards to fit on two DVDs. This approach saves

a step in the downloading process—and I'm all about saving steps when it comes to the workflow.

The pricier 8GB and 16GB memory cards are designed to meet the ravenous requirements of professional photographers for high-capacity storage. For many professionals, 200 , 400, even 1,000 Raw images captured in a day's shoot is not unheard of. These huge-capacity cards allow for extended, uninterrupted shooting and fewer memory cards to manage throughout the day. The downside is: The more images you have on a card, the more a memory card failure can be a real, frustration. Sometimes, though rarely, memory cards *do* fail. Not a pleasant experience. (Refer to the resource section at the back of the book for some card-recovery software solutions.) Another bad situation is if you lose a high-capacity card. More photos on each card means more photos lost.

Here's an example of how I gauge the number of images per CF card for my 12.2-megapixel Nikon D300 camera while shooting in uncompressed Raw mode.

- 1GB = 49 Raw images
- 2GB = 98 Raw images
- 4GB = 196 Raw images
- 8GB = 392 Raw images
- 16GB = 784 Raw images

Again, those numbers are specific to my 12.2-megapixel Nikon DSLR D300 shooting at maximum quality Raw. For estimates specific to your digital camera, check out the manual that came with it or the manufacturer's Web site.

Like almost all technology products, storage cards have dropped in price considerably over the past few years. Cards priced in the 2, 4, and 8GB range are good value and getting cheaper. They are among the most useful accessories you will buy for your digital SLR camera.

Another consideration in purchasing extra CF/SD cards is how fast the *read/write speed* is. There are what are considered "high-performance" storage cards that sport names like "extreme" or "professional quality." These are usually better then the average off-the-shelf CF/SD cards and, naturally, come at a higher cost. These higher quality cards provide extremely fast read/write speeds, meaning they are designed for sustained, rapid-fire picture taking when you are photographing events like sports and many frames per second are needed to record the action as a series. Look up in your camera manual to see how many frames per second your model can produce. By using the extremely fast read/write memory cards, you are less likely to fill up your camera's internal memory buffer and create a bottleneck in image processing speed.

TIP

When you are in the field, it is tempting to review and delete or edit images right on the camera to free up space on your memory card. However, it is often difficult to see on your camera's small LCD screen what the true quality of an image is, and it's usually better to be safe than sorry. Deleting images on the camera to make more room may not be the best solution, though you probably do want to delete those wonderful pictures of your shoes when your camera shutter gets inadvertently pressed.

Protecting Memory Cards from Damage

Understanding the causes of memory card failure helps to eliminate future disasters. Here are some handy words of wisdom from my experience:

- Always reformat the card (delete all photos) in your camera each time after downloading and saving the pictures on your computer.

 Each DSLR has a procedure for formatting the memory card specific to that camera model (**FIGURE 1.5**). Check your manual for details about how to do this procedure. By reformatting the card in the DSLR camera, rather than on your computer, you can be sure that the correct directory structure for recording images is applied to the card for your camera. Deleting or moving images to the Trash or Recycle Bin while the card is mounted on your computer is *not* the same thing as reformatting the card in your camera. A contributing factor to card failure can be the existence of previously deleted photos on the card. Always follow the storage formatting instructions for your camera after you finish downloading.

FIGURE 1.5 Formatting a memory card in the camera after images have been downloaded is the best way to make sure the operation is correctly implemented. Check your camera manual for the formatting details.

- Always create a backup by saving your files from the memory card to a DVD and your computer.

 Having your backed up images in two different places is the best insurance against losing images because of a computer crash or hard disk failure.

- If your computer doesn't have a memory card slot, transferring your images to a computer from a memory card will involve using a USB cable.

 This method can be slow, cumbersome, and a drain on your camera's precious batteries. A better way is to use a small peripheral device called a *card reader* (see next section).

- Never remove a memory card from your camera during the image transfer process.

 In most cases, the alert that your camera is still writing image to the card is a green flashing light. And always turn off the power on your camera before removing the memory card.

- Do not remove the card from the camera or card reader too quickly, as this can result in the corruption of data on the card and lead to damaged memory areas.

- Always wait a moment after snapping a photo to ensure that all the data has been written to the card before you shut off the camera.

- Always keep your camera batteries charged.

 Battery failure while shooting or writing images to the card will result in an interruption of the data transfer process, and this corruption of the data could lead to a damaged card.

- Avoid static electricity, being extra careful when handling cards in dry (low humidity) areas.

 Static can kill a card. Keep cards away from strong magnetic sources and extreme heat and cold.

- When editing pictures in any graphics application, always ensure you have moved the picture from the card to your computer first.

 Don't open or edit image files directly on the card.

- If a memory card problem occurs, stop using the card immediately.

 Do not reformat the card or delete pictures. Instead, use an image-recovery software program, such as ImageRecall's Don't Panic, Lexar's Image Rescue, or SanDisk's Rescue Pro.

Memory Card Readers

If your computer or laptop doesn't have the proper card slot, you should invest in a card reader device to read your memory cards. You connect the card reader to your notebook or PC through a USB 2.0 or FireWire port (**FIGURE 1.6**).

FIGURE 1.6 A separate card reader attached to your computer for downloading images from your cards is convenient and advisable.

COURTESY OF NIKON USA

Downloading your images through a card reader frees up the camera from having to be connected to the computer. By avoiding this bottleneck in your workflow, you can continue to shoot while your images are being downloaded. And you can prevent an interruption in the download which could

lead to file corruption if the camera battery was not fully charged. (With a card reader, you don't need rely on the camera's being fully charged.) After you've copied your images to your hard drive, reformat the card in the camera and start over with a fresh roll of digital film.

Image Formats: Raw vs. JPEG

The modern photographer's dilemma: Which format should you shoot? In a nutshell, for definitive image quality, exposure control, and shadow/highlight detail, Raw is the best choice. For speed and maximum storage space, use "Fine" JPEG.

When capturing images in JPEG mode, the camera settings used to process the image, such as *white balance* (see "White Balance" sidebar), are permanently "baked in" at the time of capture—that is, written into the data. Some in-camera tone correction and sharpening is also applied to enhance the image. Forever after, these images cannot ever be corrected by reprocessing the image with Lightroom and/or Photoshop because of the limited depth of data captured in the JPEG format, which compresses image data.

You can adjust the level of compression for JPEG capture. Low compression ratios (higher quality) provide better overall image quality than high compressed ratios do. Higher compression saves memory space on your CF or SD card, but the downside as usual is a loss in image quality. A large ("Fine" quality) JPEG takes up about a fifth to a third as much space as an uncompressed Raw image does, with little loss in resolution or detail.

Keep in mind that many DSLRs have image sensors capable of capturing 12 to 14 bits of data per color. JPEG images are limited to storing only up to 8 bits of data per color. Typically, this means some useful shadow and highlight information is never recorded when the camera saves an image in JPEG format. The Raw format, on the other hand, stores *all* the information the image sensor captures, including the extra bit depth that improves the shadow and highlight details. As a result, of course, Raw files require more storage space than JPEG files. Follow the instructions in your camera manual about selecting your Raw file format or make use of the JPEG file format at the highest resolution with the lowest compression possible.

In the process of saving the Raw file to the card, the camera generates a file that contains the three important elements of the camera's settings, the image data, and the direct image data:

Camera settings
- f-stop
- Shutter speed
- ISO
- Camera exposure mode
- Lens

Image data

- White balance
- Color temperature
- Sharpening
- Color mode

Direct image data

- Full 12 or 14-bit color depth

With JPEG, the camera converts or *samples down* the file from 12 or 14 bits to 8 bits. The potential 4,096 brightness levels recorded by each pixel are reduced to 256 brightness levels. The JPEG therefore loses fine details and is ill-suited for major color or brightness changes in Lightroom or Photoshop.

As mentioned earlier, compression is also a choice when it comes to JPEG files. JPEG by classification is a *lossy* format, meaning it creates smaller file sizes by simply eliminating some data. If compression is set to a low level (say 2:1), then there is very little data loss. High compression at 20:1, on the other hand, reduces the overall quality of the image and in some cases can introduce *digital artifacts*—see the example of extreme JPEG compression in **FIGURE 1.7**. DSLR cameras normally offer three different JPEG compression levels: Good, Better, and Best—or Basic, Normal, and Fine.

A JPEG file can in many cases produce very high quality prints. There are in fact numerous valid reasons why one would want to shoot JPEG files. Wedding photographers rarely print images above 8 x 10 inches, so the Raw file format might be a bit of overkill in that particular case. It would be wrong to say that it's not possible to achieve good results with the JPEG file format. But critical attention to exposure and white balance (WB) is certainly required to achieve the best image quality.

FIGURE 1.7 Extreme JPEG compression shows artifacts along the red to yellow edge transition in the flag graphic. Too much compression definitely affects image quality.

White Balance

Proper camera white balance (WB) takes into account the *color temperature* of the light source—the relative warmth or coolness of white light. Our eyes are very good at judging what is white under different lighting sources. In some cases, though, digital cameras can become confused as to what is the correct white balance for a specific scene. Fortunately, DSLR cameras contain a variety of preset white balances, so you don't have to deal with understanding all the illumination source color temperatures and can just simply identify lighting conditions.

Understanding which WB settings to use can help you avoid *color casts* created by your camera, thereby improving your image captures under a wider range of lighting conditions. The WB setting allows for the calibration of the light illuminating the subject. Many times the auto white balance (AWB) setting is an effective setting for the camera to determine the best balance for the image captured. Under mixed lighting conditions, the AWB usually calculates an average color temperature for the entire scene to eliminate the color cast. When you as the photographer start to evaluate the illumination of the light falling on the subject of your image, you can use the WB settings when you feel the AWB feature is not effectively representing the illumination in the scene.

Normally there are seven WB settings that can be used with your DSLR: AWB, Tungsten or Incandescent, Fluorescent, Daylight, Flash, Cloudy, and Shade. (**FIGURE 1.8** shows three different WB results). Refer to your camera's manual to learn how to enable the different WB settings. Normally it's as simple as pressing and holding down a button and turning a dial on the camera.

FIGURE 1.8 A white balance comparison for the same scene. Left: Tungsten or Incandescent. Middle: Auto. Right: Fluorescent.

When evaluating white balance for digital exposure, take into account what auto white balance is. In most situations, the auto white balance feature can reproduce a pleasing, accurate color rendering of the scene. Example: A mixed light scene in which multiple light sources are present and filtering them for the right color temperature would be impossible.

The auto white balance can render the scene incorrectly, though, especially early or late in the day, when the color quality of the light does not need correcting. In these situations, it may be best to dial in a shade or cloudy white balance to warm the capture and preserve the warm color presented by the environment and time of day.

Reasons for Shooting in JPEG

- Files are smaller, so more of them fit on a memory card
- Image quality is more than sufficient for certain types of photography, such as weddings, family snapshots, and spot news images
- Small files are more easily transmitted via email
- Some photographers don't have time to *post-process* their files (see next section)

Reasons for Shooting in Raw

The biggest advantage of capturing images in Raw is the high-bit image *post-processing* advantage. What is post-processing? A Raw file is like undeveloped film. The photographer can process and extract the best possible image quality from it, and the original file can be processed differently again and again. Think of a Raw file as your negative, which can be processed after exposure in a variety of ways.

Raw files do not have a set white balance. They are only labeled with the camera setting at the time of capture. So any WB can be changed during the post-processing of the file within the Raw converter software without any image degradation. This is extremely important when editing an image. The more values you have to work with when enhancing an image, the less image destruction occurs in the post-processing stage.

Adjusting a JPEG 8-bit image file for, say, shadow detail, will exhibit what's called *posterization*. This posterization shows up as abrupt changes in transition tones (called *banding*) rather then the smooth transitions between tones that can achieved with Raw images.

Camera Settings Checklist

Here's a good checklist of things to do before shooting:

- Format all compact SD/CF cards in camera prior to use.
- Do not reformat your cards on the computer—you may risk making the card unreadable in your camera.
- Make sure your formatted cards are stored in clean, sealed memory card cases.
- Verify that the camera's date and time is accurate (important for future image file searches).
- Check that file numbering is set for "continuous."
- Set image quality to Raw unless a special decision is made to shoot JPEG.
- If JPEG is the file format of choice, use the highest-quality JPEG.
- Check your ISO setting and optimize ISO for minimize noise (use lowest practical setting).
- Make sure you've set ISO and shooting mode to suit the situation you're most likely to encounter.
- Set exposure compensation +/– to zero.
- Adjust white balance for illumination (if necessary).
- Set your preferred camera mode: Manual, Aperture Priority, Shutter Priority, or Program.
- Set the lens to autofocus or manual focus.
- During the shoot, optimize your exposure settings for each subject.
- Evaluate your image *histogram* on the camera's LCD display and use exposures that favor the right without climbing over the right edge (see the next section for more on histograms).
- Do not reuse memory cards until images are downloaded and backed up.

The Histogram

Exposing for digital images is different from exposing for the traditional photographic process. Relying on the exposure meter in a camera is certainly important, but using the histogram display on the camera's LCD display (**FIGURE 1.9**) helps fine-tune your exposure and takes advantage of the DSLR's larger exposure latitude.

Understanding the histogram as an exposure tool is one of the most important things you can learn about your DSLR camera. Histograms are important tools that interpret the range of tones included within an image. **FIGURE 1.10** illustrates the graphic representation of a histogram and the brightness levels within a picture.

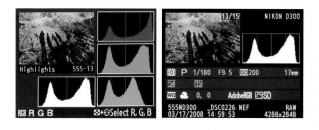

FIGURE 1.9 In-camera presentation choices for viewing the RGB histogram (left panel) and the tone black and white histogram display (right panel) for the Nikon D300.

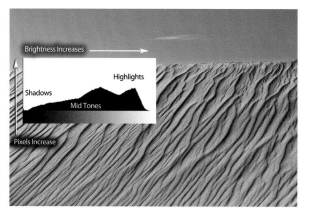

FIGURE 1.10 The histogram is a graph of the distribution of the tones within an image. The shadows are on the left, the midtones in the middle, and the high-lights are on the right.

A *histogram* is a graphic representation of the light levels in your picture. It shows you how many there are of each of the tones you have recorded. In a histogram, the scene's tones are distributed from left to right, creating peaks and valleys within the range of tones. The high peaks represent a high amount of the values of that particular tone within the image. Darker values are to the left, lighter values to the right.

To modify a histogram's appearance, you should experiment with different exposure variables with your camera mode set to Manual (M on all DSLRs). Try changing the shutter speed and aperture combinations while monitoring the histogram produced on the back of the camera after exposure. When the histogram bunches up on the left, you are underexposing the scene (**FIGURE 1.11**). When the histogram collects mostly in the middle (though extending a little farther to the right), you are correctly exposing the scene (**FIGURE 1.12**). And when the histograms crams everything to the right, you are overexposing the scene (**FIGURE 1.13**).

Understanding histograms takes a bit of time to work through all the potential variables. Sit down with your camera manual and become familiar with all the adjustments for shutter speed, aperture, ISO, and then move to all the automated exposure feature modes. When working with any of the auto mode features: A, S, or P (A = aperture preferred, S = shutter speed preferred, or P = Program), the camera's computer determines exposure based on the

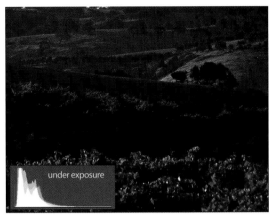

FIGURE 1.11 The histogram in this image is to the left of center. In this scene, the potential for recording all the midtone and highlight value is lost.

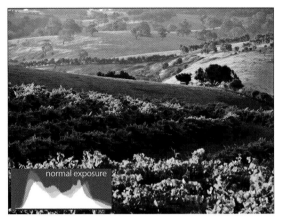

FIGURE 1.12 Flavoring the exposure to include more information to the right of center gives this image better distribution of the data, capturing all potential values from shadow to highlight.

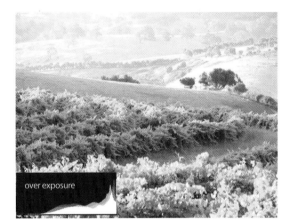

FIGURE 1.13 A histogram that is too far to the right means a severe overexposure situation.

selected mode. By using *exposure compensation* you can dial in plus (+) or minus (–) values into the camera to monitor the histogram after exposure (check your manual for how this done for your specific camera). If you favor increasing the exposure to the plus (+) side, you will be adding more information to the right-hand side of the histogram. Remember: "Right is bright." By flavoring the exposure to the right of the histogram display, you can take full advantage of the tonal scale during capture. In general, moving the tones captured to the right on the histogram (without overexposing) allows you to obtain smoother and more acceptable tone gradation and less digital noise.

When you favor your exposure *too* much to the right (as in FIGURE 1.13), be warned: The histogram should not pile up and move beyond the right edge, because that leads to overexposure and blown-out highlights (**FIGURE 1.14**).

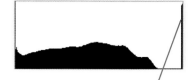

Clipped highlight histogram for car door

FIGURE 1.14 In this example the highlight information does not represent areas of important detail. The spike in the right-hand side merely represents the specular highlight in the image.

Areas that do not contain detail like the chrome specular highlight will blow out, as seen in FIGURE 1.14. In most cases, as with this image, there is no detail of value to be concerned with.

A DSLR camera can be set up to alert the user when the highlights are pushing too far to the right in the histogram. There should be a "flashing highlight" or other kind of blinking indicator (**FIGURE 1.15**) that alerts you to the possibility of overexposing highlight information. When enabled, this indicator warns you about which areas of the image are overexposed. Evaluate this and decrease the exposure slightly.

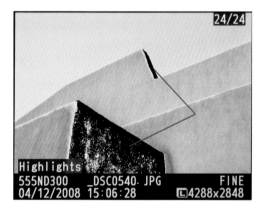

FIGURE 1.15 The clipped highlight areas can be set to flash on and off in the camera's LCD display as an overexposure warning.

In some cases, when favoring your exposures to the right, the image may appear too light on the camera display or in your Raw conversion application. This is not a problem as long as you haven't blown out any *important* highlight information.

The histogram on the LCD display of any digital camera is formed from an internally generated 8-bit JPEG, even if you are shooting in Raw. Consequently, the histogram on the back of the camera is different from the one your final processed Raw image will have! What this means is, you may have a more room then you think on the

highlight side of the histogram than your camera is indicating. Experiment with the exposures in the Raw processor in Lightroom or Photoshop to observe how much of this data is recoverable. With a little experimentation, you will be able to better evaluate and adjust exposure in the highlights and know when to ignore the warnings.

I have mentioned an element or two of what is a technically good histogram: The highlights are not clipped, and the tones cover the range from left to right effectively (though favoring the right), providing good detail within the range of reproduction. In the creative, aesthetic process of previsualizing an image, consider the example of defining an object or person against a spectacular sunset background. The point of interest to the photographer may be the object or person silhouetted against the sunset. But this histogram would not be as described as "a technically good histogram" because it would look like a football goal post, with a spike of data at both the shadow and highlight extremes. This would fall outside those parameters I am talking about. So, understand that what plays into the digital photographic process is also the *aesthetic view*, which at times does not adhere to the technical rules.

TIP

Understanding the histogram on the DSLR's LCD display is probably the single most important concept to become familiar with in optimizing exposure.

Getting a perfect exposure takes some experimentation and evaluation (**FIGURE 1.16**) at first, but with a bit of practice you should be on the way to improving your pictures and spending less time adjusting them in Lightroom or Photoshop.

If you get in the habit of underexposing to limit the chance of blowing out the highlights, you will tend to introduce noise (remember film grain?) in the midtones and shadows and lose the potential for the best color reproduction.

Be aware that not enough information recorded during exposure will lead to digital noise and lack of color fidelity (muddy-looking color). The color fidelity will be affected because the lack of data depth recorded will not be enough to maintain saturated colors.

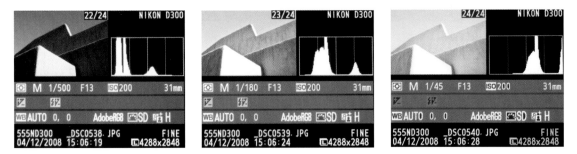

FIGURE 1.16 Each image was framed closely to include the same reflected light, and the exposures were changed to help evaluate the resulting histograms. Minus exposure value on the left, normal exposure value as indicated by the in camera reflected metering system is in the middle, and overexposed on the right.

The Computer

A significant improvement in performance with Lightroom and Photoshop will be achieved if you have a computer that can comfortably handle the software and today's high-resolution DSLR camera files. Needless to say, the fastest computers and laptops currently available are the best choice for processing and archiving a large volume of images. Your computer will benefit from having as much RAM memory as you can pack into your

system. I recommend you have at least 2GB of RAM installed on your computer, and 4GB is better.

Having said that let's look at the gear requirements suggestions for working with Lightroom and Photoshop.

Choosing Your Hardware

Professional photographers can effortlessly shoot heaps of images in a single day, racking up 5 to 20 GB or more without any trouble. Your storage requirements will grow considerably in a short period of time at this rate. If you are going to processing 10-megapixel and up digital camera files, you will not only need a fast computer with a lot of RAM, you will need to give serious thought to how you are going to store all your images over the long haul.

Adobe provides minimum system specifications for both Lightroom and Photoshop software. (Check the outside of the box or online for current information at www.adobe.com.) These specifications are the bare minimum to run these applications. It's better to exceed these recommended minimums when purchasing a computer. The suggested comfort zone in **TABLE 2.1** can always be expanded to continue to upgrade your imaging work station. Your budget and the volume of images you work with on a recurring basis will dictate what level you should consider buying into.

You will find that the Macintosh platform includes features that play well together with other Apple-branded digital toys, like the iPhone, iPod, iTV, and so on. The Mac is normally easier to configure because of its integrated system approach to the Operating System (OS) features and external devices.

TABLE 2.1 Jerry's Suggested Minimum Specs for Your Computer System

Computer platform	Pick your preferred flavor: Macintosh or Windows
Processor(s)	Dual and/or quad core Intel processors at 2.6 GHz and above
RAM	2GB minimum, but 4GB preferred
Hard drive	Start with a 500GB internal hard drive with space to add more as needed
External storage	USB 2.0 or Firewire 500GB to 1 terabyte hard drive for backup storage
CF/SD card reader	USB 2.0 or Firewire connection, or internal card slot
DVD burner	Internal or external (look to BluRay as a high-capacity DVD technology)
Monitor	High-definition LCD display monitor, 23 inches minimum

Windows tries to be all things to all people because of its huge user base, and setting it up may require bit more attention to detail. But if the basic overall suggestions are followed for platform configuration, Windows machines are just as effective for DSLR imaging.

In TABLE 2.1, I list what I consider the minimum hardware requirements at the time of this writing for working with Lightroom, Photoshop, and DSLR image files.

Setting Up Your Digital Darkroom Environment

First and foremost, before starting up Lightroom or Photoshop to work in the image editing process, pay attention to the space you will utilize for image viewing. **FIGURE 2.1** shows a photo of my workspace.

FIGURE 2.1 My workspace. Note: the walls and desktop are painted a neutral gray to reduce surface reflections and the blinds are drawn to block out extraneous light.

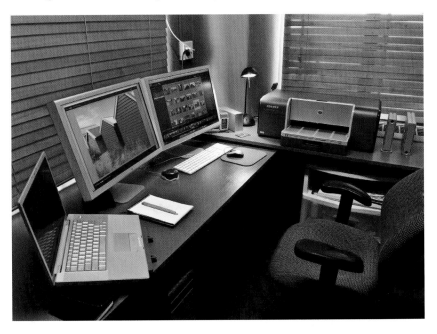

Establishing a comfortable working environment allows you to return time and time again to organize and process your images. Start off with furniture designed for working effectively and comfortably within a computing environment. If you can swing it, paint the room a neutral color or 18% gray. Next, look to the ambient illumination within in your digital darkroom. Lights should be dimmed to allow for the images on screen to be viewed correctly, without reflections from lights or unshaded windows influencing the color of the displayed images. (But don't set the ambient brightness of the lighting

in your work area so low that you can't read this book!) Low light is good, but don't set it so low that you stumble around or can't find your coffee.

If you can't control the lighting from above with a dimmer switch or don't have adjustable shades over the windows to control the room illumination during the day, at the very least use some inexpensive black foam core to create a hood on 3 sides of your monitor to eliminate reflections.

In the digital age of photography, you will find yourself spending a bit of time parked in front of your computer and monitor when not in the field or studio capturing images. This isn't really much different from standing for long hours in front of a light table sorting stacks of slides or sitting at an enlarger in the darkroom. Digital has not changed the fact that it is all still a visual process. But breaks from the computer are really important, or a fatigue factor could prevent you from enjoying and maximizing your passion for photography.

TIP

When working at the computer, take frequent breaks to prevent eye and muscle strain. I recommend a 10-minute break once an hour. Taking periodic breaks will only make you healthier and more productive. If your muscles ache and your eyes are tired, you've waited too long and will need time to recover. When you have been in front of the computer screen too long, your judgment about what is good color and tone is affected.

Your Monitor

The most important tool for viewing digital camera images is your monitor. Therefore, it is important to choose one that has a high-definition screen with good contrast that can be calibrated. (The choices are always improving—check out the recommend display manufacturers in the resource appendix at the end of this book.) At a minimum, a high-quality 23-inch or larger monitor is best for viewing images. With a large display, you can take advantage of more screen real estate for viewing your images within all applications. Screen resolutions of 1280 x 920 and 1920 x 1200 are excellent to work with. If you want to extend your screen real estate even more and spread out to create the ultimate work space, you'll be happy to know that Lightroom 2.0 supports dual monitors.

A monitor used for viewing and correcting images should have a neutral gray desktop background (**FIGURE 2.2**). Avoid using a color or an image as a background that could affect your perception of the color of the image you are displaying and adjusting on the screen. Yep, stay away from using as a desktop image that picture of you and yours on that beach with deep aqua blue water and lime green palm trees.

FIGURE 2.2 Within your computer's operating system display preferences (Mac) or properties (Windows) you should select a gray background for your desktop screen display.

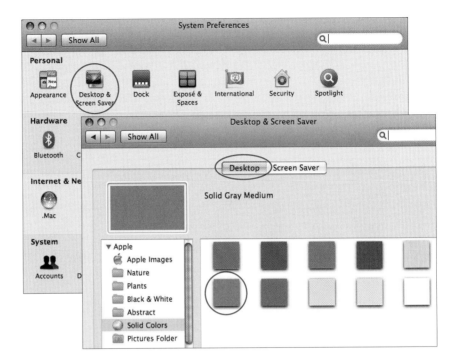

Now, if you really want to go all the way as professionals do, consider wearing a neutral gray or black shirt to avoid reflecting any unwanted colors back into your screen display that might influence your color judgment. Yes, I'm serious! Don't wear that loud Hawaiian shirt when image editing.

Monitor Color Calibration Solutions

Monitor calibration is so important to the digital imaging process that it can't be overstated here. After all, if you don't trust the colors displayed on your monitor, any other color management is a waste of time. If your monitor it is not properly calibrated, then the adjustments you perform to tone and color will be rendered incorrectly.

If color precision and the ability to match your prints to your monitor is a priority, a hardware *colorimeter* calibration solution is critical (I come back to this in a minute). With proper monitor calibration, you can predict with reasonable accuracy that the image displayed on your screen will match the print.

Take a field trip down to your local consumer electronics store and look at all the different renderings of the colors displayed by the television screens in the sales area. None of the displays actually look alike or are consistent in the rendering of color, contrast, and brightness. Too many people have adjusted the brightness and color controls, so none of the displays project a good

match. We all see color differently, too. Have at it when the sales people are not around and fiddle with the brightness, contrast, and color controls. Then do your own survey while you have a captive audience: Place two displays on the same channel so that the same image appears on both, ask two people to independently adjust the display for the best, color, contrast, and brightness. I guarantee you will get two different results, and this is an example of human visual color perception at work.

Using a measuring instrument or *colorimeter* to calibrate your display takes away the differing perception of color and provides a measured response to color that is not influenced by the inaccurate human visual response to color. In fact, the most effective way to calibrate and profile a display is to use a colorimeter. Colorimeters measure the color response of the monitor. The companion software compares the data captured to a known standard to calibrate and profile your monitor (**FIGURE 2.3**).

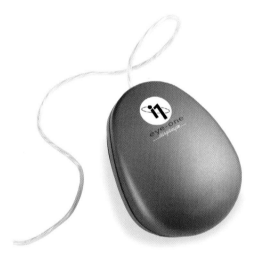

FIGURE 2.3 I use the i1Display 2 system to calibrate my display. I like the easy-to-use software interface provide by this system.

Once your monitor is calibrated and profiled, you can start processing images with confidence. Display monitors can change color, contrast, and brightness over time, so it's best to update your calibration at least every two weeks.

Monitor calibration is a two-step process. The first step involves calibrating your display, and the second step is creating a profile (or characterizing) it. The calibration step involves physically adjusting the output of your monitor to a know standard of white point (Kelvin temperture), gamma (contrast), and luminance (brightness). The second step is creating the profile using the colorimeter and companion color-management software to measure a series of gray and color patches onscreen to build an accurate description of

the color values in your image files. When an image is displayed on screen, it is accurately rendered by using a color lookup table (LUT) provided by the profile.

STEP 1: SETTINGS

Before calibrating, I clean off the dust and coffee splashes. I have been known to be klutzy at times and to not take my own advice of keeping liquids away from my system.

The first thing is to optimize the display for output with the calibration settings suggested in the companion color-management software. The software will clearly walk you through the process of using and placing the calibration instrument (sometimes referred to as a *puck*) on the center of the display. Depending on the monitor—a liquid crystal display (LCD) or cathode ray tube (CRT, the old-style TV-type tube)—follow the directions provide by the software and enter specific settings and adjustments for your monitor's white point (Kelvin temperature), gamma (contrast), and luminance (brightness) of your monitor (**FIGURE 2.4**).

FIGURE 2.4 iOne Match software interface for step 1 of the monitor calibration process requires you to select the white point, gamma, and luminance.

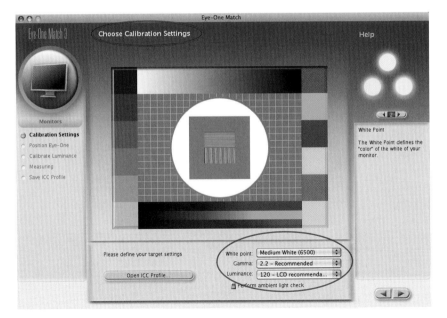

Choose the color-management software's recommend white point of 6500K (degrees Kelvin) as the default color temperature. Most monitors reach useful brightness levels much more easily at 6500K than at a lower color temperature of 5000K/D50.

After selecting the white point (color temperature) for your display, you will choose the gamma (contrast) setting for your monitor. A gamma of 2.2 allows for the maximum range of colors that your system can display. For both Macintosh and Windows computers, the color-management recommended gamma setting should be set to 2.2. And then set the luminance (brightness) value 120 (for LCD) at the software recommended level for your monitor type.

After adjusting the monitor hardware settings through the use of the color-management software, you will be alerted by the software that it is now ready to formulate the automated second step in the process of creating the actual monitor profile.

STEP 2: PROFILING THE DISPLAY

When the color-management software moves on to the second step, it will use the puck (colorimeter) to measure and compare a wide variety of specific gray and color patches on the screen, from which the monitor profile will be built. This process can take up to ten minutes as the color-management software does all the number crutching to create the profile. This profile will then be used by the computer system and your computer's video card to correctly project the calibrated display (**FIGURE 2.5**).

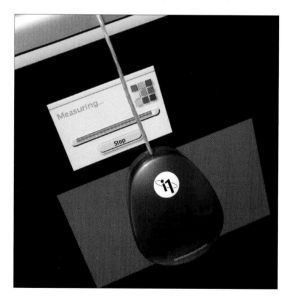

FIGURE 2.5 iOne Match software and calibrator instrument measuring a series of displayed color patches for creating the monitor profile.

TIP

If you want to move on to other paper type selections rather than the ones provided by the manufacturer in the print driver, you can usually find good profiles for fine art papers on the manufacture's Web site, with PDF instructions on how to use and apply them for printing with your specific printer. Check out the list of paper manufacturer Web sites in the resource appendix section at the back of the book.

Remember, the monitor display brightness will also change over time, just as a light bulb becomes dimmer with age. It is essential to recalibrate and reprofile the monitor once every two or four weeks to maintain an effective workflow. The process sounds more complicated than it really is. The color-management software interface offers a wizard that is easy to follow—it's like someone holding your hand. You answer questions related to your monitor type as you make the adjustments to the hardware. Simple but effective!

You can take the color-management process to the next level by purchasing a more sophisticated *spectrophotometer* (measuring device) and companion color-management software (together costing $1,200 to $1,500) for making profiles for your print output. *Device-specific destination profiles* (taking into account printer model, ink, and paper combinations) is the term used to describe this output color management. I'm of the opinion that in today's printing market, print and paper manufacturers have woken up to the fact that creating *device-specific destination profiles* does not need to be a sophisticated process for the average photographer. Many profiles for specific paper and ink combinations are downloaded to your computer when you install the printer driver.

My Mobile Photography Travel Gear

Here is a list of all the stuff I typically haul around with me as I'm working with digital photography (much of which is shown in **FIGURE 2.6**). Your list may vary, but this should give you a good idea of the kinds of gear you may well find yourself needing at some point.

Camera
- 12-megapixel Digital SLR camera
- Wide zoom lens, 17–55mm, f2.8
- Medium zoom, 70–150mm
- Long-range zoom, 70–200mm, f2.8
- Wildlife shooting: long-range telephoto, 300mm plus (rent this as needed)
- Portable flash system

Computer
- Mac or Windows laptop with at least 15-inch screen
- 2GB minimum of RAM (4GB preferred)
- 1440 x 900 minimum resolution
- 200MB hard drive, 7200 RPM
- Some kind of service care package
- A card reader (if no card slot in the laptop)
- A USB cord
- SD or CF cards, 2, 4, or 8GB

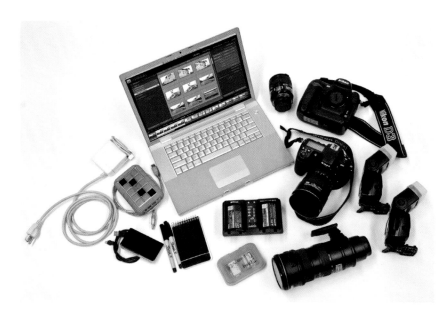

FIGURE 2.6 The essential equipment from my gear bag for capturing and processing images in the field.

Miscellaneous Gear

- Mini round reflector, 20-inch white, silver and gold combination
- Lens micro clean cloth
- Maglite (flashlight, for night photography)
- A dust-off brush
- A blower device
- External hard drive with viewer
- Rain gear
- Micro towel to get rain off gear—do not wipe water off, only dab
- Very light graphite composite tripod
- Mini tripod
- Lots of extra batteries

STREAMLINING YOUR WORKFLOW WITH LIGHTROOM

Basic Concepts
of Lightroom
and Workflow

I know you're itching to get on to Lightroom, but I would like to
cover a few important, fundamental insights into how Lightroom
was developed first before moving on to the process of stream-
lining your workflow. Here we'll gain some perspective on how
Lightroom has come onto the scene.

Why Lightroom Is What It Is

When digital capture first arrived on the scene in the early 1990s, many were a bit overwhelmed by the cost and all the equipment needed to actually adopt a digitally based photography workflow, as well as underwhelmed by the quality of the images produced compared to film. But, as for me, the great creative flexibility kept my interest. The first DSLR cameras were roughly as expensive as European luxury cars, and the computers were slow as molasses. I remember almost taking a second mortgage on my house just to buy 32MB (that's megabytes, not gigabytes) of additional RAM for my computer in 1992. But gradually the price points came down, and the higher efficiency and reduced cost of sensor chips allowed digital photography to integrate into the mainstream.

But what has happened is an increasing stack of digital images to deal with in the post-production environment. Talk about a logjam—photographers now spend more time editing and processing images then they do behind the camera. So, making the process more effective requires you to start looking at the need to develop a management approach to working with your images in a logical way.

Believe me, any system approach you adopt will be a constantly revised work-in-progress. Your needs will grow and change as you use Lightroom. The choice of Lightroom as your flexible solution is a good one because it is offered by an established software provider and built on standards that allow it to run on the two most common computing platforms: Windows and Mac. When you adopt and practice a system of managing your workflow from capture to output, it enforces and reinforces a consistent approach maintaining a process that can endure the test of time.

In the early conceptual stages, when Adobe was determining whether Lightroom could become a viable product, members of the Lightroom Development Team attended photo workshops at the Santa Fe Photographic Workshops (SFPW) and elsewhere. They were there to observe and work with digital photographers to identify solutions for processing and managing large numbers of digital images. As the Director of the Digital Programs at the Workshops for the past 14 years, I have had the opportunity to observe the growth and evolution of digital technologies. In watching the development of Lightroom in the early stages, it was interesting to watch photographers as they were introduced to the application's logical approach to the DSLR workflow. What I found was, given a fundamental overview to managing the files, that each of them adapted Lightroom to fit a variety of workflow models.

I have found Lightroom to be functional for many levels of photography, from beginning students to advanced professional/commercial shooters. Having worked extensively in teaching digital imaging applications at the SFPW, I have monitored and consulted with all facets of the photographic industry specifically on the DSLR workflow.

When working with photographers, it is important to first understand and evaluate how to structure the approach to the digital imaging workflow from their perspective. Each niche in photography has specific requirements for dealing with workflow, depending on the volume of images produced. Stock, wedding, portrait, travel, and commercial photographers can create large volumes of images quickly, whereas landscape, nature, and still life photographers don't really produce the same volume—but all want to be able to implement a system for daily use that fits with how they need to be organized. Having the flexibility built into the application is key for a variety of users, but at the same time Lightroom maintains a cohesive application that can be used by everyone, not just a small slice of the market. How you work with the program is largely established during the process of setting up the preferences (see Chapter 4).

In simple terms, the conceptual idea for Lightroom was to develop a robust database management system to search and find images and combine it with a powerful image processor to develop, correct, and enhance images (**FIGURE 3.1**). What has evolved is an effective application built for speed, with an elegant, easy-to-use interface for importing, cataloging, processing, and presenting images quickly. This well-thought-out design that includes a logical workflow makes Lightroom a valuable tool for any photographer to effectively work with large numbers of digital images. Providing this dedicated database management and image-processing engine as a solution targeted primarily for photographers is how this application has developed to this point.

FIGURE 3.1 The two main core elements of Lightroom are in green: the database management and the image processing engine. Lightroom's modular structure allows all five components in red (Library, Develop, Slideshow, Print, and Web) to use the core elements to speed up all the features.

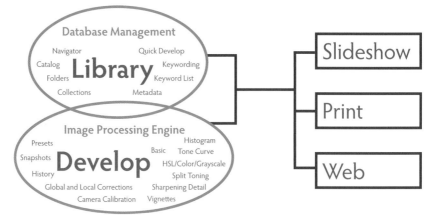

Lightroom version 2.0 provides new features that build on its stature as the effective workflow tool for digital photographers. With the introduction of Lightroom 2.0, photographers now have the opportunity to use improved cataloging tools (Chapter 7) and powerful local corrections (Chapter 12).

Worry-free Image Adjustments

The Library module's Quick Develop feature and the Develop module's image adjustments are completely non-destructive to your original files. The adjustments are recorded as *metadata* instructions (more on metadata in Chapter 4) only and are applied to output-based exports from Lightroom. This means that the original images are always preserved, and the instructions are only applied to the image when it is exported out of Lightroom. The original file is never edited at the pixel level (as is the case with Photoshop). Your image files cannot be destroyed unless you actually delete them.

Lightroom's cross-platform development means the interface looks the same on both Mac and Windows platforms. Straightforward and uncomplicated, Lightroom provides (as I have mentioned) two components to the central hub of the application: the image database system and the image processor. The image processor is the Adobe Camera Raw (ACR) processor. Using the powerful image-processing features of ACR within Lightroom's Develop module, Lightroom harnesses this powerful engine for working with Raw files as well as the following image formats: DNG, PSD, JPEG, and Tiff. Each of the other modular components works with the foundational central hub pieces to perform complementary output tasks in the process of creating slide shows, printing, and presenting Web galleries.

Lightroom's modular architecture allows for greater elasticity than most of the current workflow alternatives, such as Apple's Aperture or Microsoft's Expression Media, and allows for future third-party features to be easily integrated into a Lightroom workflow. By using the database information to recall and reference select image metadata, these future independent, easily integrated plug-in modules will perform complementary production tasks for the user. Just as Photoshop's software architecture was opened up to third-party plug-ins, Adobe has recently provided the tools for developers to do the same thing with Lightroom 2.0. One plug-in example could use global positioning metadata in the image file to link an image to a specific location on the earth through digital mapping program integration. How cool is that?

Lightroom Versus Bridge

We will be using Photoshop toward the end of this book, and you may or may not realize that Bridge (Adobe's file browser) was part of your Adobe Photoshop purchase—it is installed on your machine with Photoshop. At this point you might be asking yourself, "Why would I prefer to use Lightroom if Bridge can do many of the same functions?" Allow me to explain the difference between the two applications.

Bridge is a file browser designed to work with many different file formats in its display. It is structured to support the complete line of Adobe Creative Suite products, including InDesign, Illustrator, Dreamweaver, Photoshop, and so on. So, Bridge is a file browser application that allows the user to view all the file types within a folder (text documents, Web files, design files, illustration files, and images) in what could be described as a collaborative environment. The person dealing with the text and design side, working with another person dealing with illustrations, can view all the files in one folder through Bridge.

The biggest distinction between Adobe Bridge and Lightroom is the way they view and gather information about images. Adobe Bridge displays a folder's content on a local hard drive. To view images that are located on removable media, such as a DVDs or hard drives that are not connected to your computer, you are out of luck. Adobe Bridge will not display any information that is "offline." Lightroom's reach can extend beyond the local disk and can work with offline files that have passed through the application's import process. Any images that are in the database can be accessed by Lightroom significantly faster than Adobe Bridge.

Lightroom as an application has the advantage of moving rapidly though images because all the thumbnail views are built when you import or *ingest* your images into Lightroom. On the other hand, when Bridge is pointed to a folder of images to look at (that is, when it's browsing), it must build the thumbnails of the images and document files before the viewer can see the contents of the folder. This process can become very time consuming when Bridge is directed to view a folder containing a large number of images.

Lightroom enhancements to the workflow can help photographers in ways that a "file browser" is not designed to accommodate. The application excels on the search side, providing a dedicated database solution, whereas a file browser like Bridge does not have this capability. In addition, Lightroom integrates output solutions for printing. Bridge doesn't.

If you're a photographer working predominantly with images, Lightroom and the powerful pixel-editing capabilities of Photoshop are a complementary one-two punch. So I don't recommend using Bridge. It's just toooo slooow for the image viewing or managing process.

Lightroom's flexibility lets you make choices at the workflow image import stage for referencing image files in a variety of locations. A photographer who has many legacy images on DVDs, external hard drives, and so forth can import these into manageable catalogs (we start importing images into Lightroom in Chapter 6). Also be aware that you are not in any way, shape, or form locked out from viewing and using your images in other image-editing programs, such as Bridge, Corel Painter, Nikon NX, or others.

Naming Files

If you have been shooting digital images up until now, I'm going to guess that your computer is full of files with names like DCIM0027.NEF and IMG5723.JPG. These camera-created filenames don't mean much, and unless you remember where that folder and image placement was, you really don't have a way of searching for the item on your computer or DVD. They become lost in the computer abyss. So you may decide you need to give your photos significant names that you will recognize, such as "Kids at the beach playing catch with our cousins.jpg" or "Holiday Inn Hotel in Tibet.jpg." Not so fast: You shouldn't write paragraphs or include spaces in filenames.

Developing a method to naming and finding files is fundamental to the process of managing your stuff. If you're going to get your workflow organized, you need to establish a way to work with a file-naming structure and avoid what are called *illegal character filenames*. Some applications use programming scripts (automated instructions) to implement an action under the hood. These scripts can stumble when illegal character filenames are encountered, and the application can potentially lock up. (You may have encountered the spinning pizza wheel of death on the Mac or the frozen PC screen. Both require a force quit or restart—oh joy.) When an application cannot recognize the filename, it will usually stop its function, abort the action, or lock up the computer's processor, and it can be a bear to decipher and troubleshoot the problem: You will need to look at every filename in a folder to determine the illegal offender.

By following a standardized file-naming structure, your files will play together nicely with all operating systems. My first piece of advice is that you should limit your filenames to 32 characters and avoid the following illegal characters:

- Spaces in filenames (biggest offenders, you know who you are)
- \ (backslash)
- / (forward slash)
- : (colon)
- * (asterisk)

- ? (question mark)
- " and ' (double and single quotes)
- < (left angle bracket)
- > (right angle bracket)
- | (pipe)

You should also avoid %, #, and $ in your filenames, as these are commonly used by some applications as *variable name prefixes*, so it can get unpleasant if automating anything with filenames that include these characters.

To create visual spaces within filenames, use an underscore (_) or a dash (-). Many imaging scripts used in Photoshop throw out poorly named files or stop the processing until the file-naming structure is fixed. It can sometimes take hours to troubleshoot a file-naming problem when batch processing large numbers of images. Spaces within filenames can be especially problematic.

The rationale at work here is to allow problem-free, cross-platform compatibility. Even an all-Windows or all-Mac culture needs to interact with the other culture sometimes. The safe and sound method is to keep an eye on the limitations of both operating systems, even if you work mostly on only one OS. At the operating system level, a Mac can read files without extensions (without ending in .TIF .JPEG, and so on) whereas Windows XP does not recognize a file that doesn't have an extension. Good file naming includes an extension on all files.

The Six Basic Elements of the Workflow

All forms of the photographic workflow should include the six basic elements I discuss in this section. Photographers should personalize how these basic elements are used to meet their specific needs. Lightroom, of course, helps provide a beginning to end workflow solution.

1. Capturing Images

Capture in the traditional sense is done via the camera, and images are stored on memory cards.

Unique, instantaneous capture hardware and software solutions are supported by Lightroom automatically importing your pictures. By using your camera manufacturer's camera control software or advance wireless technology to remotely control your capture process, Lightroom can be set up to automatically import your images from a folder you identify and display the images within the application.

As a Nikon Shooter myself, the Nikon wireless hardware solution combined with the Camera Control Pro software is the ticket. On the Canon side, the

EOS Viewer Utility can work in a camera-to-computer tethered mode. This is great for working in the studio with the art director breathing down your neck, or while friends and family are looking on to critique your shots.

2. Transferring Images to Your Computer

By transferring, I mean downloading from the camera or card reader and backing up. Using Lightroom to manage the importing of your image files enables you to make some specific choices about how you want your images processed and stored. Questions that need to be answered involve determining preferences for storage and where and how to manage your image backups.

3. Organizing and Sorting

Some of this step can be achieved with Lightroom at the transfer stage as well, but in a global fashion, not image by image. Once the image files are in the location of choice and viewed within Lightroom, it's time to organize, sort by a variety of user-defined criteria, and delete poor exposures and out-of-focus images. You should also introduce keywords to tag images with user-updated, searchable metadata content. This could include things like location name, subject name, name of the object in the photo, and so on.

4. Editing

The editing process is where images can be ranked with a variety of labels in Lightroom (such as colors, stars, flags) to determine whether they are worth holding for a further review. The editing process is one of the most difficult stages in the workflow, especially when you are emotionally attached to the subjects being photographed (there are image editing workflow suggestions in the nearby sidebar).

5. Developing or Enhancing

Not all images from a shoot will make it to this level. A select few based on the ranking system in step 4 will require extra time to enhance with tone and color corrections, or may need some basic retouching. If the image requires more adjustments and correction than can be achieved in Lightroom, you need to go to a pixel-editing program such as Photoshop. You will need to export images from Lightroom for further retouching and enhancement if you choose to do your editing outside of Lightroom. This is where the advantage of Photoshop's complete integration with Lightroom stands out. When you finish the editing, Lightroom shows the edited version within in its Library. If you choose a different program to further edit your image, you need to re-import the file into Lightroom when your work is completed.

6. Presenting and Sharing

You can share your efforts with clients, friends, and family through a variety of output methods. Lightroom can help you create slide shows for onscreen or projector presentations, print directly from the application, produce Web galleries to upload to a Web site, or distribute Web browser-compatible CDs or DVDs.

Preventing Editing Overload

We all thought that when we were free of film and processing, we had arrived at a no-cost free zone—after the original expense of the digital camera. The computer system that processed our images was going to extend our creativity into new horizons. We started to take pictures of anything and everything. The downside of the "I can have everything" attitude, though, was spending a lot more time in front of a computer screen editing images rather then paying attention to the details in the camera viewfinder and getting it right from the start.

Digital photography allows us to freely experiment with visual expression. But the time required to review, edit, and process can defeat the advantage of this enhancement to the creative process. Learn to think before you shoot and focus on what it is you're trying to communicate with your images. Certainly, shooting rapidly during a sports event is required get the best shot sometimes, but with a bit of practice, you will soon learn to anticipate where the action is and learn the best angles and perspectives to photograph. As they say, life is not a race but a journey. Appreciating the visual impact you can make with your photos is a learning process that requires you to edit closely, keeping only those images that express your vision.

Bite your tongue every time you hear yourself saying, "Oh, I'll fix that in Lightroom or Photoshop." Better to get the best shot you can while shooting than to count on using software later on to fix your photo.

Tough Decisions: The Editing Process

Tough decisions are necessary in the editing process, and if you have commitment issues this might be the place to start dealing with them—by deleting images early that really don't make the grade and learning from your experiences so you don't repeat the same mistakes.

Questions to ask yourself include these:

- How many images do I need to have storage for?
- Is this image something that I will ever revisit?

- Should I just keep everything? (I hope not!)
- Will I be sharing these with someone at some point?
- Can I sell this? Did this image express what the client was looking for?

Look at deleting images you will never, ever use. And don't store everything you ever shot on your hard drives. I do, however, burn the images from the original downloaded cards to DVDs as a first step in my workflow. DVDs are cheap and work well as temporary backups until I'm organized enough to only keep the edited files. It's just a safety measure and comfort zone for me.

Here are a few suggestions on what criteria you should use to start the editing process:

- Clarity: Can you tell what the subject is? Is the image blurry from camera shake?
- Tilt: Is your photo tilted or level? (This can be adjusted through cropping.) Unusual angles can in some cases present a new perspective or introduce tension for the viewer—maybe good, maybe not.
- Soft focus: Depends if you were after this effect. Sharp focus is overrated in some cases. Motion blur and dragging the shutter as a technique are often experimental techniques and require close examination.
- Severe underexposure or overexposure: Too much noise in underexposure is not good unless used deliberately as a creative effect. Extremely blown out highlights can't be recovered.
- People's emotions and expressions: Does the picture communicate a feeling you like? Are the faces expressive? Backs of heads do not engage the viewer unless artistically placed within in the frame.
- Composition: Poorly framed images? Delete in cases where the images cannot be improved with cropping. Delete most pictures with people running out of the frame, with middle horizon lines (remember the Rule of Thirds), and with subjects in the center.
- Poor selection of point of focus: Focus point distracting? Delete.
- Reflections that interfered with subject.
- Too many similar images when shooting a series of sequences.
- Too many frames with same perspective on the same subject.
- Experiments that just don't work visually.

One more thing: Implementing an effective workflow approach to editing requires you to learn a few simple Lightroom keyboard shortcuts for navigating quickly. Check out Chapter 5 to develop your shortcut skills.

Setting Lightroom's Preferences

Working within any application, in my opinion it 's important to set up the preferences as a first step. This process of working through each of the choices helps you understand all the variables and alternatives you have from the start. In this chapter, I walk you through specifying and establishing the essential Lightroom preferences that will allow you to use Lightroom effectively and take advantage of what this program has to offer.

Follow the directions provided by Adobe for installing the Lightroom application on your computer. If you should have any questions, refer to the Read Me file that accompanies the Lightroom software. If the process is still unclear, contact Adobe Systems Inc. directly and have your software serial number available.

After installing Lightroom on your system and launching the application for the first time, you will see the opening dialog Select Catalog (**FIGURE 4.1**) for creating a default catalog on your computer. Normally the default location for this catalog will be Pictures on the Mac or My Pictures on the PC. You can at this point change the location to another folder if you want.

FIGURE 4.1 The Select Catalog dialog allows the user to identify a catalog location for Lightroom. In this case Users/Jerry/Lightroom/Lightroom 2 catalog.lrcat is the default selection.

Lightroom is flexible for a variety of different users and can adapt to different needs as time goes on. However, remember that Lightroom can only work with one catalog at a time and cannot at this point work in a networked environment. This means that you cannot have multiple computers or users working from or in the same catalog at the same time. Lightroom will only work with your computer's local and attached external storage hard drives.

Macintosh vs. Windows

Adobe Lightroom is designed to look and function the same on both Mac and Windows platforms. This book happens to be illustrated from the Mac perspective, but if you are a PC user, here are the corresponding function keys on Mac and Windows platforms:

Mac	Windows
Return	Enter
Command	Control (CTRL)
Option	Alt
Delete	Delete or Backspace

When one of the Mac modifier keys is used, replace with the related Windows equivalent to achieve the same result. It's that simple.

General Preferences

After selecting a default catalog location, choose Lightroom Preferences from the appropriate menu: On the Macintosh, the preferences are located under the Lightroom menu, and on Windows they are found under the Edit menu. The Preferences dialog appears (**FIGURE 4.2**).

FIGURE 4.2 The General preference tab allows you a few options for setting Default Catalog, Completion Sounds and Prompts. The default settings for showing the splash screen during startup and the Automatically check for updates are fine with the exception of choosing the Prompt me when starting Lightroom.

TIP

Be sure and check "Automatically check for updates" to ensure you are always working with current version of the program.

Under the default catalog heading, choose "Prompt me when starting Lightroom" instead of setting Lightroom to the default option "Load most recent catalog." By making this choice, from now on each time Lightroom is launched, the Select Catalog dialog (FIGURE 4.1) will be displayed, prompting you to choose a catalog rather than automatically launching into the most recent catalog viewed. If you prefer to use the most recent catalog when launching the application, just hold down the Option (Mac) / Alt (Windows) key to bypass the Select Catalog prompt.

"Prompt me when starting Lightroom" is the preferred method of working with catalogs illustrated in this book. A *Multiple Catalog Workflow* (MCW) is a term I use to describe the creation of a new catalog for separate events, jobs, clients, or locations. You will have multiple smaller catalogs rather than one large catalog to manage (more on this later). If you elect to not change the default setting (that is, you keep the "Load most recent catalog" setting), you can always choose File > Open Catalog or File > Open Recent to open the desired catalog (**FIGURE 4.3**).

FIGURE 4.3 Opening a specific catalog (Open Catalog) or Opening a Recent Catalog can also be done from the Lightroom application File Menu.

Presets Preferences

In the Preferences Dialog, click the Presets Tab (**FIGURE 4.4**).

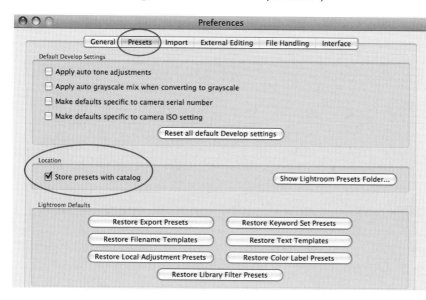

It is important here, when using the MCW, that "Store presets with catalog" is checked. This enables you to create settings such as metadata templates, develop presets, and so on to be stored with the related catalog instead of in Lightroom's default local system location. This way, when presets and templates are created for a specific catalog, they will remain in the catalog location and show up within the application when the catalog is targeted for use, even if the catalog is stored offline on another, external hard drive. However, if you do not choose this option, templates and presets are automatically accessible to all catalogs.

It is also important turn off Apply auto tone adjustments, or Lightroom will alter all your files on import with tone adjustments. You will need to experiment with Lightroom's Auto Tone adjustments to see if they are appropriate for your type of photography. This can be better managed by toggling on/off the Auto Tone feature at the import stage for specific groups of images. If checked here in the presets preferences, images that were adjusted or enhanced in other image-editing programs will have Auto Tone adjustments applied to "finished" JPEG, Tiff, or PSD files.

Import Preferences

Next, move within the Preferences dialog and click to highlight the Import tab (**FIGURE 4.5**).

FIGURE 4.5 Preferences dialog for importing images files deals with choices for Import options.

By selecting "Show import dialog when a memory card is detected," you cause Lightroom to open the Import dialog automatically after connecting to a camera or memory card reader with your computer.

If you prefer to not select this option, you will need to download your images manually to the local hard drive or an external storage device and then use the Import button or File > Import Photos from Disk after launching Lightroom. You will learn more about the options for managing your image imports with Lightroom in Chapter 6. For now, check the feature to "Show import dialog when a memory card is detected."

Selecting "Ignore camera-generated folder names when naming folders" is going to be dependent on how you manage your internal camera file and folder naming settings. I normally have number sequencing turned on within my camera and prefer not to check ignore.

If you set your DSLR camera up to shoot JPEG plus Raw, treat these image files separately by checking "Treat JPEG files next to raw files as separate photos."

The Import DNG Creation settings apply to the Digital Negative file format (DNG). DNG is an open architecture file format developed by Adobe to allow Raw shooters to potentially open their files in the future without relying on support from the camera manufactures who may discontinue Raw formats and/or DSLR cameras. Think of DNG file format as a container in which you can specify how DNG files are created during import and what is placed in the container. For more information on the DNG file format, visit www.adobe.com/products/dng.

External Preferences

Next, still in the Preferences dialog, click the External Editing tab (**FIGURE 4.6**).

FIGURE 4.6 Lightroom sends Tiff and PSD copies of Camera Raw files for editing in external editors like Photoshop and Photoshop Elements with choices for Color Space, Bit Depth and Resolution.

Lightroom exports image files for editing in external editors like Photoshop and Photoshop Elements. When exporting Images to an external editor, two choices for File format appear in the pull-down menu: PSD and Tiff. Tiff is more widely preferred for publishing output, and PSD is the native file format for Adobe applications. The settings referenced here are based on a high photo quality reproduction output (resolution of 300) for inkjet printing. When producing images for the Web, an output resolution of 72 is required.

Using the native Photoshop PSD format for external editing is my preference. Lightroom is technically named Adobe *Photoshop* Lightroom and is made to integrate with Photoshop's external editing features... with one little itty bitty caveat. You must remember that when you export or import an image file from or to Lightroom as a Photoshop file (PSD) that contains layers, you are required to save the file format for Lightroom with the Maximize Compatibility preference turned on. I refer to this again when we explore what I call *round tripping*, which means working between the two applications in harmony, in later chapters.

When determining which color space is preferred, ask yourself what the output of the file exported for external editing will be. I normally pick the native color space in which Lightroom predominantly processes raw images, which is ProPhoto RGB. ProPhoto RGB is a very large source color space supporting the most potential colors for processing images for today's 6-, 8-, and

12-color inkjet printers. Adobe 1998 is certainly a good choice as well, with the color space supporting a wide range of color outputs in the inkjet and 4-color offset press area (books, brochures, and so forth). sRGB is the smallest color space, designed for working primarily with digital slide show projection and the Web. The color management discussion can become confusing with all the choices, but Lightroom does most of the color management internally and only allows the user to make decisions about which space to use when exporting the image(s) out of the application. If an image already has a color space profile, Lightroom honors the profile when importing.

When electing to edit a Raw image file in an external application like Photoshop, choose a bit depth of 16 to take advantage of Photoshop's high-bit processing features. If you are exporting an image file for the Web, keep in mind that images in that environment only support 8 bits. Just remember that 16 bits results in twice the file size, but also provides more information to work with when making adjustments.

Pick a resolution that is appropriate for your ultimate output. Resolution can range from 72 (the Web) to 300 (printing). You can ignore the Additional External Editor because we will not be using any other applications within our workflow.

File Handling Preferences

The next tab in the Preferences dialog is the File Handling settings (**FIGURE 4.7**).

FIGURE 4.7 The File Handling preference settings are where keyword separators can be modified and File Name Generation can be controlled.

The default setting for Reading Metadata is satisfactory unless you feel you need to work with "." or "/" as keyword separators. Commas are most often used as the standard *delimiter* or separator in most database programs. But I do set my preference for the File Name Generation based on avoiding the illegal filename characters discussed in Chapter 3. In other words, I place underscores as replacements for any illegal characters and spaces.

Interface Preferences

Next, move to the Interface tab in the Preferences dialog, where you can customize a few of the key display elements (**FIGURE 4.8**).

FIGURE 4.8 The Interface settings refer to presentation features for Panels, Lights Out, Background, Filmstrip, and Tweaks.

The defaults as suggested here are good starting points, but if you are over 40 years of age, I would recommend pulling down the menu Panel Font Size to Large Font Size. The Lights Out and Background defaults are fine. I especially think the medium gray default background is great for viewing images. Other choices I prefer are to turn off "Show ratings and picks in filmstrip," "Show badges in filmstrip," and "Show image info tooltips in filmstrip." Turning these off helps avoid screen clutter within the interface.

One of my favorite interface features is the Lights Out mode. The dim level of the image surrounded by a selected screen color is adjustable within the Lightroom interface. Lights Out allows you to turn off the surrounding interface clutter and focus only on the image(s) selected, without the distractions of the interface (more on the interface in Chapter 5).

Choosing Your Catalog System

Before we visit Lightroom's all-important catalog settings, let's look at two ways you can work with catalogs. You can adopt one or the other based on your workflow demands.

A Single Catalog System

As a simple solution, the program can manage all your image files in one catalog based on their existing location. If you like organizing your files by month in a folder, and putting all the months on one drive or on any number of external hard drives, you can maintain this type of structure by just pointing Lightroom to where the files are and importing them, and they will be linked to the catalog. On the other hand, Lightroom can be instructed to copy all images to a defined location and build the database around this single location. This provides plenty of flexibility in managing and searching image files from a single catalog.

One disadvantage when you create a large single catalog is that you can run into the danger of filling up your computer hard drive with original images, preview images, and metadata XMP files that might rarely be accessed over a long periods of time. Large catalogs with 10,000 to 20,000 images can slow down your computer, depending on your machine's processor speed and internal RAM. These files can sit on your computer, taking up valuable hard drive space. Using the large, single catalog system you can outgrow your hard drive space in a short period of time if you are a high-volume photographer. Laptop users beware; it may be best to develop an external hard drive storage approach to your workflow. Most laptops do not have large internal storage capacity.

And be aware that the crack teams of Adobe Lightroom programmers are looking out for your assets. They have incorporated features in Lightroom to manage the storage problem by re-referencing the images when they are moved to other external storage drives. Using Lightroom's ability to export and merge catalogs can also provide a way to manage most workflows when they outgrow the storage space. In most cases, your pile of images will simply grow and grow and at some point will outgrow your storage capacity. There are many storage options available, but in a word, I'm thinking *BluRay* disk storage could be another bridge to storage issues. We are creating huge amounts of data to store in the digital age. Images, video clips, and other data will all require more storage as we keep collecting media.

BluRay Discs

The BluRay disc format was developed to enable recording, rewriting, and playback of high-definition (HD) video, as well as to store large amounts of any kind of data. The format offers more than five times the storage capacity of traditional DVDs and can hold up to 25GB on a single-layer disc and 50GB on a dual-layer disc. Currently BluRay drives and burners sell for around $500 to $600. As with everything else technological, wait and the price will decline.

Multiple Catalog Workflow (MCW)

A second possible scheme is to break up your workflow into multiple catalogs that can be merged at a later date. This system can work for wedding photographers, for example, who don't need to place all the images from every wedding in the same large catalog. Instead, each catalog could be organized under a separate client name. For example, 3,000 images from the Suzy Smith and Jimmy Jones wedding can have its own catalog. You might only visit this Smith and Jones catalog when prints are ordered and then store it away in an archive only to be accessed a few times down the road for some portfolio shots.

As I've mentioned, I call this separate catalog system the *Multiple Catalog Workflow*, or MCW for short. In this flexible MCW, I usually download images to my laptop and then copy files to an external hard drive and burn the images to a DVD as a backup. Having had the experience of filling up hard drive after hard drive, I have come to use a system that creates a new catalog for each event, location, and/or client.

Also remember that Lightroom can merge multiple catalogs into one catalog if and when you think all or most of the images can be contained in separate storage drives. And yes, I have two of everything for backup! (And so should you.)

If you were to adopt an MCW system for file handling where you only access the separate client catalog occasionally, you wouldn't need to create a large catalog for all your photography. I don't claim that the MCW is necessarily the best approach, but having worked with many types of photographers, I do feel it is fundamentally straightforward and easy and can help you manage your images very well. And it's easy to do: Click File > Create New Catalog.

Remember and tattoo this on your left arm: "Lightroom can only work out of one catalog at a time." Even so, I find the MCW a great way to separate and manage all my digital captures.

Catalog Settings

We are now in the home stretch as far as setting Lightroom's preferences. Now we need to visit the all-important Catalog Settings. Return to the General Tab in the Preferences dialog and navigate to and click the Go to Catalog Settings at the bottom (**FIGURE 4.9**).

General Settings

Clicking on Go to Catalog Settings sends you directly to the General tab in the Catalog Settings dialog.

Information: Provides the path to the location, filename, and creation date of the catalog. Clicking on Show is very cool in that it sends you directly to the location of the current catalog Lightroom is using, without your having to self-navigate through the OS to find your catalog file. Go ahead and try it: Click Show and watch it reveal the .lrcat file. It's really speedy.

FIGURE 4.10 Select your Backup setting to help recover your data.

Backup: Select your preferred way of backing up your catalog (**FIGURE 4.10**). I use "Once a week, upon starting Lightroom." This option creates a backup of the catalog, providing a security feature as well as some comfort for the user. Having the backup files only uses a small amount of disk space, but it's important: If the main catalog file is accidentally deleted or becomes corrupt for whatever reason, the backup file may help you recover your data. Backup files are stored in the Backups folder inside the catalog folder; or you can choose to save the files to a separate folder in a secure location if you so choose.

Optimize: The Relaunch and Optimize button can be helpful after you have imported and removed a number of image files from folders. This feature will optimize the database structure for efficiency. If your catalog is extremely large, it may be a good idea to click this button when things seem to be moving a bit slow on your computer.

File Handling Settings

Now just a few more Preferences for the catalog settings. In the Catalog Settings dialog, click the File Handling tab (**FIGURE 4.11**).

FIGURE 4.11 The File Handling preferences are important to establish how image previews are use by the application and system resources.

Preview Cache: This establishes how Lightroom renders the preview images within a catalog. The Standard Preview Size is a screen resolution default and specifies the maximum pixel dimension to be used.

Preview Quality: This is similar to JPEG quality, and the default is Medium, which is good, but High allows for an excellent image quality for reviewing images for maximum focus.

Automatically Discard 1:1 Previews: The 1:1 previews are rendered as desired and can make the library preview file large. By stipulating when 1:1 previews are discarded, you have the ability to reduce the size of the pile of previews cached on your system after 30 days. More on this in Chapter 5.

NOTE

If you set your preview size to smaller than what you will characteristically fill the screen with, Lightroom will need to generate a new, bigger preview when you zoom your image to fit the screen. This preview re-building can result in re-rendering image delays when working in Lightroom because the application redraws the image on the fly. If you find that you are waiting more than a few seconds to see the screen zoom function work, you may need to change the standard preview size. Experiment with this to see which standard preview size works best for your system.

Metadata Settings

Finally, in the Catalog Settings dialog, click the Metadata tab and select all three options (**FIGURE 4.12**).

FIGURE 4.12 The Catalog Settings dialog for Metadata is a key preference for organizing and using editing components within Lightroom.

The "Offer suggestions from recently entered values" is a great feature! As you start typing a metadata entry that resembles previous information entered, one or more suggestions will appear as you type, like an auto-fill field.

The "Include Develop settings in metadata inside JPG, TIFF, and PSD files" selection is an option to save Develop settings or image adjustments to the XMP sidecar files, thereby making the changes visible in other applications.

The most important one is the last: "Automatically write changes into XMP." Checking this option saves metadata changes directly to the XMP sidecar files (see XMP in the next section), thereby making the Lightroom changes detectable in other applications.

If you choose to not automatically write changes into XMP metadata, you can still select a file within the Library Module and choose Metadata > Save Metadata To File or just hit Command + S (Mac) or Control + S (Windows) anytime in all modes.

What is this Metadata Stuff Anyway?

Metadata is a term for the descriptive information embedded inside an image file. Metadata allows you to store information with your pictures that is transportable and stays with the file, both now and into the future.

Metadata Formats

EXIF: EXCHANGEABLE IMAGE FILE FORMAT

EXIF is one type of metadata contained in all digital cameras files. This metadata is captured by your DSLR when an image is recorded, but it is usually not editable.

Information contained in EXIF metadata includes:

- The date and time entered into the camera
- Camera settings
- Camera model and serial number
- Aperture
- Shutter speed
- Focal length of the lens
- Metering mode
- ISO setting

- The preview thumbnail generated during image capture
- Cameras with built in GPS systems or units attached to digital cameras can store location information in EXIF

Lightroom uses this information in some cases to isolate all the images based on a camera ISO settings or all the images in the catalog with a specific date and time stamp.

IPTC: THE INTERNATIONAL PRESS TELECOMMUNICATIONS COUNCIL

Another metadata format for image files is IPTC. The format was initially developed as a standard for exchanging information between news organizations in the 1970s. In the mid 1990s, Adobe Photoshop's File Info dialog enabled users to insert and edit IPTC metadata in digital image files.

IPTC allows you to add your own descriptive information within an image file, including captions, copyright information, credits, keywords, creation date, or special instructions.

Keywords are another powerful way in which Lightroom can search images. Rather than trying to remember the name of the folder you created way back when, you can embed keywords in the file's metadata when you download your images.

XMP: EXTENSIBLE METADATA PLATFORM

XMP is a newer kind of XML developed by Adobe in 2001. You can add XMP metadata to many file types, but for images it is generally stored within JPEG and Tiff files. In the case of Raw image files, where it is not possible to store the information in the file, metadata is stored in a separate file called a *sidecar file*. XMP facilitates the exchange of metadata between Adobe applications.

If you were to open up an XMP file with a text editor, you could peek at the structure of the information fields. An example of this is in the resource appendix, which shows some of the XMP files created by Lightroom in text format. I say *some* because one XMP file created by Lightroom contains about 7 pages of text instructions per image. I don't think my publisher is too keen on printing all that metadata. But having a look in the resource appendix will drive home the need to keep such info as a so-called sidecar file.

The Display Options

In this chapter I talk about Lightroom's workspace with its Panels, Filmstrip, Toolbar, and center viewing area. These elements anchor the design layout and visual presentation of the intuitive interface. Each of the five Lightroom Modules gives attention to a specific element of the imaging workflow: the Library Module for importing, organizing, comparing and selecting images; the Develop Module for adjusting tone, color, or implementing some

creative approach to processing images; and the Print, Slideshow, and Web Modules for presenting and sharing your images.

Looking beyond the fundamental design structure, the interface tools and Panel content change based on the current Module selected. Each Module includes different Panels that contain options and controls for working with your images. To speed up your workflow, it's essential to learn the viewing shortcuts to manage the visual clutter. The visual clutter can happen when too many Panels and tools are open within a Module. By learning to control all the display options, you can customize the viewing space for maintaining an efficient workflow.

Adobe provides five "rules" as a quick and easy reference in Lightroom's Help menu. To see them, click Help and navigate down to the Five Rules. These simple, easy-to-follow rules provide a helpful roadmap in the effort to understand Lightroom's basic terms and features as we now look to maneuver our way through the application.

The Five Rules

The Lightroom interface consists of five Modules: Library, Develop, Slideshow, Print, and Web.

Rule 1: The Module Picker

Note that the strip (**FIGURE 5.1**) in the upper right-hand corner is sequentially arranged for an intuitive approach to the photographic workflow. By clicking a Module to work within, Lightroom presents Panels that provide tools for working with the selected Module. The highlighted one identifies your current workspace.

FIGURE 5.1 The Module Picker allows you to access a set of features specific to one of the five Modules: Library, Develop, Slideshow, Print, and Web. Clicking one places you in the selected workspace.

Rule 2: The Panels

The left and right Panels (**FIGURE 5.2**) of the Lightroom interface provide the tools to work within each Module. Each heading when clicked within a Panel

enables features and functions to be performed exclusive to the selected Module. When a different Module is chosen from the Module Picker, the left and right Panels present new tools.

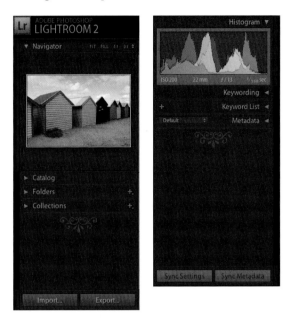

FIGURE 5.2 The left and right Panels contain the tools related to the current Module selected. The headings for each of the tools can be clicked to reveal or hide the feature set within the Panel.

Rule 3: The Filmstrip

The Filmstrip (**FIGURE 5.3**) is at the bottom of the interface and provides a current view of the images within a specific folder or collection. You can use the Filmstrip to select different images for presentation within all Modules. To select a different image thumbnail, click the selection or use the arrow keys to navigate left or right within the Filmstrip. To adjust the size of the Filmstrip thumbnails, click and hold the bar above the thumbnail row and pull it up or down to reduce or enlarge.

FIGURE 5.3 The Filmstrip works as a quick image navigation feature for use within all Modules. Revealed in the strip is the current selected folder or collection of images. Pressing F6 toggles the Filmstrip view on/off.

Rule 4: Important Key Commands

Learning a few basic keyboard shortcuts is essential to working with Lightroom effectively. Memorize the basic ones presented here in Rule 4 (**FIGURE 5.4**), and you will hunger for more as you continue to use the application.

The Five Rules

✓ 1. Module Picker
✓ 2. Panels
✓ 3. Filmstrip
→ 4. Key Commands
 5. Finally...

Important Key Commands

Expedite your work by learning important keyboard shortcuts:

Tab	Hide and show side panels
Shift-Tab	Hide and show all panels
F	Cycle full screen mode
L	Dim the lights
~	Flag the selected photo(s)
Command-/	Module-specific shortcuts

FIGURE 5.4 Basic, simple, and easy key commands to commit to memory from the Five Rules dialog, found in the Help menu.

A keyboard shortcuts screen that provides all the shortcuts specific to the current Module selected can be accessed for easy reference by pressing Command (Mac) or Control (Windows) + / (forward slash). Now how easy is that, right at your fingertips! Go ahead, give it try.

To dismiss the display of shortcuts for the specific Module and continue to work, just click the tips presented. I toss out some additional keystrokes as we proceed through the book and provide a complete reference for Library and Develop in the resource appendix.

Rule 5: Enjoy

Yes, the people listed on the startup splash screen when you open Lightroom want you to benefit from and enjoy the program as well as your images.

Workspace Overview

The photographic workflow in Lightroom is organized into specific segments, or Modules, for each part of workflow, as I have mentioned. The Library Module focuses on and manages the heavy lifting for importing, exporting, cataloging organizing, collections, keywording, selecting, rating, sorting, and comparing images. The Develop Module focuses primarily on all the aspects of image adjustments. And the Slideshow, Print, and Web Modules focus on output and presentation.

The main focus in this book will be to concentrate our attention on the heavy lifting components of the organization and processing of images within the Library and Develop Modules. The output workflow side of Lightroom (Slideshow, Print, and Web Modules) is easily learned from the information provided in the Help menu. I have plenty of ground to cover here in just organizing and processing images with Lightroom, and then I move to cover further editing in Photoshop.

Menu Bars

The main menu bar, as with almost any application, is at the top of the screen. Normally menu bars do not change when you are working within the application, but Lightroom's does change as you access other Modules to reveal new menu items (**FIGURE 5.5**).

If you are inclined to use every pixel of screen real estate when viewing your images, you can hide and reveal the menu bar by toggling the F key two times and then F again to return to the full view mode. There are three toggle modes: normal, full screen with menu bar visible, and real full screen.

Identity Plate Editor

Customizing the appearance of Lightroom is an interesting feature, one that even allows for the replacement of the Adobe Photoshop Lightroom 2.0 logo in the upper left-hand corner. Personalizing the appearance of the interface can be helpful when making client presentations. Or maybe you just want smaller or larger type for the Module Picker. You access the Identity Plate Editor (**FIGURE 5.6**) by clicking Lightroom > Identity Plate Setup (Mac) or Edit > Identity Plate Setup (Windows).

The Identity Plate Editor supports font color style changes and logo graphics (**FIGURE 5.7**).

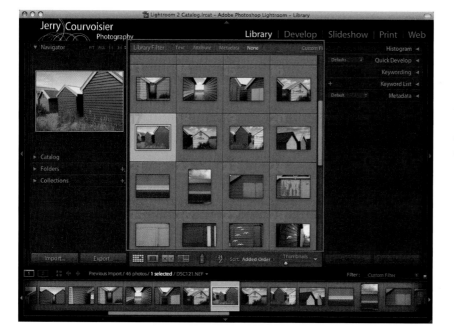

FIGURE 5.7 The Identity Plate Editor can also be used to insert a logo graphic in place of the Adobe Photoshop Lightroom 2 graphic. This is great for personalizing a business presentation with your own "vanity plate."

Central Image Display Area

Now let's get comfortable and explore the interface display options Lightroom provides. When working in all five of the Lightroom Modules, the center viewing area (**FIGURE 5.8**) uses a variety of view, or mode options within the space to edit, compare, and zoom.

FIGURE 5.8 The Library Module workspace is enabled, and the central viewing area is presented here in the default Grid View. The left Panel is for working with Catalogs, Folders, and Collections; the right Panel is for Histogram, Quick Develop, Keywording, Keyword List, and Metadata.

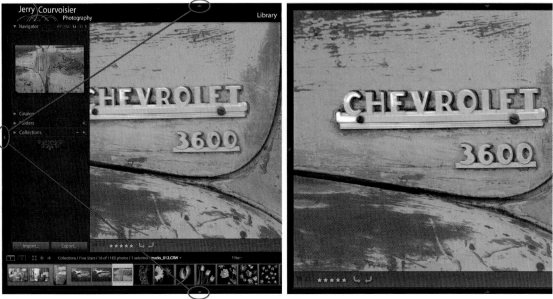

Before After

FIGURE 5.9 Click on the small gray triangles on each of the four sides. Clicking hides the Panel for an expanded view of the central viewing area. This works in all Modules.

The small gray triangles (**FIGURE 5.9**) in the middle of each of the four sides of the interface can be clicked to hide each of the Panels, increasing the screen real estate. Or use the Tab key to push the left and right Panels out of the screen viewing area.

Grid View

Grid Compare

Loupe Survey

FIGURE 5.10 The central viewing area workspace has four different settings, shown here in order: Grid, Loupe, Compare, and Survey. These viewing options are easy to access and come in handy as you work through the Library and Develop Modules.

The default Library display in the center viewing area is the Grid View, or mode. Pressing the G key moves you directly to the Grid View. Consider the Grid View home base: You can be in any Lightroom Module, and pressing G places you directly in the Library Module with the Grid View. Just below the center display, look to the lower left-hand corner and observe the four rectangle icons (**FIGURE 5.10**). Each of these can clicked to change to one of four different views, or presentation modes, in the following order, left to right: Grid, Loupe, Compare, and Survey.

We will now explore simple shortcut keys here as we navigate through the different display options that will have you accessing and editing your images quickly.

TIP

Remember if you ever feel lost and want to "go home," press G to take you back in the Library Module Grid View.

Loupe View

Navigate to and click on the Loupe icon, the second from the left within the group of four, to display the Loupe View (**FIGURE 5.11**). Or press the E key to expand the view to a single image on the display.

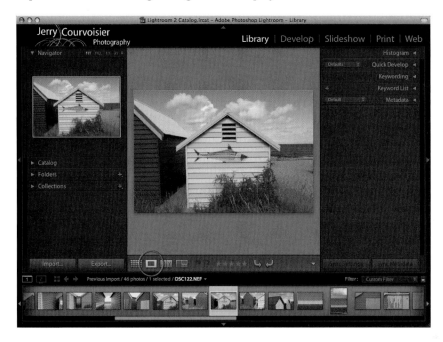

FIGURE 5.11 To access the Loupe, click the Loupe view icon button or press E. In Loupe View, you have an expanded, single-image view. To quickly move to the next image in the group, use the arrow keys to cycle through them.

Compare View

Click the third icon to enable Compare View (**FIGURE 5.12**). Pressing the C key also enables the Compare mode. In Compare View, the selected or highlighted image is held on the left-hand side as the Select image, and a Candidate image is viewed on the right-hand side. Using the left or right arrow keys on the keyboard moves new images in and out of the Candidate View. Note that the black diamond in the Filmstrip along the bottom of the screen indicates the Select, and the white diamond indicates the current Candidate.

To change your Select to a different image, click a new image in the Filmstrip. A new Select appears in the left-hand display, and the black diamond icon appears in the upper left-hand corner of the image in the Filmstrip to indicate that it is the current Select.

FIGURE 5.12 The Compare View is a great viewing option to look at images side by side. The shortcut is the C key. Tab + C moves the side Panels out of the way, and the screen real estate expands to more easily compare images.

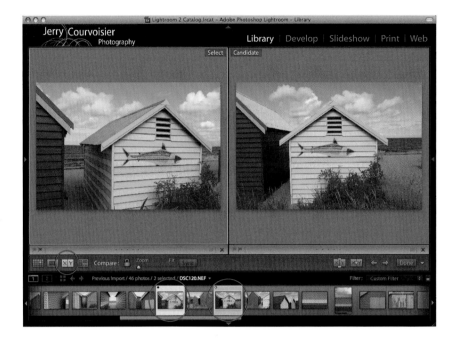

Tabbing Around Tips

Now is a great time to experiment and press the Tab key to move the left and right Panels out of the way in order to stretch the view area to accommodate larger images when comparing them side by side. Shift + Tab moves not only the left and right Panels out of the view but the bottom Filmstrip, the top Module Picker and the Identity Plate as well. Hit the Shift + Tab keys again to enable all the Panels on the screen again. Tab and Shift + Tab work across all Modules to provide the same viewing option.

In the Grid View, this screen view option provides light table emulation. (I remember bending over that light table for hours to sort all those slides. Maybe I'm giving away my age. Currently people attend my workshops who have never used film before.) Now just for kicks, try the following set of keystrokes: Shift + Command + F (Mac) or Shift + Control + F (Windows) maximizes the image to full screen and hides all Panels. To bring the Panels back, press Shift + Tab + F. Very cool! Or as the people who never shot film would say, way cool, dude.

Survey View

Last in this group of four icons is the Survey View (**FIGURE 5.13**). Click on the last icon to the right in the group to enable this mode. The shortcut key for Survey is N (go figure). You should use Survey View when you select multiple images from the either the Grid mode or in the Filmstrip along the bottom of the interface. As you roll the mouse pointer over the displayed images in Survey View, an X appears in the lower right-hand corner. Clicking the X eliminates the image from the Survey group.

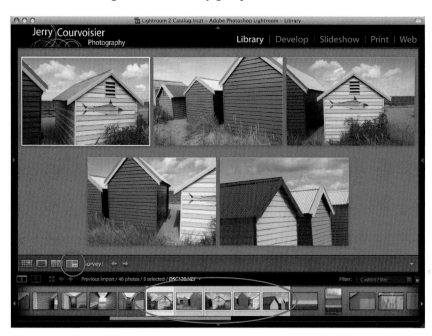

FIGURE 5.13 The Survey View places multiple selected images from the Grid or Filmstrip in the center display area. Use the N key as the shortcut after selecting images. There is no limit to how many images can be displayed, but use a reasonable number so you can definitively see differences. To eliminate an image, park your mouse pointer over an image and click the X that appears.

Zooming

Zooming into and out of images in Lightroom is as easy as tapping the Z key or clicking an image in the Library and Develop Modules. Do you remember the preference setting for the Interface tab? "Zoom clicked point to center" was checked as a default setting. Clicking a specific area within an image zooms the area to a 1:1 display and clicking again returns the image to fit the current display window frame.

When in the Grid View, the Navigator Panel on the left-hand side can be useful for zooming into and inspecting specific areas of an image (**FIGURE 5.14**). If the Panel's not showing, click the word Navigator, and the left Panel will slide down into view. Whatever image is currently selected will appear in this window as well.

FIGURE 5.14 Zooming in Lightroom can be done in a variety of ways, but one of the easiest is to use the Navigator Panel as a tool to inspect specific areas at different zoom ratios. Fit, Fill, and 1:1 are certainly helpful in checking image focus and noise.

Place the mouse pointer on the image in the Navigator window, in an area you want to zoom to at 1:1, and click. The center Panel display zooms to 1:1, and you will observe in the Navigator window a smaller square. This square is the area that is currently expanded to 1:1 in the center display. To see another area in the same frame, drag the square to another location in the Navigator window, and the view remains at the 1:1 zoom level with a new View of the same image in the center display. This is great for checking for image noise and critical focus. To return the image to filling the screen display without the zoom enabled, move the mouse pointer to the center work area display of the image and click once. The image fills the center working area and at the same time changes the view from the Grid view to the Loupe View. Click it again and you're back to zooming; click again and your not. Or tap the Z key for zooming in and out. Lightroom provides lots of choices for zooming and inspecting images when you're editing. Become comfortable with one or all of the different zooming techniques Lightroom has to offer, and your editing process will also zoom.

Lights Out View

Lights Out is a cool feature that dims the interface down to display an image or group of images separate from and brighter than the interface clutter. By tapping the L key, Lightroom dims the interface to a preferred level (80% is the default). Press L again, and the interface goes to complete black, as illustrated in **FIGURE 5.15**. Press L a third time to turn off the Lights Out function and return to the interface. In the Lightroom Preferences Interface dialog, the Lights Out screen color can be changed to five color choices: black, three shades of gray, and white.

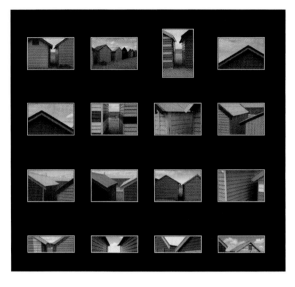

FIGURE 5.15 The L key tapped once dims the interface display by a user preference percentage. A second tap blacks out the interface, leaving only the selected image(s) displayed against a dark background. A third tap disables this Lights Out feature and returns to the interface.

Secondary Display

If you're lucky enough to work with dual monitors, use the Secondary Display feature to expand your screen real estate to enjoy multiple monitor viewing. To enable this great feature, click the small computer monitor icon (**FIGURE 5.16**) to reveal the window pane for the second monitor. When the new floating window appears, click and hold the mouse button down and drag it over to your second monitor. If you don't have a second monitor, you can still use this display window as a floating window within the Lightroom interface.

FIGURE 5.16 Multiple Monitor view can be achieved by clicking on the small number 2 computer monitor icon on the left-hand side of the Toolbar.

Secondary Display can be set to one of four viewing modes, which should be familiar to you by now—Grid, Loupe, Compare, and Survey—by clicking the heading of your choice in the upper left-hand quadrant (**FIGURE 5.17**). The Loupe View mode in the Secondary Display has three options in the upper right-hand side called Normal, Live, and Locked.

- **Normal** maintains the view of the current image selected.
- **Live** is interactive, as you mouse over an image within the Filmstrip or Grid it becomes visible in the window.
- **Locked** maintains the view of an image until it is unlocked by toggling to one of the other two views using the keyboard command Control + Shift + Return (or Enter on Windows).

FIGURE 5.17 Select Grid, Loupe, Compare, or Survey to enable the viewing mode for Secondary Display. Then choose Normal, Live, or Locked (highlighted by the red rectangle) to enable each viewing preference.

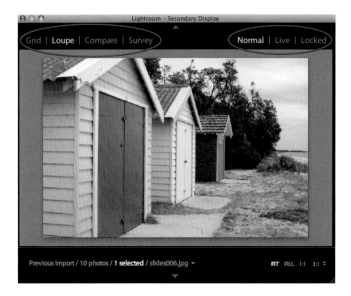

One final display option that I think you will really find useful is to change the background color when in Loupe or Survey views (**FIGURE 5.18**). This feature is easily accessed by clicking on the right mouse button when the mouse pointer is parked on the background color. The contextual menu enables you to choose one of five colors and textures for the background display. Depending on the image content, the background color black can enhance the viewing of a high key image. *High key* images contain predominantly light or white values. *Low key* images that contain predominantly dark values can benefit from a white background.

FIGURE 5.18 The display mode background choices of Loupe and Survey have five colors and one texture. These choices are accessed with a right click of the mouse when the mouse pointer is parked on the background.

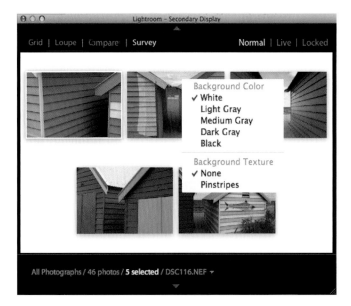

Feel free to explore and practice the suggested keyboard shortcuts. They can be real time-savers, and again we are about spending more time in the field photographing rather than sitting in front of our computers, right? Shortcuts can literally save you several minutes or even an hour or more a day. Get to know these gems by making an effort to commit them to memory.

One way to push yourself to practice shortcuts is to try and use one or two new ones every time you use Lightroom. You will quickly find that they become second nature. I include the most important shortcuts throughout the book for both Mac and Windows, but feel free to make use of the handy shortcuts reference page in the resource appendix.

Importing Your Images

In this chapter I explore the image import stage. Everyone has
a different example for why and how this or that system works
or doesn't for his or her workflow. Having had the experience
of instructing large photography workshop groups to efficiently
download and manage images for critique, I can attest that work-
ing with Lightroom can be very effective.

Photographers always want to be in control. That's why you bought your DSLR. The camera allows you to control all the parameters of exposure, focus, perspective, lens selection, stopping or blurring motion, and so on. Normally, I'm not fond of using any application to auto download my images. In the past, I found comfort in inserting the camera's memory card into a card reader and having the card mount onto my desktop as a volume to be copied. After the card mounted, I dragged the images from the card to a folder I created on the hard drive and watched the copy process. I felt good seeing the Copy dialog box start to count down the images being copied to the destination folder. But it was also like watching paint dry. I did this copy process manually, without software assistance, so many times that I was resistant to changing my approach.

Lightroom finally fixed all that. It's great! Every step of the process can be managed within your workflow, from determining where you will store and back up your images, to file renaming, to using keywords to find your images down the road. As a photographer, you will realize at some point that you need to adopt a logical filing system. Without one, it's like trying to find something in a library where the books are arranged randomly.

Digital photography allows many choices about how to take on this organization process, and Lightroom is designed to be flexible enough to work with a simple, separate catalog system. I feel the option of working with the Multiple Catalog Workflow, as I call it, creating individual catalogs for different subjects, dates, locations, or events, is a great way to manage your images. These catalogs can then be exported to different locations for backup and even merged with other catalogs.

Before setting up your system to import images into Lightroom, it's a good idea to open the Preferences dialog again (Command , on a Mac / Control , on Windows). Double-check that the General tab preference for the Default Catalog setting is set to "Prompt me when starting Lightroom" (refer to Chapter 4, FIGURE 4.2), and that in the Import preference tab "Show import dialog when a memory card is detected" is checked (FIGURE 4.5).

Creating a New Lightroom Catalog

We will start the import process with a brand new catalog.

If Lightroom is closed, launch it, and it will prompt you to identify a catalog to use (**FIGURE 6.1**). In this example, select Create New Catalog unless you want to return to your most recent catalog.

Adobe Photoshop Lightroom – Select Catalog

Catalog Location

/Users/Jerry/Pictures/Lightroom/Lightroom 2 Catalog.lrcat (default) ▼ (Change...)

☐ Always load this catalog on startup
☐ Test integrity of this catalog

Note: Lightroom Catalogs cannot be on network volumes or in read-only folders.

(Create New Catalog...) (Cancel) (Continue)

FIGURE 6.1 When the select Catalog dialog is presented, select Create New Catalog.

File Edit Library Photo Metadata
New Catalog...

FIGURE 6.2 When working within Lightroom, you can always create a new catalog by using the menu File > New Catalog.

If you are currently working in Lightroom, go to the menu and choose File > New Catalog (**FIGURE 6.2**).

After clicking Create New Catalog, the Create Folder with New Catalog dialog (**FIGURE 6.3**) appears. Create a catalog folder and identify it with a name that has some relevance to the images it will contain. Examples would be naming by date, event, client name, and/or location. In my example in FIGURE 6.3, the images are from a classic car show event held on July 4th, 2007, in Santa Fe, New Mexico. I use the name classic_cars_sf for this folder.

Navigate to the location you will use to store this catalog and click Create. This creates a named folder at that location. In this case, the destination is in the Pictures folder on my computer.

FIGURE 6.3 When the Create Folder with New Catalog dialog appears, identify a location, name the folder in which the catalog will reside, and click the Create button.

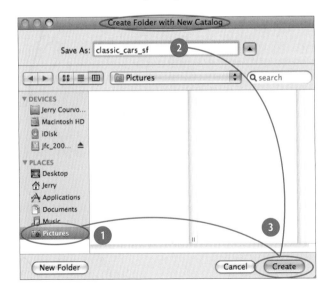

Don't Mess with Data Files

Once the classic_car_sf catalog is created, Lightroom generates a file called classic_car_sf .lrcat in the folder (**FIGURE 6.4**). After images are imported here, another file called classic_car_sf Previews.lrdata is generated as well in the same folder. These are the working *data files* associated with the application. If these become separated from the catalog folder, Lightroom won't know the path to reconnect the data associated with the catalog. Be warned: Do not put these files in the trash!

classic_car_sf

Name classic_car_sf.lrcat

Name classic_car_sf
Previews.lrdata

FIGURES 6.4 When a new catalog is created from Lightroom, two files are generated within the folder: Catalog_name sf .lrcat and catalog_name Previews.lrdata.

If your images are already on your hard drive or in another location, and you want to import them into Lightroom, I outline this slightly different process later in this chapter. But first insert a memory card into your card reader.

Importing Images from a Memory Card

Because the Lightroom preference for detecting a memory card when inserted is now set, when the camera's memory card is inserted into a card reader, or the camera is connected directly to the computer via cable, like magic Lightroom presents the Import dialog box (**FIGURE 6.5**).

Initially the Import dialog box looks a bit intimidating, but understand that it is only asking input questions in relation to how you want to implement your workflow. So let's divide up the dialog into smaller pieces to fully understand each input area, which I have labeled 1 through 5, as reference points, in FIGURE 6.5.

FIGURE 6.5 The Import Photos dialog box is where choices are made to control the Show Preview (1), the File Handling (2 and 3), the File Naming (4), and the Information to Apply (5). This dialog is the start of the workflow management process.

Previews

First turn on Preview (labeled 1 in FIGURE 6.5) in the lower left-hand corner. The preview thumbnails are shown on the right-hand side of the Import dialog when Show Preview is checked. A small checkbox for each preview is available to toggle on/off the accessibility of an image for importing. Unchecking a preview thumbnail excludes that image from the import process. This is great for images you know will not make the edit cut. I for one can be pretty klutzy, inelegantly pressing the shutter without actually pointing the camera in any useful direction. Such pictures do not need to be imported into a catalog to take up valuable hard drive space. Check All and Uncheck All are also available options, as well as a slider control in the lower right-hand corner, to increase or decrease the size of the image thumbnails.

File Handling

At the top left of the Import dialog is the File Handling area (labeled 2). In this example, Lightroom enlightens us that we are importing 34 images taken on July 4, 2007. This is the total count of how many images are on the card to be downloaded.

Because we are downloading from a Compact Flash (CF) card, we currently have only two choices under this heading (I will look at another workflow after this lesson that allows us to import images from existing locations on other hard drives, CD-ROMs, DVDs, and so forth):

- Copy photos to a new location and add to catalog
- Copy photos as Digital Negative (DNG) and add to catalog

The quickest import choice here is the first one. Choose it unless you prefer to use the DNG format in your workflow (refer to the Adobe Web site for information on the DNG format).

Continuing through this part of the Import dialog:

Copy to: This is the path to where the images will be copied. Currently these images will land in the catalog folder we set up earlier (classic_car_sf). You can always choose a different location if you would like to keep the image files separate from the catalog files. The catalog files do not take up as much space as the image files, so if storage space is a concern, the images can be stored separately from the data files. Lightroom will identify the path to the referenced location.

Organize: I prefer to put all the images from the same shoot into one folder. Other choices in this pull-down menu are to create folders in a variety of date formats. I personally do not use dated folders and instead rely on the date and time being correctly entered into the camera. The information generated from capture has the Exchangeable Image File Format (EXIF) metadata. The image capture populates the EXIF metadata date and time fields in the image file. This data is searchable with the Lightroom Library metadata browser.

Don't re-import suspected duplicates: Always check this option. Makes perfect sense that duplicates should not end up in your catalog.

Eject card after importing: Always check this one, too.

Backup To

"Backup to" (labeled 3) identifies the path to the backup hard drive. In FIGURE 6.5, for example, the download_backups folder is created on my jfc_2008_back_up hard drive. This folder contains the original files imported in a folder called "Imported on_ Month DD, YYYY."

I always have a backup strategy to ensure that my images are always stored in two separate places (**FIGURE 6.6**). Call me paranoid, but I have seen too many photographers lose valuable images because of hard drive failures. The chance of losing both hard drives at once is remote, so currently my best insurance against image protection is to always have two of everything.

Nikon d300

Working Hard Drive

jfc_back-up_hd

FIGURE 6.6 Selecting a backup hard drive is an important consideration for a workflow. Having your images always in two places is the best strategy for preserving digital data for now.

File Naming

The Template option accesses the all-important "to do" at this point in the workflow. I use the template choice of Custom Name - Sequence to eliminate the camera-generated image file numbers. By enabling this template in the pull-down menu, the Custom Text field is always available for input. The custom naming function is useful for assigning text to files that relate to the shoot. Wedding photographers, for example, might be inclined to put the client's name in the Custom Text field. Example: courvoisier_001.nef.

If I have multiple memory cards from a shoot, the start number I use for the first card in the series is 100, and subsequent numbers for the other cards from the same shoot are imported starting at 200, for the third card 300, and so on. Currently I do not use cards larger then 2GB, so my image count per card never exceeds 100 when shooting in the Raw file format. Develop a system that you can refer to time and time again. Everyone has a different approach based on their workflow and the volume of images captured. If your cards have greater capacity, move the subsequent number series up to accommodate. Examples: 200, 400, 600, and so on.

Information to Apply

The Develop Settings pull-down menu (labeled 4 in FIGURE 6.5) has a variety of presets that can be applied as image adjustment instructions on import. As you become more familiar with these presets, and possibly start making your own for specific capture conditions, you may want to have Lightroom apply some of these adjustments on import. For now, let's not go there. Let's understand that it may become more useful as you learn more about the develop presets later on in this book. So, initially choose None for Develop Settings.

As you learn in Chapter 4, metadata allows you to add your own descriptive information in an image file. This metadata includes captions, copyright information, credits, keywords, or special instructions. The first metadata template I set up is for my copyright information to be applied to all images that pass through Lightroom import (**FIGURE 6.7**).

FIGURE 6.7 The Edit Metadata Presets feature enables you to create IPTC Copyright information for all images imported. When you click Done, you are prompted to save the preset for future use.

TIP

Once you have filled in the info and clicked Done, Lightroom prompts you to save your choices as a named template for future use. By creating the metadata preset template, it now becomes available whenever you start the import process as a selectable preset, allowing you to effortlessly apply the same information time after time.

There are many fields of International Press Telecommunications Council (IPTC) information to work with, depending on how you expect to use your images in the future. Explore the options (by clicking the up and down arrows in the Metadata field) for entering your own descriptive information. I primarily fill in the IPTC copyright information for all my images here, which saves me from having to do it at a later date.

Suggestions for Adding Copyright Information

Here is an example of the copyright info and statement I use when creating my copyright information for the template:

Copyright: © Jerry Courvoisier

Copyright status: Copyrighted

Rights usage terms: All images copyright © Jerry Courvoisier. All rights reserved. Do not reproduce (in whole or in part) without prior written permission.

Copyright info URL: www.jerrycourvoisier.com

The Keywords field can help you organize and find images later. Separate all word blocks with a comma as a delimiter. Here is where I globally enter keyword information from the shoot. I do this at the import stage, when the information and image content is fresh in my mind. By entering basic keywords up front, I can later look at specific images related to the classic cars and then individually add more keywords, such as make and model.

In the Initial Previews field drop-down list, you have several choices:

Minimal Previews: The camera's default thumbnail is used and the larger image preview isn't built until you actually select an image. This certainly makes images import faster, but a quality issue will become apparent, because when an image is selected, Lightroom has to render a standard-sized preview on the fly. The time lag when creating previews on the fly slows down your editing process.

Standard-Sized Previews: Selecting this in the import dialog allows Lightroom to build color-managed thumbnails during the import process. These previews will be at the preference size that was set up in the Catalog Settings, File Handling dialog (shown back in Chapter 5). Running with Standard-Sized Previews adds to the time it takes to see all your images displayed, but they will be color managed and all set for editing when the import is done. Rendering standard-sized previews on import for the best screen resolution setting is an efficient choice.

1:1 Previews: This is also a selection choice here under Initial Previews. This choice enables full size, base resolution image files to be generated for critical inspection, and allows zooming into important image areas to check for detail and noise. Base resolution images are the actual size at capture. Example: My Nikon D300 has a base resolution of 4288 x 2848 pixels, or 12.2 million pixels (megapixels). These extremely large image previews are cached in the catalog folder file (*catalog_name*_Previews.lrdata).

The down side to the 1:1 Previews generation on import is that it takes some time to generate the images and it uses up large amounts of hard drive space. If you do choose to use the 1:1 Previews, the Catalog Settings preference for File Handling has an option that can be set to automatically discard the 1:1 Previews after a period of time if you choose not to keep these large previews in your catalogs. As an example, while researching the effective size relationship of importing a series of images with the Standard-Sized Previews selected, my image preview cache file (catalog_name_Previews.lrdata) expanded to a total of 54.1MB for my catalog. When I imported the same series of images at the 1:1 Previews size, my preview cache ballooned to 224.5MB!

The need to manage these larger previews becomes a necessity unless you copy your catalogs to other storage devices. You can stuff up your local hard drive quickly if you're not careful about managing the 1:1 Previews. The down side to not building 1:1 previews on import is that if you frequently zoom into your images for close inspection, the zooming up slows down the program while it renders the image on the fly for the 1:1 view. There is a slight a hesitation as the image is processed from the master file to create a 1:1 preview.

Importing Images from a Folder

Importing images from folders is necessary when the images you want to import into Lightroom are stored and organized in preexisting locations on your local hard drives, external hard drives, and/or DVDs. The Import dialog box has a few different choices that will need to reference an existing location. By referencing files in their existing location, you cause Lightroom to create a link from the existing folder to the catalog without your having to copy or move any image files. Based on the scheme of the Multiple Catalog Workflow, as an example I will create a new catalog to import some images captured at a tulip farm outside Seattle that are stored on another hard drive.

Either quit Lightroom and re-launch it to select a new catalog from the Select Catalog dialog box or, with Lightroom running, choose File > New Catalog. The Create Folder with New Catalog dialog appears (**FIGURE 6.8**). You can create the catalog folder on the local hard drive and store all your catalog data in a central location, such as the default Pictures folder (Mac) / My Pictures folder (Windows) or create the folder on external hard drive (such as my jfc_2008_back_up_1). Name the new folder tulip_farm_wa.

Because the catalog folder with the data and preview cache files resides in the Pictures folder (Mac) / My Pictures (Windows) folder on my local hard drive, separate from the original image files, I can view the images in the Library Module even when the external storage is offline. The flexibility and options are what makes the application a good tool for a variety of workflows.

NOTE

You can modify this folder-naming scheme to fit your own workflow, and the one I give here is only a suggestion.

FIGURE 6.8 Importing images from a folder or external source and creating a new catalog in the process.

Once the folder is named, Lightroom quits and re-launches with the new empty catalog identified in the title bar (**FIGURE 6.9**). The program is now ready to import new images into this Catalog.

To import the image files into the new Lightroom catalog (tulip_farm_wa.lrcat), click File > Import Photos from Disk or click the large Import button at the bottom left-hand corner (**FIGURE 6.10**).

FIGURE 6.9 Lightroom now displays in the title bar the current catalog in use.

FIGURE 6.10 Import images from a referenced location by using File> Import Photos from Disk or clicking the large Import button.

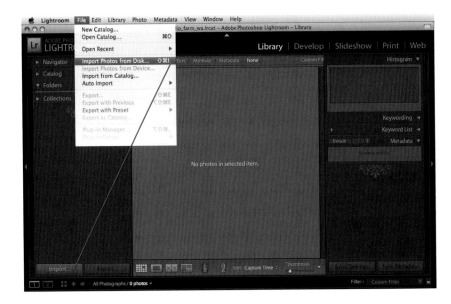

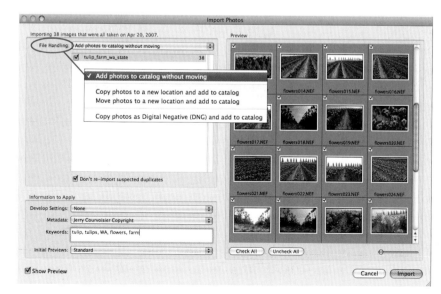

FIGURE 6.11 From the Import Photos or Lightroom Catalog dialog, choose the folder to be imported.

The next dialog to appear is the Import Photos or Lightroom Catalog (**FIGURE 6.11**). Navigate to and choose the folder that contains the images you want to import. The name of the folder will be repeated in the catalog directory as the import name.

Once the images or folder(s) are selected, Lightroom displays the Import Photos dialog (**FIGURE 6.12**). Here again are choices that affect how the image data is managed. It should be noted that there are differences in

FIGURE 6.12 The Import Photos dialog has fewer input areas than the Import Photos dialog displayed when auto importing from a memory card.

the Import Photos dialog from the auto-detect memory card import. The Import Photos dialog for the File Handling choices now has "Add photos to catalog without moving" as the default selection. Other choices under the pull-down menu relate to move or copy functions during import. The goal here is to reference the images at the current location. These images are currently organized in a folder at another location and that is where they will remain. By referencing these files, Lightroom builds the data associated with the location and files.

The Information to Apply area of the dialog box is the same as you saw earlier in the chapter. As you can see, I have not enabled any develop settings, have selected the metadata copyright template to be added to the import, have added keywords relevant to the images being imported, and have checked Standard Initial previews.

After setting up the options you are ready to click the Import button in the lower right-hand corner. Lightroom builds the preview image files and creates the database references to the images in the current location.

As the import takes place the Grid within the Library mode populates with image thumbnails. Lightroom alerts you with a progress bar to indicate the import progress (**FIGURE 6.13**). Understand that when importing thousands of images, it's probably an opportunity to do some multitasking. Go have lunch, read a photo magazine article, check out all the controls on your DSLR. Or just take snooze. The length of time this will take depends on the size of the images being imported.

FIGURE 6.13 The progress bar tells you how far along the import is.

When the external hard drive containing the images referenced on import is placed offline, only the previews generated on import are available for viewing from that specific catalog. Any Develop adjustments would require that the originals be online for the program to access. My approach to using the Multiple Catalog Workflow is to have the catalog data and preview files generated on import reside locally within the Pictures folder on my local hard drive until I decide to merge or export the catalog. The Multiple Catalogs (catalogs and images residing in a variety of locations but referenced with the Lightroom database) can at some point be combined into a main catalog by simply exporting or importing them.

Organizing Images in the Library

After the import process is complete, the Library Module is where you begin to view, sort, manage, organize, compare, and rate your images. Digital photography allows you to make many choices about how to take on the management process, and Lightroom's design is flexible enough to work with a simple separate catalog system. Take some time to review and think

through the following issues. The success of user-designed management depends on the answers to a few questions:

- Do you want everything you ever shot? If the answer is yes, be prepared to have lots of storage space and very large catalogs.

- Do you want to only save and catalog your best series of images? This could be a reasonable approach, involving managing your images with ratings and selecting only the best for storage.

- How do you want to search and retrieve your images? A simple file-naming structure as we looked at in Chapter 3 along with keywords will help you narrow down a search for a specific image or series of images.

- How do you want others to retrieve and have access to your image files? When you're away, will your system be accessible? Will others be able to work and understand the system easily?

- What is it you want visually to leave behind? If you download and store everything then you could leave the door open for someone else to assess your visual strengths and weaknesses. If not, then you must include everything that needs to be cataloged and have a multi-level rating system that provide options for digging deeper into your image selections.

- What do you like to photograph? Landscapes, wildlife, portraits, social events, commercial products, travel shots, social documentary themes?

All these questions require some kind of classification system to catalog. Take just one and try to break out how you will manage the images captured.

- What kind of filing system should you adopt? Should you file, for example, by year_month_date? If your camera is set properly to the correct date and time, then the captures will automatically include the correct EXIF metadata.

- Keywording metadata can help with such data as: Who is it? Where is it? What is it?

- Do you need to label or rank your images? How aggressively do you need to edit them?

The Library's Left Panel

The Library Module is the management location for your images. In this section I take a look at the catalogs, folders, and collections in the left Panel. Each has a unique function in the process of managing your images. You can create additional folders or collections, move photos between folders, and add them to collections in this area. You will see my reference to a catalog I

FIGURE 7.1 The left Panel of the Library Module contains the organizational structure featuring Catalog, Folders, and Collections. Click each heading to expand the underlying features and once again to collapse.

FIGURE 7.2 The contextual menus can be accessed with a right click of the mouse when the mouse pointer is parked over a Panel header.

created called Image Pool to help demonstrate the options provided by the Library Module to manage, organize, and rate your images. This catalog is on my local hard drive, and the original images are referenced on a backup storage hard drive (jfc_2008_back_up). Remember home base? Tap the G key to move directly into the Grid view.

The Panel on the left side of the Library (**FIGURE 7.1**) has four headings. Starting from the top and moving to the bottom, the Panel starts with Navigator, Catalog Folders, Collections, and includes the Import and Export buttons at the bottom. Each heading in the left and right Panels throughout Lightroom can be expanded to show its content or collapsed to only make the header visible. Clicking anywhere on the header word toggles the expanding and contracting function on and off. The triangle next to the panel header designates whether a panel is expanded or collapsed. A triangle turned downward shows the expanded panel and its content.

Throughout Lightroom, right-clicking reveals the contextual menu for specific areas. When the mouse pointer is parked over a Panel, click the right mouse button to reveal the contextual menu (**FIGURE 7.2**). These contextual menus control a variety of features within the interface. When you prefer to only work with the Folders heading within the Panel, for example, turning off Catalog and Collections hides them from view.

Solo Mode

Having many headings open at the same time within a Panel can make it difficult to navigate efficiently. The Lightroom default setting provides access to all the Panels all the time, requiring you to use the scroll bar to navigate up and down to bring header content into view within the space provided. Lightroom offers a more efficient feature to help navigate the Panel. Change the Panel mode to Solo mode by using the right-click contextual menu. This allows you to open only one heading at a time. Your targeted heading opens while the other headings stay collapsed. When Solo mode is active, the triangles next to the header names change from a solid to a dotted appearance. Clicking the header of a collapsed Panel to expand it collapses the previous open Panel. Option-click (Mac) / Alt-click (Windows) the header of any Panel to quickly enable or disable Solo mode.

Catalog

As we have learned the catalog is a filing structure, and without this structure it would be impractical for digital photographers to manage large numbers of images. The catalog system in Lightroom provides great flexibility in managing, accessing, and processing your images.

When expanded, the Catalog heading in the Library's left Panel reveals: All Photographs, Quick Collection, and Previous Import (**FIGURE 7.3**).

ALL PHOTOGRAPHS

The All Photographs selection under the Catalog heading represents the total number of images in the current working catalog, which I call the *image pool*. As images are imported or deleted, the All Photographs number reflects the current number of images referenced by the database. When All Photographs heading is clicked in the Panel, the Library Grid and Filmstrip view display every single image contained within the catalog. This heading does not break down the images in a folder structure; it only shows the entire contents of the image pool catalog when highlighted.

QUICK COLLECTION

Quick Collection is a temporary group of images for specific tasks. There can only be one Quick Collection at a time in the catalog. Images selected to be a part of a Quick Collection are displayed separately from the catalog within the Grid or Filmstrip views. These Quick Collections are temporary until they are named as a specific Collection. A Quick Collection has the advantage of speed in creating a group of images quickly to isolate them for something specific.

To select an image for the Quick Collection, highlight an image in the Grid view and tap the B key; or park the mouse pointer on the highlighted image in the Grid view and click the small circle in the upper right-hand corner (**FIGURE 7.4**); or drag the selected image(s) to the Quick Collection option under the catalog heading. The interface will momentarily flash the words *Add to Quick Collection*, and the circle will be filled with a light gray. As images are selected for the Quick Collection, the number under the heading will rise to indicate how many are currently selected.

The disadvantage is that Quick Collections are not permanent. To make a permanent collection, you must save the group of images as a named Collection. As you will see later in this chapter, converting a temporary Quick Collection to a permanent Collection is an option that is available from the Collections heading.

When you remove images from the Quick Collection they are not removed from the catalog. A quick way to see your Quick Collection from anywhere in the catalog is to use the keyboard Command + B (Mac) or Control + B (Windows). Likewise, to remove all images from the Quick Collection click the Quick Collection heading, use Command + A (Mac) or Control + A (Windows) and then tap the B key.

FIGURE 7.3 The Catalog heading contains three sections: All Photographs, Quick Collection, and Previous Import.

FIGURE 7.4 To add an Image to a Quick Collection, click the circle or press the B key.

PREVIOUS IMPORT

The Previous Import heading when clicked isolates the last imported images into the catalog as a separate group in the Grid and Filmstrip. The next time images are imported into Lightroom, the Previous Import will show the total number of new images imported into the catalog. Previous Import is a quick way to isolate and view the last images brought into the catalog.

Folders

Folders are the hierarchical structure used by Lightroom to organize, categorize, and isolate different image content such as events, locations, or clients. Folders can be renamed, deleted, moved, and copied to other disk drives or storage.

VOLUMES

When you click the Folders heading, it reveals the *volume(s)* (hard drive locations) in which the database-referenced images reside and the amount of space available in gigabytes (**FIGURE 7.5**). The number before the slash represents the available space, and the number after the slash is the total gigabytes on the volume. Right-clicking the volume within the Folders heading brings up a contextual menu with information about the volume, such as Show in Finder, Get Info, Photo Count, and Status.

Right-click volume to display volume information

FIGURE 7.5 Right-clicking the volume reveals the disk space information, and right-clicking a folder reveals available management options.

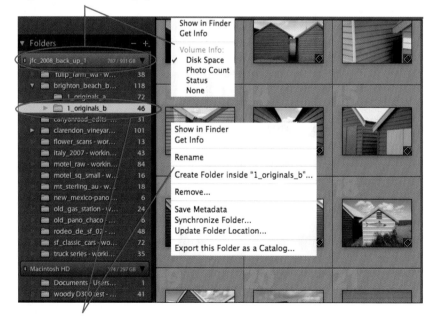

Right-click Folder to display Folder info

FOLDERS PANEL

The Folders Panel is where all the folders imported into a catalog reside. The structure is similar to arranging folders in a directory. You can make changes by moving images and/or folder(s) from one folder to another folder. If you do this in Lightroom, the folder changes will be reflected at the system level of your computer as well. You can create new folders and delete them as well. The folders are arranged in a list based on the order in which they were imported originally, with the number of images to the right of the folder.

A highlighted triangle on the left of a folder indicates a nested subfolder. To target a folder for viewing, click the folder to highlight it, and the Grid and Filmstrip will isolate only those images for viewing. Folder information can quickly be accessed with a right click of the mouse. The info menu allows for quickly finding a folder location on a hard drive, creating a new folder within the folder, removing, renaming, and exporting the folder as a catalog.

If a folder is moved at the system level to a new location, the Folders Panel shows a question mark on the folder and on any images that were relocated to alert you to an unlinked folder/image within the catalog (**FIGURE 7.6**).

The "missing folder" condition is simply resolved with a right click on the folder to reveal the Find Missing Folder command (**FIGURE 7.7**). Click this option in the contextual menu.

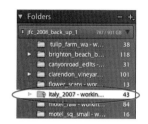

FIGURE 7.6 The Folders heading shows a question mark (?) when a link to the catalog is broken. The folder has been moved, and Lightroom does not know where to find it.

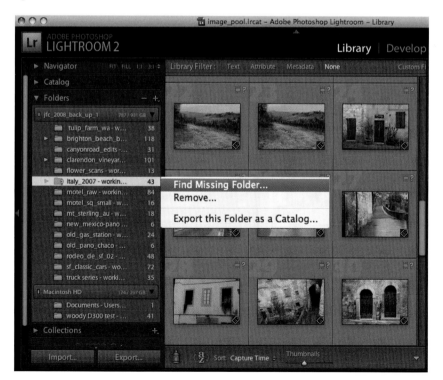

FIGURE 7.7 Show the available options in the contextual menu by right-clicking a folder. When Lightroom detects a missing folder or image, use the "Find Missing Folder" option to search for it.

With the Select New Location dialog, navigate to the current location of the moved folder and click Choose (**FIGURE 7.8**). This re-links the image within the catalog when you identify the missing folder or image.

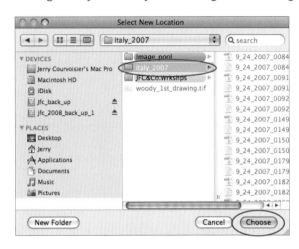

FIGURE 7.8 The Select New Location dialog allows you to choose where the missing folder currently resides.

If a single image has been relocated from one folder to another at the system level, the image in the Grid mode shows a question mark icon within the surrounding image border (**FIGURE 7.9**). Clicking on this question mark (?) reveals a dialog with the previous location path. Click the Locate button.

FIGURE 7.9 If Lightroom detects a missing image file, a question mark appears as an icon on the image surround in the Grid View.

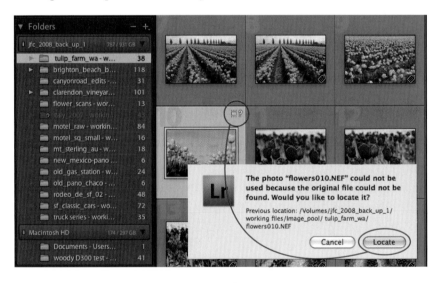

A navigation window appears (**FIGURE 7.10**).

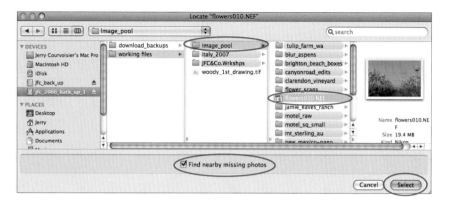

FIGURE 7.10 Locate individual broken links to the catalog with the Locate dialog. Check the "Find nearby missing photos" feature if you suspect others within the library have been moved.

What is unique to this navigation dialog is the checkbox "Find nearby missing photos." If multiple image links are broken, this might repair them without your having to navigate to individual images that have broken links.

ADDING AND DELETING FOLDERS

You add folders to a catalog by clicking the plus sign (+) to the right of the Folders heading. The choices presented are: Add Subfolder or Add New Root Folder. The display choices for the Panel are found here as well. My preference is to list the folders under the heading by Name, but other choices, "Path from Volume" and "Folder And Path," are found here as well (**FIGURE 7.11**).

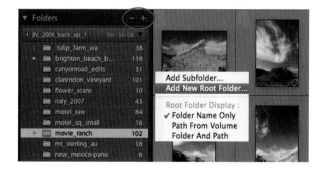

FIGURE 7.11 Clicking the plus (+) to the right of the Folders heading adds folders to the catalog. Decide here if you prefer to add a new root folder or a subfolder. Use the minus (-) sign to delete a folder.

When you decide which type of folder to create, Lightroom advances you to the Choose or Create New Folder dialog (**FIGURE 7.12**). Click the New Folder button to name and choose this folder. The folder will appear under the Folders heading with a zero to the right of the name until images are placed in the folder.

FIGURE 7.12 The Choose or Create New Folder dialog. 1) Choose New Folder. 2) Type name. 3) Or Choose existing folder.

Adding images to this folder from the current catalog is as easy as drag and drop. In the example illustrated here (**FIGURE 7.13**), the new folder created is nm_landscapes. Here I'm selecting New Mexico landscape images from the Library Grid view to be moved to the destination nm_landscape folder. The visual clue that all the images are selected is the gray border for each image turns white. To properly select the images for moving, click one of the images in the group, hold the mouse button down, and drag the images to the destination folder. You will see a stack of images as illustrated (FIGURE 7.13), and the destination folder will highlight as you hover the stack of images over it. Release the mouse button, and the images will be transferred.

FIGURE 7.13 Dragging single or multiple images and dropping them onto destination folders is easy in Lightroom.

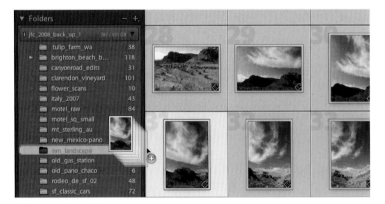

Using Lightroom to drag and drop images does physically move the images around your hard drive. The advantage of doing so in Lightroom is that it allows the program's database management to update the links to the files. Moving images around at the system level outside of Lightroom requires, in most cases, the manual re-linking of files and folders with question marks to the Lightroom database. Why waste the time?

RENAMING FOLDERS

To rename a folder, select a folder in the Folders panel of the Library Module. Right-click and choose Rename from the drop-down menu. A dialog appears with an input field to rename the folder (renaming it on your hard drive as well). Again, it's better to do this in Lightroom to avoid having to later manually re-link the folder and its contents.

Collections

At times you may want to visually look through multiple folders to find a certain category of images to be used for a specific purpose. These images may have been taken at various times for different reasons, and may be stored in different folders. Any image that illustrates a specific theme or subject can become part of a Collection. You might look through folders for images that express the conceptual theme of "celebration" or try to find all the images in folders that contain the color green.

Collections, as I mentioned earlier, are a selected series of images from the catalog. They are not moved or copied to a folder, but are simply referenced by a specific criterion. Another way to say this: The content of a Collection is simply a pointer to the image in the catalog.

When I photograph classic cars at car shows, normally the lighting conditions are extremely bright between 10 a.m. and 2 p.m. The opportunity to photograph these cars under the best conditions is limited, and the reflections off the vehicles are difficult to impossible to control. Although this kind of photography is a challenge, I normally concentrate on the graphic elements of the design lines and signature logos that make these old cars unique. At any rate, let's use classic car photos to illustrate Collections.

SIMPLE COLLECTIONS

In this example I want to separate all the car photos that visually reference the Chevrolet brand. I'll start by creating a Quick Collection and adding images from my folder sf_classic_cars that relate to Chevrolet. Remember to press the B key to add an image to the Quick Collection. Once the images are collected, click Quick Collection under the Catalog heading to see only the Chevrolet images. Now use the Select All command, which is Command + A (Mac) or Control + A (Windows), and all the images will be highlighted within the Grid and Filmstrip views. Make a simple named Collection by clicking the plus (+) icon next to the Collections heading (**FIGURE 7.14**). You can select from three types: Create Collection, Create Smart Collection, and Create Collection Set. Two user-viewing options for sorting image collections are also available just below the solid line within this menu: Sort by Name and Sort by Kind. I'll choose Create Collection here.

FIGURE 7.14 Clicking the plus (+) sign in the Collection heading provides some choices for the different types of Collections available, as well as the sort order for this heading.

The next dialog to appear is appropriately named Create Collection, with input fields for Name and Set (**FIGURE 7.15**) and options to "Include selected photos" and "Make new virtual copies." (More on virtual copies at the end of this chapter, but I won't mess with that for the time being.) Making a simple Collection of all the Chevrolet car details is the objective here. In this case I will name it Classic Chevrolet Collection, enter None for creating a set, and check "Include selected photos."

Under the Collection heading, the new Collection now appears, and the number next to it represents the number of images in the Collection (**FIGURE 7.16**).

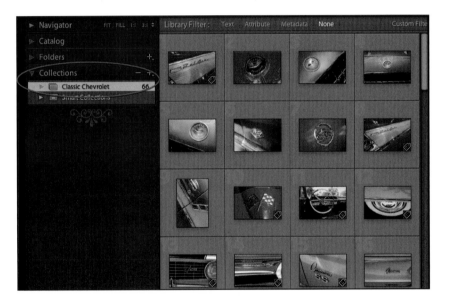

FIGURE 7.15 The Create Collection dialog has an input field for the relevant Name, Set, and Collection options.

FIGURE 7.16 The Classic Chevrolet Collection that was created has 66 images. It is now presented in the Grid mode and isolated from the folder images.

On further review of the sf_classic_car folder, I may find I've missed some related images. To add other images to the Collection, I simply drag and drop these images from the Grid to the Classic Chevrolet heading. Now return to the Quick Collection heading, select all the images and press B to eliminate the Quick Collection.

I can delete any of the images from the Classic Chevrolet Collection by high-lighting the image and pressing Delete (Mac) or Backspace (Windows). To delete the whole Collection, click to highlight the Collection name and click the minus (-) next to the Collections heading in the Panel, or right-click on the Collection and click Delete.

SMART COLLECTIONS

Smart Collections, new to Lightroom 2, function as gatekeepers by only let-ting images into a Collection which adhere to a specific set of rules. A Smart Collection, for example, may only admit images that are rated with 5 stars (**FIGURE 7. 17**). When more images in the catalog are rated at 5 stars, they are included automatically. Pretty smart!

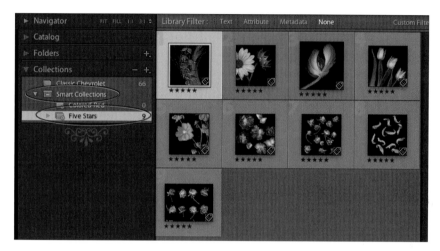

FIGURE 7.17 The Smart Collection in this example is only showing images from the catalog with five stars.

Smart Collections can become quite sophisticated. You can use multiple criteria-based parameters for grouping special-purpose images. To create your own Smart Collection, click the plus (+) sign next to the Collections heading as before, but this time choose Create Smart Collection (**FIGURE 7.18**).

The Create Smart Collection dialog appears, with input fields for Name, Set, and Match, sounding a bit like a tennis broadcast (**FIGURE 7.19**). Choose a name for the Smart Collection and toggle the pull-down Set menu to Smart Collection. In between Match and "of the following rules" is a pull-down menu. Choose All or Any, depending on how you want to set up the rules of engagement. In this example I choose All and proceed to the pull-down menu for setting up the criteria. During an editing session, I often set up some keywords (more on keywording later in this chapter). The rules I'll use in my example here are found in the pull-down menu on the left. This is an extensive list of different parameters for creating Smart Collections. To add another rule, click the plus (+) sign, and another rule comes into view. Depending on how many rules you enable, you can create some really sophis-ticated Smart Collections.

FIGURE 7.18 Clicking the plus (+) sign next to the Collections heading brings up choices for creating a new collection. Choose Create Smart Collection.

FIGURE 7.19 In this
example, the Create
Smart Collection has a
name field and two rules
to implement in the pro-
cess of separating image
files from the catalog.

FIGURE 7.19 In this example, the Create Smart Collection has a name field and two rules to implement in the process of separating image files from the catalog.

I'll name the Smart Collection "Washington State" and set up two rules for it. First, the Collection will Match Any Searchable Text (in the image files imported into the catalog), specifically those with the letters WA. This is not a case-sensitive search. Lightroom will only look for wa, WA, wA or Wa delimited grouping of these two letters only. The second rule regards file type. Only Raw files will be included in this collection; no JPEG or Tiff.

In my case, when the Smart Collection rules are implemented the Washington State (WA) collection grows to 38 images (**FIGURE 7.20**). As more images are imported into the catalog and meet the Smart Collection rules, the number will grow further. As images with these criteria are deleted, the number will shrink. The Slideshow, Print, and Web Modules can utilize further implementation of the Smart Collections. By selecting the WA Smart Collection for the Web Module, you will only use the images from this Collection to create a Web gallery and print this grouping of images to a contact sheet format.

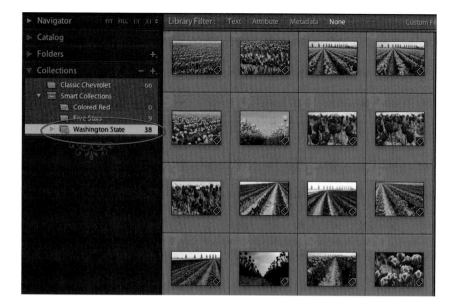

FIGURE 7.20 This example is the implementation of the rules setup when creating the Smart Collection. Thirty-eight images match the collection rules and are now available separately from the catalog.

The third choice associated with the create Collection Heading is the Collection Set. Collection Sets let you store collection by type. Think of a Collection Set as a file box that includes one or more Collections. A Collection Set does not actually contain photos; it only contains Collections, including simple Collections and Smart Collections.

The Library's Right Panel

The right Panel of the Library is used to access the metadata information managed by Lightroom. The headings in the right Panel include Histogram, Quick Develop, Keywording, Keyword List, and Metadata, along with the Sync Settings and Sync Metadata buttons at the bottom (**FIGURE 7.21**). The right Panel is where most of the keywording and metadata are managed outside of the Import dialog.

Histogram

The Histogram is available in the Library and Develop Modules for monitoring the image data collected by the exposure as well as the adjustments made with Quick Develop and all the Develop Module's tools. When needed, Quick Develop can be useful to see the effects of small tweaks to image adjustments.

FIGURE 7.21 The right Panel with the triangle pointed downward to reveal the Histogram. The Panel also includes headings for Quick Develop, Keywording, Keyword List, Metadata, and the Sync Settings and Sync Metadata.

Quick Develop

The Quick Develop Panel allows for 16 different adjustments. Designed for simplicity, the Quick Develop Panel (**FIGURE 7.22**) in the Library Module includes a cluster of simple Saved Presets, White Balance, and Tone Control adjustments. The Tone Control adjustments use the left and right arrows to control the plus or minus adjustments to single or multiple images selected within the Library Module Grid View. The left or right adjustment arrows provide an easy way to nudge an adjustment quickly. The up and down arrows reveal preset adjustments for saved presets, different cropping ratios, color or black and white image treatments, and white balance settings for Raw captures.

FIGURE 7.22 The Quick Develop pull-down menus are helpful for selecting Saved Presets, Crop Ratios, Color Treatments, and White Balance. The Tone Control buttons are arranged with right and left arrows that allow you to increase or decrease an adjustment.

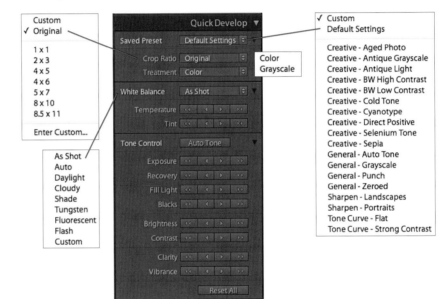

To use the Quick Develop adjustments, select one or more images that require an increase in exposure and start clicking the single right arrow a few times to see the improvement. The single arrow buttons are a 1/3 stop increments to increase or decrease in exposure, and the double arrow buttons are a full stop increase or decrease. If you have gone a bit overboard with the adjustment, reverse it by clicking the left arrow to reduce the plus exposure effect. To reset a single adjustment to its original state, click the word next to the adjustment arrows. To reset all the adjustments, click the Reset All button at the bottom. Explore all these adjustments at least once to see the result. It's important to have the Histogram heading open to observe how your adjustments affect the image as well as viewing the image in Loupe View.

The Auto Tone button can be useful for setting the exposure automatically. Normally I'm not a fan of auto anything, but in some cases the Lightroom Auto Tone adjustment can make an immediate improvement in your image; other times it can make your image too dark or light. Experiment with Auto Tone, but remember that to back out of this adjustment you will need to click the Reset All button. When an image is adjusted based on input from the Quick Develop heading or the Develop Module, a small +/- icon appears in the image thumbnail to alert you (**FIGURE 7.23**).

FIGURE 7.23 The +/- patch is an indicator that an image has been processed with either Quick Develop or in the Develop Module.

All these adjustments are similar as those found in the Develop Module, but they really don't have the precise control that can be obtained with the full complement of tools found there. I turn to these fundamental tools only when I need to make small changes to the exposure, brightness, and contrast of a single image or a series of images requiring only small tweaks to visually enhance.

Keywording

Keywording is an essential part of the process when managing your images. It's all about being able to search for your images using words that describe image content and/or location. Stock photographers use quite extensive keywording schemes as bait to attract interested customers, sometimes creating up to 100 keywords describing the content, concepts, and location of an image.

Certainly for the average photographer, long lists of keywords are not required, but it is a good idea to get in the habit of at least using a few critical word descriptors to quickly find your images using text-based searches. Lightroom makes this process easy with the ability to insert global keywords into metadata on import and selective keyword entry in the Library Module. Normally I make global keywords in the Import dialog relating to location, client name, or event and then assign keywords for content in Lightroom. The Keywording heading in the right Panel has all the fields for keyword entry at your fingertips (**FIGURE 7.24**). Each option has a specific function for the task at hand.

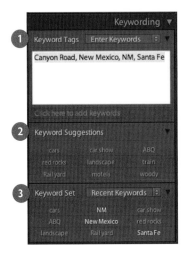

FIGURE 7.24 The keyword heading has three options: 1) Keyword Tags, 2) Keyword Suggestions, and 3) Keyword Set.

KEYWORD TAGS

Keyword Tags is where the current keywords associated with the image(s) are listed. If you need to enter specific keyword(s) to further describe image content, use the field to manually enter more words. Use a comma (,) to separate the words as you type. The Grid view by default exhibits a small keyword tag icon on the image thumbnail if the image has been keyworded (**FIGURE 7.25**).

FIGURE 7.25 The image thumbnail from the Grid View contains a keyword tag icon as a visual clue that this image has keywords in its metadata.

KEYWORD SUGGESTIONS

Keyword Suggestions are drawn from a list of words already in the database and can be used as well. You can add a keyword for selected images from the Keyword Suggestions list to the Keyword Tags field by clicking it. To delete a keyword, highlight it as you would in a word processor and press Delete (Mac) or Backspace or Delete (Windows). If you accidentally delete keyword tags, immediately press Command + Z (Mac) or Control + Z (Windows) to undo.

KEYWORD SETS

As you add keyword tags to the catalog, the list may become a bit unwieldy to manage. That's where Keyword Sets come in. They organize your keywords into groups for specific events, locations, assignments, or clients so these can be easily accessed better as a group for reuse. To enable a Keyword Set,

click Recent Keywords within Keyword Sets > Edit Set (**FIGURE 7.26**). The Edit Keyword Set dialog appears with open fields to be filled with relevant words for the set. In this case, the set of word created relates to Santa Fe. This Santa Fe keyword preset I've now created will be available in the pull-down menu in the Keyboard Set header.

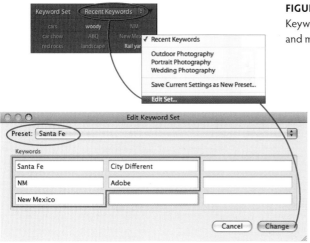

FIGURE 7.26 You can create Keyword Sets to organize and manage your keywords.

Keyword List

Keyword List shows all the keywords in the current catalog (**FIGURE 7.27**). Add or subtract keywords with the plus (+) or minus (-) signs to the left of the Keyword List heading. To find all images with a selected keyword, click the keyword in the list. As your list continues to grow, it may be easier to use the Filter Keywords input field. Type the word associated with an image to see these images in the Grid or Filmstrip viewing modes.

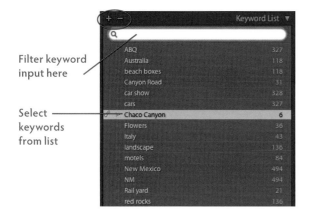

Filter keyword input here

Select keywords from list

FIGURE 7.27 The Keyword List contains a list of all the keywords in the catalog. Under this heading, words can be added or subtracted and filtered.

Metadata

As explained in Chapter 3, metadata is a term for the descriptive information embedded inside an image file. Metadata is how you store information with your pictures that is transportable, staying with the file no matter where it goes.

The Metadata heading in the right-hand Panel in the Library Module is where you update metadata information (**FIGURE 7.28**). Viewing different fields based on the type of data referenced is controlled by the pull-down menu to the left of the Metadata header. These are combinations of different types of metadata, so if you want you can just look at IPTC or EXIF metadata, for example.

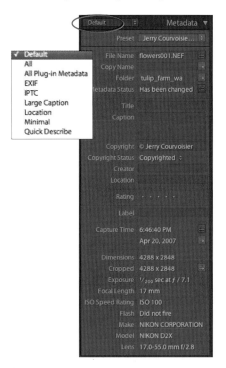

FIGURE 7.28 The metadata information for viewing as well as the ability to insert information into open text fields is achieved here in the Metadata Panel.

Inserting metadata updates, such as captions and copyright information, can be done here to a selected single image. Anywhere a field is open for input, you can enter information.

To embed information in multiple images requires using the Sync Metadata button at the bottom of the right Panel (**FIGURE 7.29**). You first select multiple images that will contain the same metadata and then click the Sync Metadata button. Doing so reveals the Synchronize Metadata dialog, where you can select field(s) for updating and click the Synchronize button to have all the images updated together.

FIGURE 7.29 If multiple images in the Library require the same metadata update, select the images first in the Grid mode and click on Sync Metadata in the right Panel. The Synchronize Metadata dialog appears, to input data.

The Toolbar

Lightroom's Toolbar resides just below the main viewing area and above the Filmstrip (**FIGURE 7.30**). It holds a range of tools, not surprisingly, and is customizable. The Toolbar, for example, is where you can access the different viewing modes. Because I have committed the shortcut keys for the viewing modes to memory (given in Chapter 5), I prefer to not have the viewing mode icons clutter up the Toolbar. The Toolbar also has many icons related to the

FIGURE 7.30 The Toolbar presents simple tool icons that can be clicked to toggle functions on/off. The Toolbar can be customized by checking or unchecking the viewing of a specific tool using the pull-down menu on the far right hand side of the bar.

editing process, which are easily hidden if you elect not to have them take up valuable screen real estate. The pull-down menu at the right side of the Toolbar is where you select and deselect which tools it shows. To hide the Toolbar completely press T, and press it again to reveal it. Getting to know the editing keyboard shortcuts enables you to eventually move the Toolbar out of view and access it only as needed. Every effort to reduce screen clutter will allow more screen real estate for viewing your images.

The Toolbar icons functions are self-explanatory and I will not focus on each with an individual explanation. Click and observe the functions to your heart's content. Nothing here will blow up or break. The Help Menu is an online user manual and is available for information if you're really stuck on an icon's function.

Perhaps the most useful tool is the painter (spray can) icon (**FIGURE 7.31**). When you click the icon, a pull-down menu appears with choices for what to spray on images in the Grid. Options include Keywords, Labels, Flags, Ratings, Metadata, Settings (Develop Presets), and Image Rotations. To experiment, select Keywords from the pull-down list and type in the field a word or two, say *red rocks*. The painter can is now loaded with the words *red rocks*, and every image you "spray" by clicking it will have *red rocks* added as keywords. If you accidentally spray the wrong image and want to remove the sprayed keywords, click the image again, and the mouse pointer becomes an eraser (and takes away the keywords). When finished using the painter tool, return it to the Toolbar by dragging it to the left-hand side of the Toolbar. The painter tool will be become disabled, and the other tool icons will appear in the Toolbar until clicked on again.

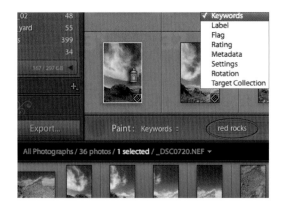

FIGURE 7.31 In the Toolbar, the painter can be enabled to spray images with a variety of keywords, labels, settings etc.

Editing Images in the Library Module

There are many different approaches to ranking images and adding color labels to manage the process of picking images for enhancement or further review. Many photographers probably only use a rating system with stars, whereas others use a combination of stars, color labels, and flags. There really isn't a correct way to approach your image ranking process. I only make suggestions based on my photography and teaching experience. Lightroom provides many options, and reviewing the questions earlier in the chapter, which ask about what kind of photography you do, can help you manage the process. Ranking relates to how you will approach saving your images. You can make the process very complex or very simple.

By exploring the editing options in this section, try to develop an approach that works for you and your photography. It's essential to your workflow that time spent in front of the computer monitor is productive, so you can enjoy getting back to work with your camera.

View Options

Before we move on to the editing process, I want to take a quick look at setting up the Grid View options because this is an area where you will be spending a lot of time. With these options you can streamline your workflow for speed and efficiency, based on what the Grid is visually providing.

To begin, click View > View Options or press Command + J (Mac) or Control + J (Windows) to bring up the Library View Options dialog (**FIGURE 7.32**). Click the Grid View tab to show the available options for the cells in the Grid view. *Cells* relates to the area within the grid where the image thumbnail resides. In addition to the image thumbnail, user-definable information can viewed based on options available in the Library View Options. These include tinting cells when color labels are applied, flags, adjustment and keyword thumbnail badges, Quick Collection markers, index numbers, and more. Yes, compact cells show less information than the expanded versions. You can compare your preference immediately as you toggle back and forth between the two, watching the cell sizes and information content for each view change dynamically.

Take some time to turn on and off all the choices here to preview all the Grid View options. My suggestion is "less is more," but you should be the judge as to how much information you want to view as you start the editing process. I prefer the Compact Cells option because it is clean and simple compared to the distraction of Expanded Cells. I make one suggestion: Check "Show clickable items on mouse over only." This little gem only allows clickable items like flags or image rotation buttons to appear when the mouse cursor hovers over a thumbnail.

FIGURE 7.32 The Grid View tab in Library View Options has choices for the size of the cells as well as the information presented.

As far as the Loupe View options (listed in Library View Options as a tab), I'm a fan of the defaults, but again look and see which display information is important to you when editing. I normally hide the information options in Loupe View to eliminate screen clutter and access my preference for exposure details when needed. Optional information like filename, exposure, lens settings, and so on can be accessed by pressing the I (for *info*) keyboard shortcut. When in Loupe view (obtained by pressing E) press the I key multiple times to review the user-defined information options selected in Library View Options.

Flags

A simple system for editing can be employed using Lightroom's flags. Flagging images in the Library Module is a way to focus on editing images for picks and rejects. These rejected images can later be deleted, and the picks reserved for further review. Flag icons are found in the upper left-hand corner of each image in thumbnail view (**FIGURE 7.33**). Flags have three basic options: Pick, Reject, or Unflagged. Apply the Pick flag by pressing the P key. Apply the Reject flag (what I privately call the pirate flag) with the X key. To return an image to an Unflagged state, press the U key. This system is simple to use: Do you want to flag an image with yes, no, or maybe? The image is either a favorite, a reject, or unflagged. Rejected image are screened back to a light gray in the Grid view to denote the "pirate flag" has been applied.

Pick flag Reject flag Unflagged

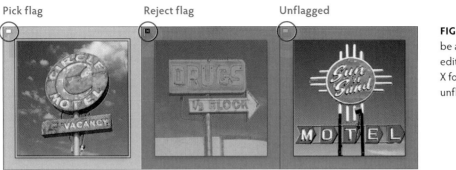

Rejected images are
dimmed to gray

FIGURE 7.33 Flags can be applied when image editing. Use P for pick, X for reject, and U for unflagged.

Star Rating

I do not to use the flagging system for editing my images because it does not provide enough latitude for my evaluation process. I prefer to edit my images using stars instead, because they allow me to rank images at six levels: unranked through five stars (**FIGURE 7.34**).

The fifth star reminds me of how much I prefer to stay at 5-star hotels and resorts. A 5-star image is certainly, to my mind, portfolio material, and the initial edit will establish the unranked images as the ones to be deleted later from the disk. Unranked images do not stand a chance of being promoted to a potential star and do not meet the editing criteria. I go through the selection process and rank everything that I think has any potential whatsoever in the first round with one star.

FIGURE 7.34 Stars attached to the image thumbnail.

To apply a star to an image, click the image thumbnail to select and use the numbers 1 through 5 on your keyboard. Just press the number of stars you want the image to have, and they will be applied to the image thumbnail. To reduce a stared image to no stars, highlight the image and press 0 (zero) on the keyboard.

Image Editing: Round One

I prefer to follow a consistent sequence of steps each time to expedite the editing process, rather than agonize over each image endlessly. Any image in my workflow that has a problem as I see it, becomes unrated unless the problem was created on purpose, such as a creatively out-of-focus area.

Here is my six-step edit procedure:

1. Highlight the folder from the Library's left Panel to work with.
2. Press G for Grid mode.
3. Scroll to the top of the Grid and highlight the image in the upper left-hand corner.

4. Press the E key or double-click on an image for the Loupe view.

5. Increase the screen real estate by pressing Shift > Tab. Both Panels and the Filmstrip become hidden from view.

6. Now use a two-handed approach: With your right hand use the right and left arrow keys on the keyboard to cycle through the images. Use your left hand to press the number 1 to apply a single star to the potential selects in this first-round review.

Revisit the process again after a short stretch break (we call such breaks *rump fluffs* back in the Santa Fe Photographic Workshops digital lab).

Ranking and Filtering

Lightroom has a great filtering system that allows you to separate images using a variety of search criteria. Navigate to the top of the central view area and click the Library Filter bar (**FIGURE 7.35**). If the Filter bar is hidden from view, press the backslash (\) key once to show it. Listed in Library Filter bar from left to right are the words Text, Attribute, Metadata, and None. Click Attribute. This filter allows you to filter images based on flag, star rating, and color label. You can click on a single selection to narrow the search for a specific attribute.

FIGURE 7.35 The Library Filter bar is set to the Attribute feature. This allows for filtering images by flag, star rating, and color. The single star rating is currently highlighted.

Flag Star rating Color label

Image Editing: Round Two

Revisit the editing procedure again, with a more critical eye, this time promoting images on closer inspection that have the potential to move from one star to two stars. The basic setup is the same for this round with just one small viewing change. For this second star edit, in addition to arrow keys to advance to the next frame, bring the left Panel Navigator into the workspace so that you can view images for critical focus. Click the image thumbnail once to enlarge or use the Z key to zoom in and out. Move the Navigator square around to inspect specific areas to evaluate the details and focus (**FIGURE 7.36**).

You can make global adjustments to exposure, tone, and color in the Quick Develop mode in library, so not every image is headed for the trash bin if you feel it's worth a little enhancement. As you become efficient with the editing process, you will be able to visually evaluate which images are candidates for the Develop Module enhancements and which ones will need the external processing in Photoshop.

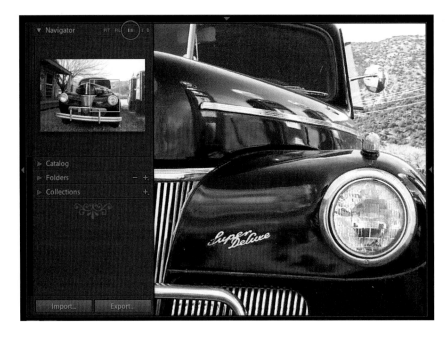

FIGURE 7.36 Bring Both Loupe View and the Navigator Panel into the workspace view to help evaluate zooming in and out to 1:1 when inspecting critical details such as focus.

Use all the Library View Options when appropriate (discussed in Chapter 5). Compare (press C) to view similar images side by and survey (press N) to view a group or series of similar images to narrow down and promote only images that have potential.

Image Editing: Round Three

Now, after another break, continue the process of editing. This time press the backslash (\) key once to show Lightroom's Filter > Attribute. Use the Filter attribute to edit images based on a rating equal to two stars. This will only show images in the Grid that have two or more stars. Depending on the volume of images shot and the emphasis of the photographic project, these 3-star images are my best. Yes, this is where you really need to say to yourself, "These are my best effort." The images left from this 3-star edit will be reviewed at a later date to evaluate the potential for 4- and 5-star promotion.

The images that were unrated should be filtered again for deletion. Do a quick last check to confirm that all these unrated images are to be deleted. Next select all the unrated images that appear in the Grid and press Delete (Mac) or Backspace (Windows). A dialog appears, identifying your choices (**FIGURE 7.37**). Clicking Delete from Disk moves the images to the trash. Clicking Remove only removes the images from the database, while retaining the image files in the original folder. The Cancel button is for those who have separation anxiety or commitment issues. Delete from Disk is the way to go. Clean and simple editing without regret.

NOTE

Once they have been deleted from the Lightroom database, they must be imported again in order to reappear in the catalog.

FIGURE 7.37 The dialog that appears when the Delete (Backspace) key is pressed. The big question is: Do you want these deleted from the disk or only removed from the Lightroom database?

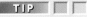
TIP

One variation in my workflow is that I use Green to identify which images have been printed from my selects.

If you have any regrets or made a mistake, at this point you can still retrieve the images from the Trash (Mac) or Recycle Bin (Windows) and restore them back into their original folder(s).

If you prefer to use color labels rather than stars, just work up an approach to understanding what the colors will represent in terms of editing. A color can surround the image as a label (**FIGURE 7.38**). A color label can be applied in combination with stars as well. But don't make things too complex. Colors are applied from the keyboard using the numbers 6 through 9: 6 is red, 7 is yellow, 8 is green, and 9 is blue.

FIGURE 7.38 Color labels can be applied as another method in the editing process.

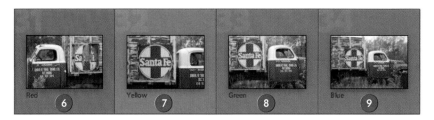

Stacking Images

You can make a *stack* to gather a group of similar images together to ease the management of the visual clutter in the Grid and Filmstrip views. In my example of the similar images of the old Santa Fe railroad service truck, I prefer to incorporate these images as a stack for easier viewing management. Stacking images allows easy access to all the similar images instead of having them sprinkled throughout the Grid. To create a stack, move to the Grid view (press G) and select the images to be included in the stack. Click Photo > Stacking > Group in Stack. Or better yet use Command + G (Mac) or Control + G (Windows). The images will now be gathered under one image, and the visual clue that a stack is implemented is a document icon with a number denoting the how many images are in the stack. To reveal the images in the Stack, click that number to expand the stack for viewing. Click again to collapse the stack (**FIGURE 7.39**).

To undo a stack, press Shift + Command + G (Mac) or Shift + Control + G (Windows). Stacking images is a great way to conserve visual space and gather similar images in one place when editing your shoot.

Click to expand

Expanded stack

FIGURE 7.39 Similar images can be gathered and stacked together in a stack. The number in the icon represents the total number of images in the stack.

Creating Virtual Copies

Creating a virtual copy allows you to keep multiple versions of an image in the Lightroom catalog. You can have multiple versions of an image with different adjustment settings of the original (master) image. A virtual copy is not an actual image; it is only a representation of the image adjustment instructions (metadata) applied to another preview of the master file. Making virtual copy variations of an image without actually duplicating the master file really saves space and allows for image experimentation (**FIGURE 7.40**).

To create a virtual copy, select an image in the Library Module Grid view (G). Click Photo > Create Virtual Copy or right-click the image thumbnail and choose Create Virtual Copy from the contextual menu. You can now apply separate develop settings to each virtual copy you produce without affecting the master file. Remember the non-destructive image editing discussion in Chapter 3? Using virtual copies is a great way to see many variations of the same image. A "page curl" icon denotes a virtual copy, and the number of images in the stack is identified by the document number icon.

Original image preview

Three variations of the same image as virtual copies

FIGURE 7.40 The color original is at the left and three virtual copy variations were produced from Quick Develop presets. Note the page curl icon identifies the virtual copies.

IMAGE PROCESSING WITH LIGHTROOM'S DEVELOP MODULE

Adjusting Images in the Develop Module

This chapter provides a snapshot of the Develop Module's image-processing features. The Develop Module is the processing engine for your Raw, JPEG, Tiff, and PSD image files and is the logical next step in the DSLR workflow. Here is where you work on individual images and massage the adjustments to enhance the tonality, color, and sharpness. Remember, not all images need to be elevated to this level of adjustment, only those select

images that need some tone and color enhancement or creative conversions to black and white need to be worked on in the Develop Module.

Overview of the Develop Module

The image-processing environment in the Develop Module, with the Adobe Camera Raw (ACR) engine, provides a well-defined, precise, and comprehensive approach to the image adjustment process. The Library Quick Develop Module only scratches the surface of the power compared to the adjustments available in the Develop Module. The utility of the Develop Module is that it is a completely visual process, meaning all adjustments are based on your visual interpretation and perception of how an image can be improved or adjusted.

The list of adjustments in the Develop Module is quite extensive and at my last count incorporated 115 sliders and numerous pull-down menus in the right Panel alone! For space reasons alone, then, I will not be looking at each and every one of these in this book. Study Lightroom's user manual for information on every single aspect of the program. Depending on how geeky you are, it might make for some great bedtime reading or be the perfect cure for insomnia. My focus in this chapter is to organize an approach to optimizing image quality quickly within a productive workflow.

With the Develop Module's basic adjustments you can globally compose and crop, make a wide assortment of global color and tone adjustments, and apply sharpening and noise reduction to your images. Now updated in Lightroom 2, with the Develop Module can make local adjustments to specific areas of an image with a brush tool to modify exposure, brightness, contrast, saturation, clarity, sharpness, and color. This new feature is like having a palette of image adjustments loaded up on the tip of your brush to "paint" locally on your image. What a great idea! Just reach for the adjustment brush whenever you need to add a spot of sharpness, softness, exposure, or color.

Furthermore, it's amazing to think that these adjustments are all done non-destructively with metadata instructions. Metadata instructions only affect the previews generated in Lightroom; they do not affect an image until it is actually exported out of Lightroom with your instructions. Stepping backwards to eliminate your adjustments in the Develop Module is like the movie *Groundhog Day*. Just reset a specific adjustment or reset the image back to the original view and start over again. No pixels are harmed or changed in the original master file when creating your vision of how you would like others to view your masterpiece in the Develop Module. Repeat after me: "Non-destructive image editing." How cool is that? The beauty of it is that you can

Remember that you must maintain a calibrated monitor in order to have a realistic tone and color presentation that reflects your image enhancements. You can make great adjustments all day long, but they won't mean anything if you can't reproduce your handywork in print or on another monitor.

experiment freely and not worry about ruining the file. You can even set up virtual copies of the same image. By using the Develop Module's Before and After view, it's easy to compare and evaluate your adjustments.

Besides the image-adjustment features in the local corrections, Lightroom lets you make image-adjustment presets that you can use again and again. You can even import and export presets and exchange them with other photographers. Lightroom comes with a series of preinstalled presets to get you started.

The Develop Module's Left Panel

To begin working in the Develop Module (**FIGURE 8.1**), select an image in the Library Grid view (by pressing G) that you would like to move to the Develop Module. Advance to the Develop Module by pressing D or clicking on Develop in the Module Picker. Note that the Develop Module includes two sets of Panels for viewing and developing your images. In the left Panel the Navigator, Presets, Snapshots, and History Panels are for saving, previewing, and selecting changes you've made to an image. The Develop Module center viewing area refreshes the image in real time as you use adjustment features. Just as in the Library Module, beneath the central viewing area you have the Toolbar and then the Filmstrip.

FIGURE 8.1 Panels and headers are dedicated to image processing in the Develop Module. The center viewing area is now the selected image.

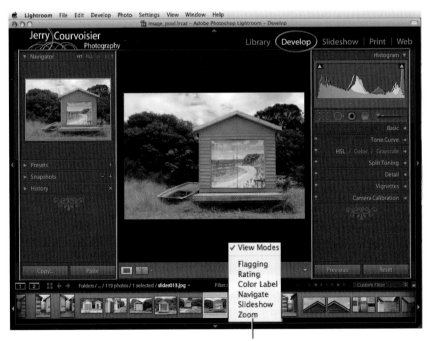

Toolbar icons

The Navigator Panel

The Navigator Panel is both a sample preview and navigation tool for the Develop Module. If you zoom into the image (by pressing Z or clicking on the image), the white box shows your current positioning in the viewing space when zoomed to 1:1 or higher. When zoomed to a 100 percent you can easily reposition the white square (by dragging it with the mouse) to inspect details within the frame. Changing the view mode to Fill will fill the entire central viewing area, but your image will be cropped within the available frame real estate. The defaults are Fit and 1:1, and I seldom change these within my workflow.

Presets

The Presets heading, when expanded in the left Panel, contains the 18 default Lightroom presets. When the mouse pointer is rolled over a preset, the Navigator displays the effect of the targeted preset (**FIGURE 8.2**). This is a great feature for experimenting with a variety of image adjustments to quickly determine whether you like a specific change, without using the full complement of image adjustments in the right Panel. You can also add and remove your own custom presets using the + and - icons to the right in the Presets header. This will certainly become useful as you create your own Develop adjustments.

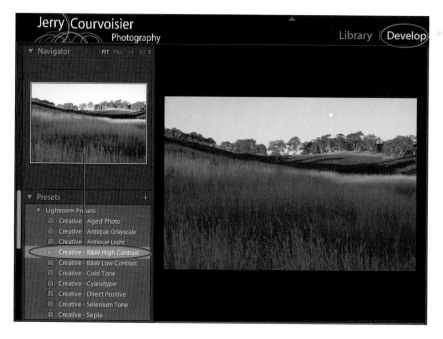

FIGURE 8.2 The preset for high contrast black and white is applied to the Navigator preview frames by rolling the mouse pointer over the preset.

As an example: Let's say I created a simple plus-one-stop exposure increase and wanted to repeat it without engaging the Develop exposure adjustment slider every time (more about adjustments as we work with the right Panel). How would that work? Click the plus (+) preset icon. The New Develop Preset dialog appears with a plethora of adjustment choices to check (**FIGURE 8.3**). In my simple example, the only choice I require is the exposure adjustment preset. Name the preset with a descriptive name, and from then on it appears in the Presets header under User Presets. If at some point you want to eliminate the preset from the User Preset list, highlight it and click the minus (-) icon.

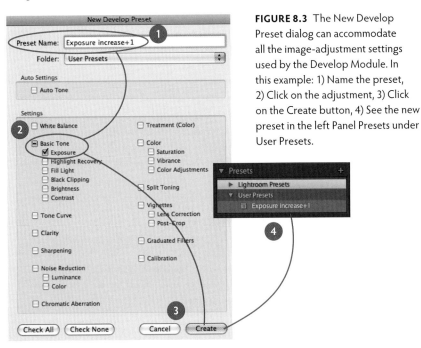

FIGURE 8.3 The New Develop Preset dialog can accommodate all the image-adjustment settings used by the Develop Module. In this example: 1) Name the preset, 2) Click on the adjustment, 3) Click on the Create button, 4) See the new preset in the left Panel Presets under User Presets.

Snapshots

Snapshots are similar to Photoshop's History palette snapshot.

The Snapshots heading has a plus (+) and minus (-) icon to capture snapshots of development adjustments in progress (**FIGURE 8.4**). At any point in time during the development process you can take a snapshot by clicking the plus icon and then refer back to it by clicking the snapshot whenever you find it necessary to review your past progress. You can save as many snapshots as you like, and these only apply to the image you are currently working on. Snapshots are another great way to experiment and review different development stages while working on an image. To eliminate a snapshot from the list click the minus (-) icon.

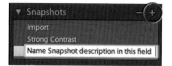

FIGURE 8.4 Snapshots allow you to add (+) a snapshot to the list whenever you want to save a specific point in time during the development process.

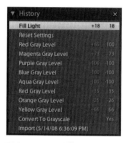

FIGURE 8.5 The History Panel keeps a running list of all adjustments made to an image in the Develop Module. Any of these can be highlighted to observe the specific adjustment.

History

The History header in the left Panel is like a time machine that maintains all the adjustments you have made to an image (**FIGURE 8.5**). As you adjust the image, the actions or *states* are listed chronologically under the History header. At any time you can return to a specific point in time to observe what was recorded. You can step backward sequentially or skip to another state by placing your mouse pointer over the state and clicking. You can preview each state by rolling the mouse pointer over the list in the History header and view the effects in the Navigator. You can change the names of the states, but you cannot change the order in which they are listed. Clicking the X icon next to the history header clears all the history adjustments from the list.

Copy and Paste

A simple copy and paste function is available in two buttons at the bottom of the left Panel. Clicking the copy button displays the Copy Setting Dialog (**FIGURE 8.6**). The settings selected will be copied to when the copy button is clicked.

Select a new image(s) in the Filmstrip that you want to apply the copied settings to and click the paste button.

FIGURE 8.6 In the Copy Settings dialog, select the adjustments to be used and click the copy button. Use the paste button to apply to image(s) in the Filmstrip.

Bottom left Panel

The Develop Module's Right Panel

In the Develop Module's right Panel are critical tools for adjusting and fine-tuning your images. Here I will familiarize you with the orientation of the headers in the right Panel. I explore them in greater detail in later chapters. For now feel free to click around, observe, test-drive, kick the tires, and push a few sliders. Again, it's all non-destructive. Get a feel for where these tools and features are located and how to access them easily.

The Histogram

The Histogram heading is at the top of the right Panel. This Histogram is a step up from the Histogram displayed in the Library module because it is segmented into four interactive elements. When you position the mouse pointer in any one of the four segments and click and hold down the mouse button, you can push the double arrow cursor to the left or right to adjust how much lighter or darker the image is within the segment. These segments correspond to the Basic heading adjustments for Blacks, Fill Light, Exposure, and Recovery (**FIGURE 8.7**).

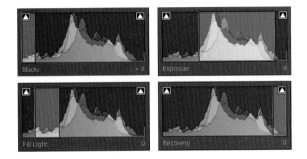

FIGURE 8.7 The four segments of the interactive Histogram. Each highlighted area can be modified for the Blacks, Fill Light, Exposure, and Recovery adjustments.

Shadows and Highlight Clipping

Right-click the Histogram to bring up a contextual menu that customizes the display. Note that the Histogram also has two triangles on the upper corners. When clicked, these indicators are enabled for monitoring image detail clipping within the shadows and highlights. *Clipping* occurs when there is a lack of detail in the shadow and highlights areas. Photographers refer to this lack of detail in terms like *blocked up shadows* and *blown out highlights*. When the clipping indicators are on, black clipping appears as blue spots within the image. Highlight clipping is indicated by the color red (**FIGURE 8.8**).

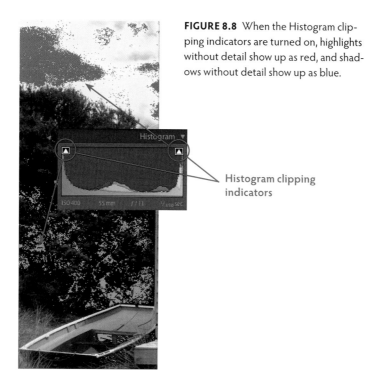

FIGURE 8.8 When the Histogram clipping indicators are turned on, highlights without detail show up as red, and shadows without detail show up as blue.

Histogram clipping indicators

The Local Adjustment Toolbar

Under the Histogram is the toolbar for local adjustments (**FIGURE 8.9**). From left to right, the icons (with their corresponding keyboard shortcuts given in parentheses) are crop overlay (press R), spot removal (N), red eye correction, graduated filter (M), and the adjustment brush (K). Clicking on a tool icon opens a Panel containing the options for that tool; clicking it again closes the Panel. Local corrections in Lightroom are based on the brush model rather than on selection-based actions. This means they fit better with the scheme used for Photoshop's adjustment layer masking (Chapter 14).

These local adjustment tools should have a significant role in your workflow. You will need to get over a bit of a learning curve to successfully operate this heavy machinery. But have no fear: I explore these in depth in Chapter 10 to help you develop your skill set.

Crop overlay (R) Red eye correction

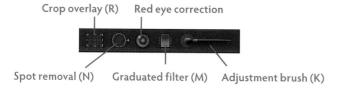

Spot removal (N) Graduated filter (M) Adjustment brush (K)

FIGURE 8.9 The five icons in the toolbar under the Histogram enable the local corrections and features associated with crop overly, spot removal, red eye correction, graduated filter, and the adjustment brush.

Basic, Tone Curve, HSL/Color/Grayscale, and Split Toning

FIGURE 8.10 These headers within the left Panel focus on tone and color correction.

The next group of four headings are the global color and tone image-adjustment features. Going down the list you have Basic, Tone Curve, HSL/Color/Grayscale, and Split Toning (**FIGURE 8.10**). You will use these features primarily to implement corrections to tonal areas and color with a variety of slider-based correction tools. With the exclusion of the Basic header, these adjustments can be tuned off and on individually with the switch icon to the left of each header.

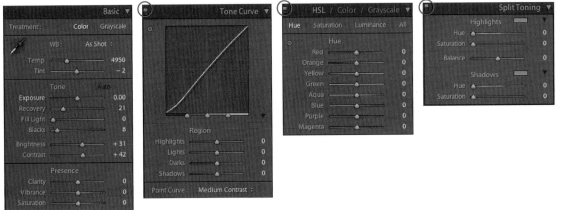

Detail, Vignettes, and Camera Calibration

The last three headings in the right Panel are the Detail (sharpening, noise reduction, and chromatic aberration), Vignettes, and Camera Calibration (**FIGURE 8.11**).

The Detail header has adjustments to help reduce noise, adjust sharpness, and correct for color fringing, which is created by lenses introducing chromatic aberrations. This color fringing can occur in very extreme contrast

FIGURE 8.11 Detail, Vignettes, and Camera Calibration deal primarily with sharpness, noise reduction, lens problems, and camera calibration profiles.

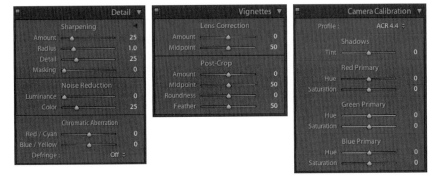

conditions and with wide angle lenses. Lightroom's adjustment in most cases can reduce the problem.

The Vignettes header addresses lens-correction problems from light falling off along the edge of the frame due to the wide angle lens not collecting enough light along the edges. The vignetting can also happen with overshading from lens hoods along the edges of the frame. The Vignettes feature makes the correction by either lightening or darkening the edges of the frame. This feature also has potential creative applications when used to direct the viewer's attention to a specific area of an image.

The Camera Calibration header adjustments can be useful in situations that require special processing or profiling for lighting conditions within a studio. These adjustments are designed to correct problems caused by the illuminating sources having specific color characteristics that are outside the generic camera profile. Camera sensor profiles may require a little tweaking to produce consistent results based in a variety of parameters.

The Develop Toolbar

From Module to Module, the Toolbar changes. You can modify the Toolbar for each Module independently to fit your approach to using the tools and controls. When the mouse pointer is parked over the Toolbar, right-click to bring up the contextual menu for the Toolbar choices. In the Develop Module, I prefer to check the View Modes, Before and After, Navigate, and Zoom. If you prefer to hide the Toolbar, press the T key (**FIGURE 8.12**).

FIGURE 8.12 The Develop Toolbar can be modified to work with your approach to image adjustments. Here, the View Modes, Before and After, Navigate, and Zoom are currently active.

Before and After View Mode

The Before and After view mode allows you to see your work in progress and is quite handy when working in the Develop Module. By default, the Before adjustment is on the left-hand side of the center viewing area. Remember your viewing option shortcuts; the left Panel can be hidden when working with the image adjustments on the right Panel. **FIGURES 8.13** and **8.14** show Before and After views. The first example is an overall view I prefer to work in (FIGURE 8.13). The second view is an example of using the Zoom (Z) with the Before and After view for critical image inspection at 1:1 (FIGURE 8.14).

FIGURE 8.13 Accessing the Before and After view from the Toolbar can be a great way to use the Before view as a reference while working in the Develop Module.

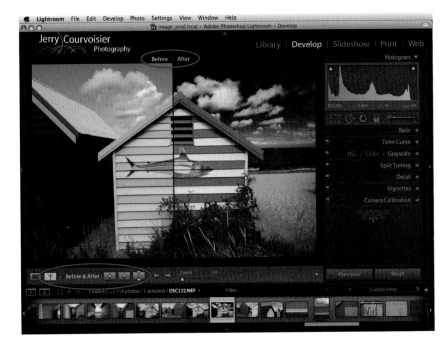

FIGURE 8.14 Using the Before and After view the Zoom feature at 1:1 can be useful for critical inspection of your adjustments.

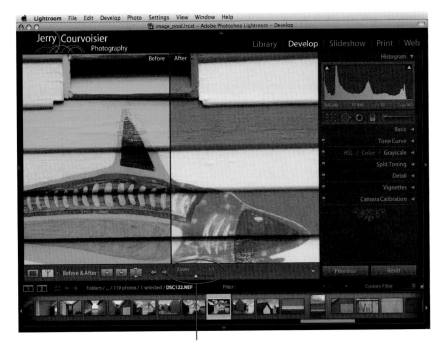

Before and After view with
Zoom enabled (Z) at 1:1

Global Develop Corrections

In this chapter I explore global development corrections in the right Panel in the Develop Module. In Chapter 8 I took a look at the Histogram heading with its shadow- and highlight-clipping features, as well as the interactive, segmented Histogram. Now I focus on working with the Basic header, the tone curve, color corrections (hue saturation and luminance), grayscale, split toning, detail, vignettes, and camera calibration.

Because of the non-destructive nature of the adjustments in Lightroom, *experiment* is the key word here. You will learn more without the fear that you are degrading the image in some way. I outline in this section an approach to the process of development, but feel free to bounce around the Module to explore all the adjustments. Not every image needs to be adjusted in a specific way. These are only recommendations on getting the boat in the slip, weather permitting.

The Develop adjustments in the right Panel are set up in logical image-processing order. Use the following steps as a guide for processing images in the Develop Module:

1. Select an image to develop from the Library Module.

2. Press the D key to switch to the Develop Module.

3. Evaluate the Histogram and look for any clipping of highlight and shadow information.

4. Remove any colorcast associated with exposure using the neutral balance eyedropper.

5. Make global corrections to the image, starting from the top and working your way down through the Panels of Tone, Contrast, and Color adjustments.

6. Use the crop overlay to improve visual composition, and the spot-removal tool to clear up any sensor dust spots and cosmetic effects that might need correction (Chapter 10).

7. Make local corrections using the adjustment brush tool or the graduated filter tool (Chapter 10).

8. Copy, paste, or synchronize adjustments to other images requiring the same corrections.

Adjustments in the Develop Module can be reset if you're unhappy with the result. There are five ways in Lightroom to reset the controls. Without reverting to the Edit menu or paging through History and snapshots, I find the following two methods work for me in most situations:

- To reset all the adjustments, click the large reset button at the lower right of the Image Adjustment Panel.

- To reset individual adjustments without starting completely over, double-click the individual slider control triangle to reset a slider control to zero.

TIP

When working with the slider controls in the Develop Module, small changes are better than big swings on the slider bars. To move the sliders incrementally, click the slider control triangle and use the keyboard's up and down arrow keys. This technique allows you to make incremental changes, gently nudging your image adjustments. Many of the image adjustment Panels also have an on/off toggle switch located on the left-hand side of the Adjustment header. This switch turns on/off all adjustments in a selected Panel. One of the best suggestions from the Lightroom engineers is to pull out the right Panel to resize it so that it is wider and the sliders are extended, thereby making adjustments more accurate and easier.

Basic Image Adjustments

The Basic header reveals a tool that is divided up into five segments (**FIGURE 9.1**).

FIGURE 9.1 Shows the Basic controls in the Develop Module. These are segmented into five specific image-correction tools.

FIVE BASIC CONTROL SEGMENTS:

— Treatment

— White Balance

— Tone controls

— Brightness and Contrast

— Presence

- Treatment identifies which kind of visual information, color or grayscale, is to adjusted. If you work with the default setting Color, then all the available Basic adjustments will be accessible. With the Grayscale setting, all the color adjustments are grayed out, and subsequent headers and Panels will be based on the Grayscale setting.

- The WB allows you to control the white balance, color temperature, and tint manually or choose a white balance preset option from the pull-down menu.

- The Tone segment focuses on tone information relating to exposure, highlight recovery, fill light, and the blacks within an image. The Auto Tone adjustment automatically sets the black and white points for an image.

- The Brightness and Contrast segment controls, as you might guess, the brightness and contrast of an image.

- Presence deals with, in effect, changing the color saturation of all colors by adjusting the clarity, vibrance, and saturation controls.

As an example, I work with image from Italy using the split-screen Before and After view to monitor the adjustment progress (**FIGURE 9.2**). My first inclination is to identify a neutral point in the image to correct the cool white balance. Enable the white balance eyedropper by clicking to remove it from the Basic Panel and dragging it to an area to be sampled.

Note that when you move the eyedropper to the image area, another Panel appears with a series of squares to help you identify a *neutral point* in the image. The readout of numerical values here is in percentages for red, green,

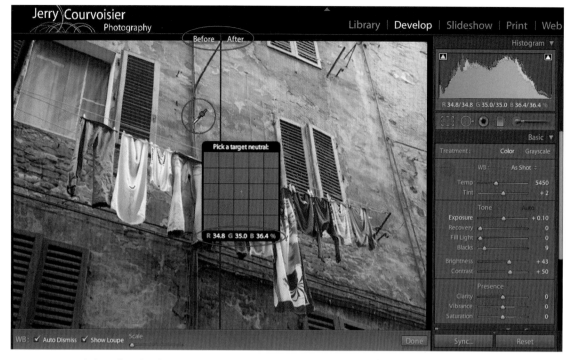

FIGURE 9.2 By clicking the white balance eyedropper in a neutral area, the image shifts to a warmer or cooler cast based on the area sampled by the tool.

and blue. Numbers relatively close in value indicate a neutral area at the sampling point of the eyedropper. Values presented don't need to be specific to a particular range; they only need to have percentage values for the red, green, and blue that are close numerically. Example percentages could be Red 32, Green 35, and Blue 31 (dark midtones), or Red 82, Green 85, and Blue 81 (light midtones). These numeric percentages represent neutral values within the image and can be used for balance with the eyedropper.

Click once to shift the white balance to an overall neutral using the sampled point. You will see the numbers for Temperature and Tint shift accordingly. In the case of FIGURE 9.2 the temperature moves slightly to a warmer temperature. You can fine-tune the Temperature and Tint values with the control sliders to make the image appear slightly warmer or cooler.

If you click an area that's not neutral and that contains a predominant color, the change affects the whole color and cast of the image, rather than just color temperature and tint. Experiment with the eyedropper by clicking a variety of different places in the image. If you make a poor selection, press the W key to reactivate the eyedropper to avoid clicking again on the white balance eyedropper in the Basic Panel.

TIP

Eighteen-percent gray cards have been a photographic standard for many years and can be purchased at any camera store. By including a shot of the gray card in a captured frame, you can use it as a color balance standard. Just click the white balance selector eyedropper on the gray card in the image, and it will correct any color balance problems. Try this gray card technique out in a mixed light illumination scene or under the shade of a tree.

FIGURE 9.3 To eliminate the highlight-clipping indicator from the fabric, move the recovery control slider to the right until the red disappears.

To illustrate the tone controls in the basic Panel, **FIGURE 9.3** exhibits a small amount of highlight clipping, indicated by the extreme red clipping indicator in the light-colored laundry on the clothesline. If you move the recovery slider to the right, the exhibited red clipping indicators disappears. This is a great tool to effectively recover highlight detail loss from camera overexposure.

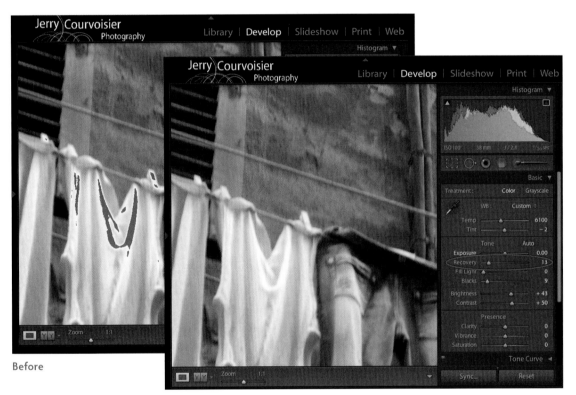

Before

After

The other tone control sliders for exposure, fill light, and blacks can be adjusted left or right. The exposure slider control can move plus or minus four exposure stops, making the image lighter or darker. This adjustment influences the midtone to highlight tone values primarily. The Fill Light adjustment reveals more detail in the low-value midtones and shadow areas but maintains the extreme shadow (blacks) information. Finally, the blacks slider control increases or decreases the dark shadows without affecting midtones or highlights. The blacks slider can also affect the contrast of an image if moved aggressively to the right, effectively compressing the tonal range.

The next segment in the Basic Panel addresses brightness and contrast (**FIGURE 9.4**). The brightness slider primarily affects the midtones and not the

white point or black point of the image. Normally the brightness slider should be used judiciously to either lighten or darken the image slightly. I don't recommend aggressive adjustments with this tool; a gentle nudge of the slider to the left or right is all that's normally required to increase or decrease the overall brightness of an image.

The Contrast slider when moved aggressively to the right effectively creates bigger differences between light and dark tonal values. By moving the slider left, the contrast of an image is greatly reduced, producing a gray, flat image without much punch. Moving the slider to the right increases differences between light and dark tonal values, which can enhance visual expression as well as create visual impact for the viewer. I'm of the opinion that you can produce better contrast control by using the Tone Curve adjustment that I discuss later in this chapter.

The last three sliders under the Presence heading deal primarily with the saturation of *all* the image colors using clarity, vibrance, and saturation controls (**FIGURE 9.5**).

FIGURE 9.4 The brightness and contrast sliders can be use to provide gentle incremental adjustments to images.

FIGURE 9.5 Clarity, vibrance, and saturation affect the color and depth of the image overall.

The clarity slider adds visual depth by increasing the midtone contrast when a plus adjustment is applied and a softening effect with a minus adjustment. A gentle nudge to the right is an extremely effective adjustment for bringing clarity to an image. A plus clarity adjustment adds depth to an image by increasing the midtone contrast. Negative clarity adjustments start to soften and blur the midtones. Extreme adjustments of clarity both plus and minus provide some creative effects overall (**FIGURE 9.6**).

The vibrance slider is not as heavy-handed as the saturation slider. It minimizes the clipping of color as it approaches full saturation. The adjustment for saturation can be best used in portrait situations. Vibrance adjustment ignores skin tones when applied, avoiding oversaturation.

The saturation slider adjusts all the image color equally, providing double the saturation on the plus side and eliminating color on the minus side. A –100 saturation adjustment desaturates all colors in an image, leaving a muddy gray mess without contrast.

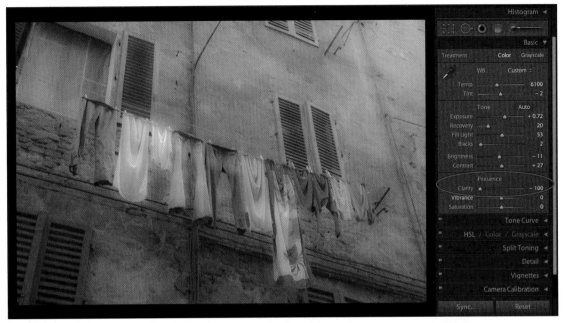

Clarity −100 adjustment

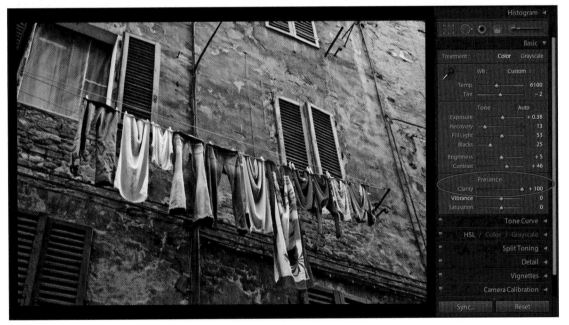

FIGURE 9.6 Illustrates the creative effects of extreme clarity adjustments.

Clarity +100 adjustment

Tone Curve Adjustments

The Tone Curve header uses "regions" of adjustments relating to highlights, lights, darks, and shadows (**FIGURE 9.7**). When you use a control slider to make adjustments to one of the four regions, an odd-shaped balloon appears to identify the region of adjustment. By pushing the sliders left or right, the highlighted region curve takes on a new shape based on the how far to the left or right the control slider is moved.

Regions of adjustment in the tone curve

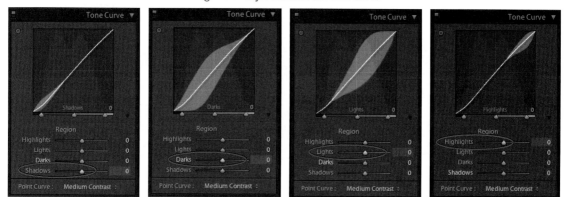

FIGURE 9.7 Tone Curve adjustments have regions relating to highlights, lights, darks, and shadows. These balloon-shaped regions represent the limits of adjustment with the tone curve.

Unlike Photoshop's tone curve, which doesn't have any limits to the shape of the curve, Lightroom's balloon within the tone curve creates a limit for the adjustments. This is actually a good thing, because it prevents the image from becoming overly processed when exported from Lightroom. Besides using the control sliders, the tone curve can be directly manipulated by inserting the mouse pointer on a region of the curve and holding the mouse button down as you push up or down on the curve. One more method of adjustment for the tone curve is to enable the target mode in the upper left-hand corner of the Panel. Place the mouse pointer directly on the image, hold down the mouse button, and move the mouse pointer up or down to directly affect the region on the tone curve. How cool is that? This targeted adjustment is not just limited to the tone curve, but applies to hue, saturation, luminance, and gray.

The Tone Curve Panel also offers some preset point curve contrast adjustments for linear contrast, medium contrast, and strong contrast in the pull-down menu at the bottom of the adjustment Panel. These preset point curves are great for enhancing image tone. My approach is to use one of the preset curves as a starting point and then continue to adjust the regions to

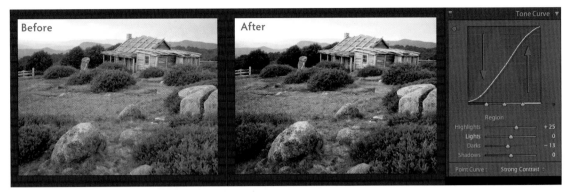

FIGURE 9.8 The Before and After view of the Tone Curve adjustment uses the point curve to manually adjust the curve by pushing the shadows down and highlights up. Creating a steeper curve helps enhance the contrast.

further enhance the image. **FIGURE 9.8** is an example where the strong contrast curve was used by pushing down on the shadow adjustment and up on the highlight adjustment, rendering the image with a bit more contrast and saturation.

Hue, Saturation, and Luminance Adjustments

The three sets of color adjustments in the HSL Panel look a bit overwhelming at first glance, with all the different sliders controls for hue, saturation, and luminance (**FIGURE 9.9**). You will feel comfortable using these adjustments when you understand what hue, saturation, and luminance are.

Every color consists of three fundamental elements to describe its physical characteristics. *Hue* is identified by the name of the color, such as red, green, or blue. You can adjust the hue to a different color value by moving its adjustment slider to the left or right. For example, if you were to move the yellow slider to the right under the Hue adjustment, it would become greener, and moving it to the left, the color becomes orange. Hue represents a shift in the color.

Saturation can be described as the intensity of color. Other words used to describe saturation include *hot* or *vivid*. Saturation adjustments should be handled with care. Too much plus color saturation adjustment can produce cartoon-like results that might look great on the screen, but will be difficult to reproduce in the print process. My advice is to stay within the colors of nature and not adjust the saturation level to an extreme. When saturation adjustments become extreme, the image information starts to degrade as

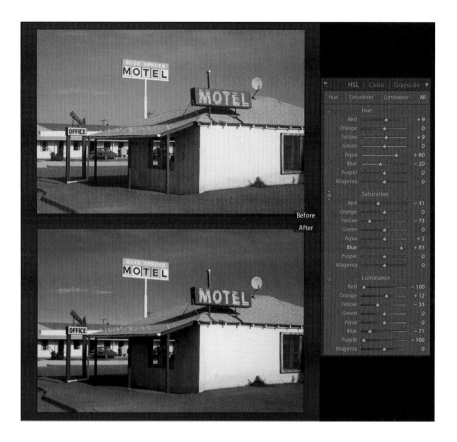

Before
After

FIGURES 9.9 The HSL sliders were positioned to improve colors. Predominantly the blue sky was enhanced, and the red saturation was reduced along with the luminance.

well. By developing an approach that only bumps the saturation intensity levels in small increments, you can create visually pleasing image-rendering results. Desaturating an image color is the process of introducing gray to the color. When an image is completely desaturated, it lacks color and is therefore just a grayscale rendering.

Luminance is the brightness or darkness of the color. Using the luminance adjustment on specific colors makes that color lighter or darker. Experiment with the HSL control sliders to get comfortable with these image adjustments. They can be quite helpful at improving color intensity. Just remember to not go overboard with these adjustments, especially saturation.

Next is the Color Adjustment Panel. It is a separate but combined adjustment that contains all the hue, saturation, and luminance adjustments for a specific color (**FIGURE 9.10**). You can select a color such as red and have the adjustments for hue, saturation, and luminance together, rather than spread out separately in the Panel. By choosing a specific color, all three elements of color are presented for adjustment at once.

FIGURE 9.10 Color adjustment is a combination of the hue, saturation, and luminance for a specific color selected—in this case, red.

FIGURE 9.11 The Grayscale Mix uses color information to adjust the gray values within the image.

Finally, click Grayscale (**FIGURE 9.11**). The Grayscale Mix is a wonderful adjustment tool that can control the color content of the image to create grayscale values. Clicking the Grayscale header renders your image in black and white. Start moving the control sliders for each color to produce the desired black and white values within the image.

Selecting the Before and After view option in the Develop toolbar lets you monitor the color and black and white images side by side (**FIGURE 9.12**). This helps target a specific color and lets you easily compare how your adjustments affect the grayscale values produced. Each color slider control actually indicates how light or dark a color appears in the black and white rendering of the image.

It's my suggestion that you do not set your camera controls to black and white at any time. Why? Eliminating the captured color information also eliminates your ability to "season to taste" your vision of the black and white image. We've seen in our workshops a huge resurgence in an appreciation for the dynamic black and white print. The Grayscale tool is powerful because it allows you to see variations with the use of the virtual copies I discuss in Chapter 7.

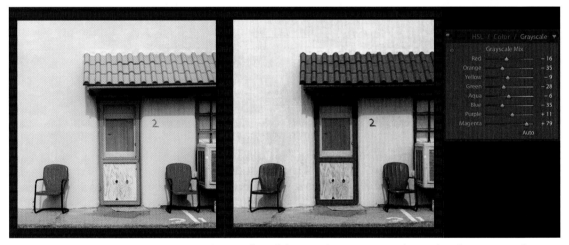

FIGURE 9.12 Green walls, red chairs, and orange trim can be rendered in a variety of ways in black and white.

Split Toning Adjustments

The term *split toning* comes from the traditional darkroom. Split toning was when a low intensity of a warm or a cool color was added to specific areas of the image, normally to the low to middle tonal areas, while leaving the rest of the image with a neutral appearance. When properly applied, the result

can produce an image with greater apparent depth. The digital equivalent of this effect really expands the adjustment to an unlimited range of colors that can be introduced. When applied with Lightroom's Split Toning adjustments, the effects can sometime change the emotional response of the viewer to the image.

Split Toning adjustments in Lightroom are extremely easy. The Split Toning Panel is divided into three segments to control hue, saturation, and color in highlights and shadows (**FIGURE 9.13**). The middle segment controls the balance between the selected split tone colors in the image. Split toning works on color images but is best realized as a visual effect when applied to a black and white image.

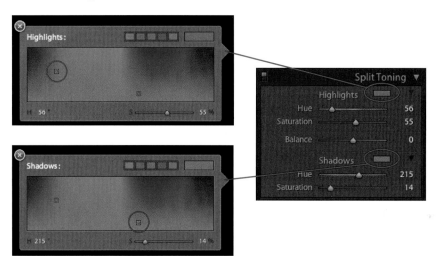

FIGURE 9.13 Select a color by clicking the color patch to the right of the words Highlights and Shadows. Use the Panel to select a specific hue and dial up its intensity with the S slider.

Choose an image and adjust it as a black and white using the grayscale controls I reviewed earlier in this chapter. In the Split Toning Panel, choose a color for the highlights by clicking the color patch to the right of the word Highlights. Another box, called Highlights, will appear for the hue and saturation selection. Position the mouse pointer on a color and click to select the hue. Use the S (saturation) control slider to determine the intensity of the selected color. Clicking the X dismisses the box from view and enables your selection. Proceed to do the same for the shadow split.

Working with split tones, I normally determine a color for the highlights and then find a complementary color for the shadows. Using the Loupe view (press E) preview option, adjust the balance control slider to enhance the mix of the selected colors between highlight and shadows. Subtle changes in color work better when applying Split Toning adjustments to an image. It's best to not overpower the grayscale image with loud colors and strange color mixes. In **FIGURE 9.14** I'm using a yellow highlight and a soft pastel blue as the shadow

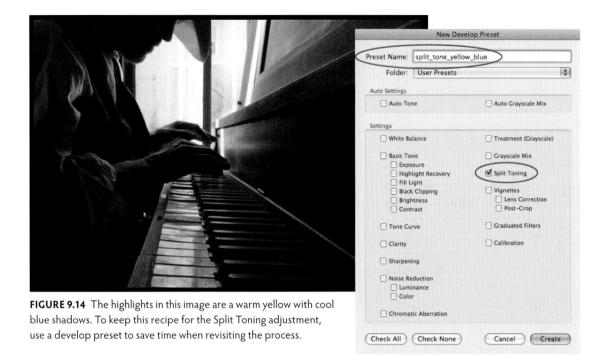

FIGURE 9.14 The highlights in this image are a warm yellow with cool blue shadows. To keep this recipe for the Split Toning adjustment, use a develop preset to save time when revisiting the process.

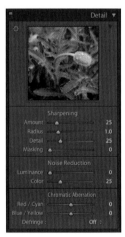

FIGURE 9.15 Detail adjustment controls focus on sharpening, noise reduction, and chromatic aberration. The small preview window helps to view areas for detail and masking control.

selection for the split. After spending some creative time adjusting the colors and the balance, I can use my recipe for this specific split tone again if I create a develop preset and reuse the Split Toning settings on another image or series of images in the future (I cover presets in Chapter 8).

Detail Adjustments

The Detail adjustment header in the Develop Module is segmented into four areas, as shown in FIGURE 9.15.

- The small window at the top maintains a preview of the 100 percent view of the image Detail adjustments.

- The second segment is for Sharpening adjustments. You can control the amount, radius, detail, and masking of the adjustment here.

- The third segment uses color and luminance sliders to adjust the Noise Reduction.

- The last segment in this Panel adjusts for lens-based Chromatic Aberration problems.

There are three areas in Lightroom that address sharpening: Here in the Develop Module and then again in the Print and Web Modules. Normally sharpening is the last step in the workflow before making a print, because

printing papers have different qualities and characteristics in how they respond to ink. We can certainly tweak the sharpness with some powerful detail adjustments here in the Develop Module to enhance an image.

The focus with this adjustment tool is to sharpen only the "detail" within the image. Overall sharpening can create artifacts in areas that lack detail if you're not careful. Under the Sharpening header, the amount control looks to define edges within the image. Think of *amount* as the volume control on a radio. The increase in "volume" creates an increase in contrast along edge details.

The radius is like the radio station tuner, fine-tuning to get the best reception. Dragging the radius slider to the right or entering a value between 0 and 3 identifies the number of pixels bordering the edge pixels that will be affected with the sharpening. The larger the radius value, the wider the edge effects, and the wider the edge effects, the more obvious the sharpening. Lightroom has a numeric limit of 3 for the radius control slider. This stands in contrast to Photoshop, where the radius number can be adjusted quite high, introducing a halo effect along edge detail. This halo effect can be observed frequently in newspaper images that have been over sharpened. Newspaper images are sharpened with a heavy hand to create more contrast because the cheap, rough paper surface these images are printed on soaks up plenty of ink and bleeds the continuous tone elements together.

The detail control slider allows you to employ a relief map to observe the edge detail adjustment (**FIGURE 9.16**). Textures in an image become more distinct using higher values on the detail control slider. Moving the slider to the right while holding down the Option (Mac) / Alt (Windows) key enables viewing of the generated relief map. This map looks like an embossment of the image.

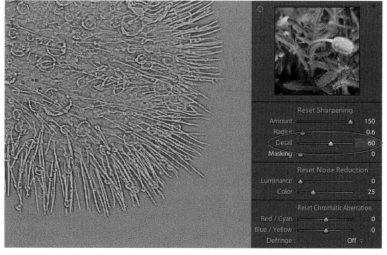

Hold down Option (Mac) / Alt (Windows) key

FIGURE 9.16 In this image of an immature poppy flower, you see an embossed relief map detail by moving the detail slider to the right while holding down the Option (Mac) / Alt (Windows) key.

Hold down Option (Mac) / Alt (Windows) key while moving masking slider

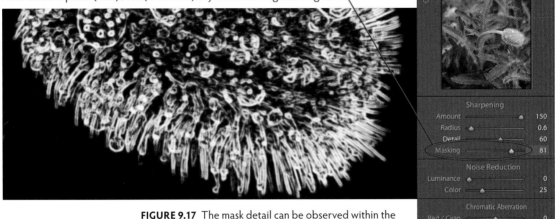

FIGURE 9.17 The mask detail can be observed within the image by employing the Option (Mac) / Alt (Windows) key while moving the masking slider.

Lastly in the Sharpen segment is the masking slider. Moving this slider right isolates the areas of detail to be sharpened. A value of 0 sharpens the image overall; as the slider is moved to the right, a more defined mask enables finer control of the areas where sharpening will take place. Moving the slider to the right while holding down the Option (Mac) / Alt (Windows) key enables viewing of the generated mask (**FIGURE 9.17**).

Masking black conceals, white reveals, and gray is a percentage of adjustment based on density. When viewing a mask, pure black areas are not affected by adjustments, whereas white areas (selections) will reveal the adjustment. In an effort to control masking, I sometimes blur or sharpen the mask. Soft, feathered-edge masks provide smooth transitions of an adjustment, just like traditional burning and dodging methods in the traditional darkroom.

Noise Reduction adjustment is another segment of the Detail Panel. Digital noise appears primarily as visible artifacts in the shadows or in situations of extreme underexposure. Noise can also be found in digital images where high ISO values were used in capturing images in low-light conditions (you may remember a similar situation involving film grain with high-speed, high-ISO films).

There are two types of digital noise. Luminance noise contains no color and produces grayscale artifacts. Pushing the luminance slider to the right effectively blurs the luminance noise. The other noise artifacts are related to color information. Color noise often looks like spotted groups of red, green, or blue pixels in the affected areas (**FIGURE 9.18**). The noise reduction slider for color, basically desaturates the speckled red, green, and blue pixels to reduce the effect.

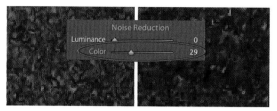

RGB color shadow noise Color shadow noise desaturated

FIGURE 9.18 An extreme magnification of the underexposed areas of an image show the RGB (red green blue) effect in the deep shadows. Moving the noise reduction slider right desaturates the RGB problem.

Chromatic aberration is another detail correction feature in Lightroom. This effect is produced by the failure of the lens to focus all the wavelengths of light on the same plane, which can result in some strange color fringing (**FIGURE 9.19**). The defect presents itself in images normally along areas of high contrast, in light to dark transition zones. Typical examples include rooflines and trees against the bright sky. The aberration is a color fringing, either red/cyan or blue/yellow, that occurs along the transition zone. Many times these problems don't present themselves unless you look under extreme magnification, and unless the problem is extremely severe you won't see this fringing problem in the print production.

 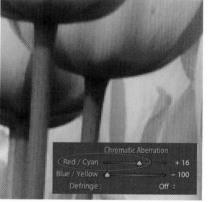

Chromatic aberration Chromatic aberration corrected

FIGURE 9.19 In this extreme magnification, the green stems against the yellow petals of the tulips show the fringing problem caused by chromatic aberration. Adjusting the red/cyan slider eliminates the problem.

FIGURE 9.20 Amount and midpoint control sliders for the Lens Correction adjustment can correct density differences stemming from light falling off at the edge of the frame.

Vignettes

Lens Correction adjustments are sometimes required when a wide-angle lens is used. Depending on the scene recorded, a condition can occur where light falls off along the edges of the frame. *Lens vignetting*, as it's called, can be easily corrected using the amount and midpoint sliders (**FIGURE 9.20**). Moving the amount slider to the plus side lightens the edges of the frame; to the negative side, it darkens the edges of the frame. The midpoint slider controls how far

in from the edge the light or dark vignette expands into the frame. This Lens Correction adjustment can also be used creatively to focus a viewer's attention on the subject in the scene (**FIGURE 9.21**).

The Vignettes Post-Crop adjustment has expanded features that include control sliders for roundness and feather (**FIGURE 9.22**). The post-crop approach allows you to crop your image first and then apply the vignette adjustment feature, whereas the Lens Correction vignette can only apply the adjustment to the full frame as shot.

FIGURE 9.21 The negative amount was positioned so that the edges of the frame would become dark, and the midpoint control slider was positioned to let the dark edges expand into the frame gradually.

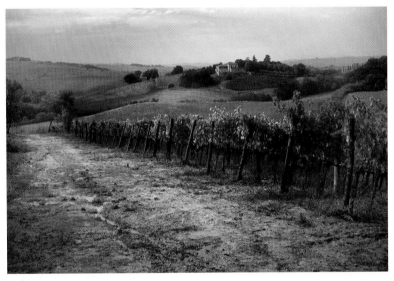

Before

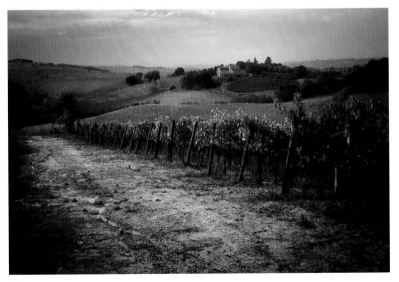

After

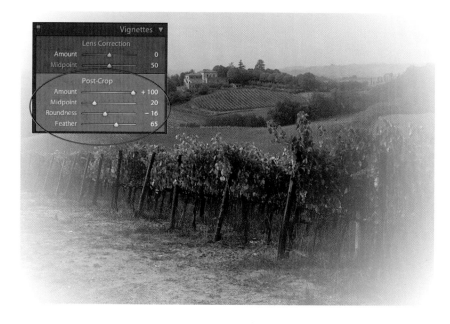

Camera Calibration

Lightroom uses two camera profiles for every camera model it supports to process Raw image files. These profiles are produced by Adobe under different controlled lighting conditions. When you set a white balance, Lightroom calls upon the specific profile for your camera to help estimate how to use the color information. Lightroom uses the Adobe Camera Raw color profiles developed for each camera model. You can adjust how Lightroom translates the color from your camera profile by using the controls in the Camera Calibration Panel (**FIGURE 9.23**).

Rarely, but in a few cases, you might want to modify the standard profile when you notice your studio lights consistently produce a warm colorcast. You could make adjustments to the profile using Camera Calibration Panel to compensate for this warm cast. Then save this new profile adjustment as a preset to be applied only to the images from your studio lights.

FIGURE 9.23 Moving the saturation control sliders can modify the profile used by Lightroom to develop the color information from your specific camera model.

Local Adjustments

Local Adjustments are new to Lightroom 2 and provide outstanding and powerful features to enhance your images. These easy-to-use additions are welcome elements to the workflow. The Develop Module's Local Adjustments toolbar appears just under the Histogram for easy access (**FIGURE 10.1**).

These tools include the following (with their keyboard shortcuts shown in the figure):

- Crop overlay
- Spot removal
- Red eye correction
- Graduated filter
- Adjustment brush

Now, let's look at these in detail.

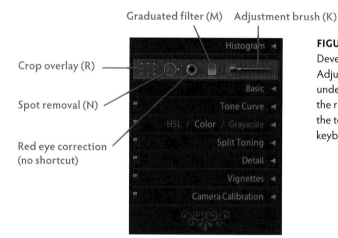

FIGURE 10.1 The Develop Module's Local Adjustments toolbar is under the Histogram on the right Panel. Here are the tool names, with their keyboard shortcut names.

Crop Overlay

What would a digital darkroom be without a crop tool? In addition to a crop tool, Lightroom provides creative assistance with six overlay grids to assist with compositionally cropping your images. Think of overlay grids as templates to assist you in finding visually pleasing lines or curves to direct the viewer's attention.

To enable the crop overlay tool from the Develop Module, click on the first tool icon on the left-hand side of the Local Adjustments toolbar under the Histogram Panel, or press the R key to expand the tool options for Crop and Straighten If you're looking for a specific aspect ratio, a pull-down menu with a variety of standard ratio options is available, as well as a selection for custom aspect ratio options (**FIGURE 10.2**).

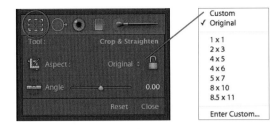

FIGURE 10.2 Clicking on the crop overlay icon reveals the expanded feature set with selections for controlling crop aspect ratios and an angle control slider.

When the crop overlay tool is engaged, you will see an outline around the image with a series of eight handles that can be dragged with the mouse to reposition the frame to the desired crop. This is a freehand approach, and there are no restrictions on constraining the crop to a certain aspect ratio (**FIGURE 10.3**).

When the crop overlay tool is enabled, you can sequence through a variety of compositional grid elements by pressing the letter O on the keyboard. Each time you press O, a new compositional grid appears as an overlay. The crop overlay grid can be set to six optional overlays as compositional guides for framing the image (**FIGURE 10.4**).

FIGURE 10.3 When the crop overlay tool is enabled (R), freeform cropping can allow for different image interpretations. Use the eight handles to drag the overlay within the frame to the desired crop.

Cropping handles

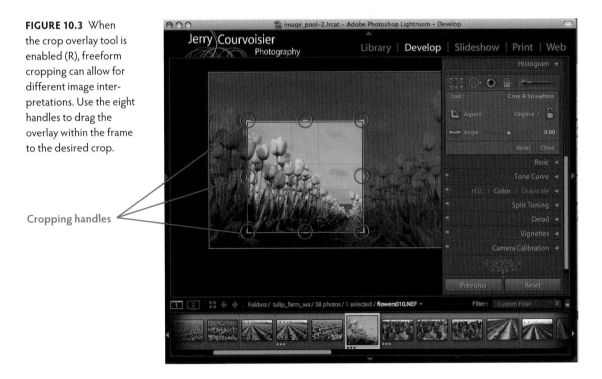

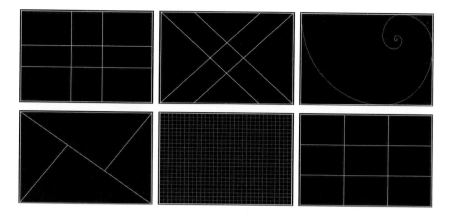

FIGURE 10.4 When the crop overlay tool is enabled, pressing the O toggles through six different creative overlays to assist with compositional element framing.

TIP

It's important to understand that these overlay elements are certainly nice as rules for creative composition, but you should also rely on framing your image in the viewfinder and paying attention to the compositional rules during the capture process. Forcing yourself to "crop" in camera will force you to engage more fully in the photography process and evaluate the scene more closely before clicking the shutter. Take time to force yourself to look at all four corners of the frame to evaluate the composition. Make sure that a light post isn't sticking out of somebody's head or the frame isn't too busy to really have a central focus point for the viewer.

The crop tool can help when "operator error" sneaks into the framing or a horizon line needs to be straightened and balanced to improve the visual impact of an image. If an image needs to be rotated slightly, position the mouse pointer outside the frame and click and drag when you see the curved double arrows. An angle control slider is also available to work with numeric control if you prefer. To easily disengage the crop overlay, press the Esc key (your panic button) or use the Reset within the Tool Options Panel.

Spot Removal

The spot removal tools in Lightroom are good for quick cloning and healing and great for cleaning up artifacts from image sensor dust spots. Annoying dust spots on an image sensor will appear in the same spot, in every frame, until physically removed. To avoid this pesky workflow problem, you need to make sure that the sensor in your Digital SLR is exposed as little as possible to the outside environment. When changing lenses on your camera, it's a good idea to turn the camera off so that the sensor is not in a positively charged state that would allow negatively charged dust particulate to migrate to the sensor when exposed for the few seconds it takes to change a lens.

Lightroom's spot removal tool allows for both cloning and healing. Cloning is a sample and replace operation that allows you to sample information from one area of the image and use it to replace information in a destination area you choose. Healing on the other hand is a matter of "blending" the surrounding information to eliminate the spot and is best used to reduce skin blemishes and to perform a little digital Botox.

Click on the second circle icon from the left in the Local Adjustments toolbar to enable the spot removal feature set (**FIGURE 10.5**). A brush size control and opacity slider is available within the Panel to control the size of the area to be sampled.

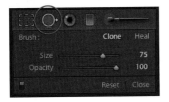

FIGURE 10.5 The spot removal feature has two attributes, cloning and healing. Each one uses a spot brush with control sliders for size and opacity.

Here's the basic way to use the spot removal tools:

1. Magnify the image by zooming (Z) to the spot you want to remove.
2. Select from the Panel the clone or heal tool.
3. Place the mouse pointer within the image area and observe the size of the circle, which represents the size of removal area.
4. Adjust the size of the circle using the size control slider to match the size of the spot you want to eliminate.
5. Place the circle over the spot you want to remove, click, and drag the new circle that appears to a location that represents information you will use to replace the bad spot. You now have two circles, one representing the spot to be replaced and one representing the new information to be placed over the spot. An arrow provides a visual clue as to where the source information is from and where it's placing the new information over the selected spot (**FIGURE 10.6**).

As you continue to use a new clone or healing removal tool, each placement of the circle on the image will create a source circle and a destination circle with an arrow corresponding to each new spot removal. To eliminate a spot removal circle, highlight the circle and press Delete. You'll see a cute puff of smoke as the spot repair is removed. Press H to hide the spot removal circles from view.

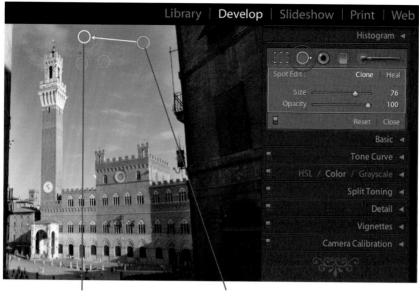

Destination sample placement Source sample

Working with Brushes and Circles in Lightroom and Photoshop

To work more effectively within this workflow, learn to use the left ([) and right (]) bracket keys to control the size of the brush or circle from the keyboard rather than using the control sliders. Pressing and holding down the left bracket key reduces the size of the brush, and the right bracket key increases it. The adjustment brush uses the same bracket keys to control size, but with the addition of the Shift key as a modifier to control and adjust the hardness or softness of the brush edge as well, with just a bit of tapping on the keyboard.

Clone, Heal, and Adjustment Brush

Left bracket = Smaller brush / circle size

Right bracket = Bigger brush / circle size

Adjustment Mask Brush

Shift + left bracket ([) = More edge feather (softer)

Shift + right bracket (]) = harder edge

Red Eye Correction

Red eye is a condition that rears its ugly head when on-camera flash is used in low light or dimly lit conditions. This condition creates some scary images that are best suited for Halloween greeting cards. The subjects being photographed are normally positioned in low-light situations where the iris of the eye is expanded to help their vision. The camera captures their eyes as red because the flash reflects off the blood vessels in the back of the eye. Many consumer point-and-shoot cameras and some digital SLRs with pop-up flash units have a pre-flash capability to eliminate the problem. Pre-flashing the subject makes the iris contract, and then a second flash automatically hits the subject with correct exposure.

Lightroom's red eye correction feature is rather simple to use. Zoom to the problem area (the eyes) of the image. Next, select the red eye correction tool from the Local Correction toolbar (**FIGURE 10.7**). Position the mouse pointer on the eyeball and adjust the selected area using the two control sliders. One slider controls the size of the circle to fit the size of the pupil area. The second slider darkens the image information to reduce the red eye effect. Basically the approach is to desaturate the red in the area selected. Press the H key to hide or show the red eye circle. To remove the red eye change, select the red eye circle and press Delete.

FIGURE10.7 The red eye correction adjustment feature has a Pupil Size slider and a Darken slider to desaturate the red problem.

> **TIP**
>
> Sometimes red eye can't be avoided when you're trying to photograph in dimly lit conditions. One way to avoid the condition completely is to use a flash that is not on the same axis as the lens. Pop-up flashes are usually not high enough to create the angle required to avoid the red eye reflection. In the DSLR realm, there are many great flash attachments that will enhance your photography in this way and others. Invest some time in learning the ins and outs of flash photography by attending a professional seminar or workshop.

Masking and Local Adjustments

In its early days, Lightroom was only able to allow global image adjustment corrections. Local adjustments specific to an area of the image was the staked-out territory of pixel-editing programs such as Photoshop. Today you can make local corrections to a specific area of the image in Lightroom, very much like burning and dodging (darkening and lightening) in the traditional photographic darkroom.

Working with local adjustments in Lightroom can be a bit challenging at the start and can take a bit experimentation to get it right. My approach to local correction workflow is to be a little heavy-handed on the adjustments because you can go back to the Panel and edit the settings in real time. This way I'm able to see and fine-tune the coverage of the adjustment and the quality of the edge mask produced, working in combination with the

modification. Local adjustments are also non-destructive as well and are not permanently applied to the image.

When looking to the new graduated filter we need to explore some fundamental information about the masking that is applied via the metadata instructions for correction. The adjustment feature provides correction to specific areas of an image based on the adjustment controls applied in the Gradient Adjustment Panel. To get a basic understanding of the masking feature, it's best to look at a gradient to see how adjustments are applied. Repeat after me: "Black conceals, gray is a percentage, and white reveals." A gradient mask is one that starts from black, gradually moves to gray, and then white, or vice versa (**FIGURE 10.8**).

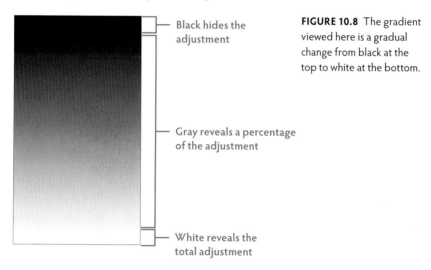

Black hides the adjustment

Gray reveals a percentage of the adjustment

White reveals the total adjustment

FIGURE 10.8 The gradient viewed here is a gradual change from black at the top to white at the bottom.

Gradients can be drawn to abruptly change at a specific point to provide an area of transition between a defined edge or drawn from any angle to define an area. Gradient adjustments are for the most part smooth transition adjustments that "meld" into the image rather then taking on an abrupt cut-and-paste look and feel. This transition zone gradient is what allows for the fine-tuning of the adjustment.

In the days of film, gradients were produced with a graduated neutral density filter placed over the lens. The filter was positioned with the dark component of the gradient at the top or bottom, depending on what masking of exposure was required. These filters were capable, for the most part, of reducing the extremes of exposure by producing a gradient effect as the image was exposed. Today the Lightroom approach offers superior control when working with images that have a large difference between highlight and shadow transitions. The gradient filter is often best utilized in landscape situations where the sky might need to be darkened in relation to the foreground information.

Graduated Filter Tool

The graduated filter tool lets you apply exposure, brightness, contrast, saturation, clarity, sharpness, and selected color adjustments gradually across an area of an image (**FIGURE 10.9**). You can make the gradient area as extensive or as constricted as you like.

The graduated filter tool is found in the local adjustments toolbar, fourth from the left (**FIGURE 10.10**).

Abrupt transition
zone gradient

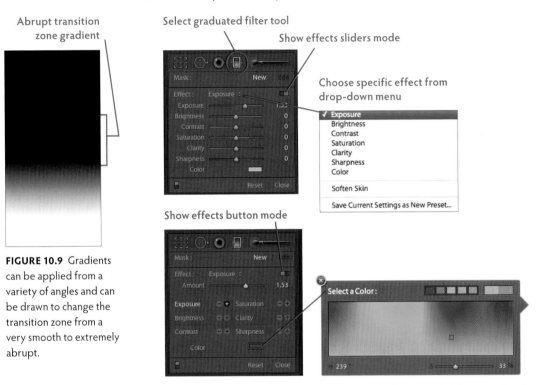

Select graduated filter tool

Show effects sliders mode

Choose specific effect from
drop-down menu

Show effects button mode

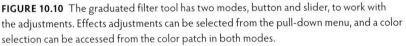

FIGURE 10.9 Gradients can be applied from a variety of angles and can be drawn to change the transition zone from a very smooth to extremely abrupt.

FIGURE 10.10 The graduated filter tool has two modes, button and slider, to work with the adjustments. Effects adjustments can be selected from the pull-down menu, and a color selection can be accessed from the color patch in both modes.

Applying Graduated Filter Effects

To apply the graduated filter, follow these steps:

1. First click the graduated filter icon from the local adjustments toolbar or press the M key.

2. Pick one or more effect(s) you want use: Exposure, Brightness, Contrast, Saturation, Clarity, Sharpness, and/or selected Color (see FIGURE 10.10).

3. Determine which mode you prefer to work with: sliders or simple buttons.

4. Enable the Before and After view (by pressing Y).

5. Place your mouse pointer in the image area, and a cross will appear for the insertion point.

6. Click, and three lines will appear with a graduated filter pin circle target in the center.

7. Click and drag in the image area to apply a graduated filter across an area of the image. A graduated filter pin will appear at the center of the effect. Three white guides represent the high, center, and low fields of the filter effect.

8. Position the graduated filter by holding down the mouse button and dragging above or below the line, stretching or contracting the gradient to cover the area of the image you want to adjust.

9. When the mouse button is released, the Mask mode in the graduated filter tool will switch to Edit, and the effect sliders will be available to refine the adjustment area.

10. Use the sliders or the plus (+) or minus (-) buttons to adjust the image for a specific correction or series of corrections.

Refining Your Graduated Filter Adjustment

To move the center pin, click directly on the pin and drag the adjustment to a new position. To rotate the adjustment, position the mouse pointer near the center white line until a curved, double arrow appears and then drag to rotate the adjustment. To expand or contract the edge of the graduated filter adjustment, click and drag one of the outer white lines out to expand the range of the gradient effect, or drag in toward the center of the pin to contract the range of the adjustment. Remove the adjustment by positioning the pointer over the center pin and pressing Delete.

Press the H key to hide or show the graduated filter pin and lines in the image display area. To undo the adjustment, press Command + Z (Mac) or Control + Z (Windows) or use your Adjustment History. Click Reset at the bottom of the graduated filter tool to remove all filter adjustments and to set Mask mode to New.

In the following example, I'm using the graduated filter to make a gradual adjustment to the sky as it relates to the foreground (**FIGURE 10.11**). In this case, I have used a variety of effects sliders to adjust the scene. The exposure adjustment darkens down the sky gradually by about half a stop. A small boost to the contrast helps separate the clouds. Another boost to the saturation helps bring up the level of blue intensity. And clarity helps delineate the mountains in the background. This adjustment of the sky by making a smooth transition to the foreground did not require Photoshop to selectively isolate the sky for adjustment.

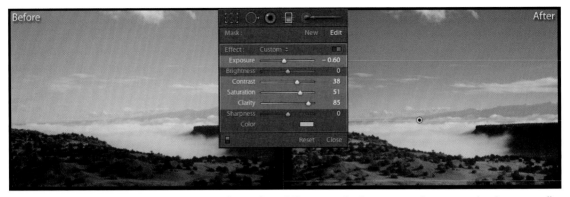

FIGURE 10.11 In this graduated filter example, the image can be improved with some small changes to the exposure, contrast, saturation, and clarity.

Because the local adjustment features are able to apply seven different adjustments, multiple graduated filter adjustments can be applied to the same image for different effects. Just click the word New to enable another graduated filter adjustment. Combinations of adjustments can also be applied. As an example, two or more adjustment settings could be applied within the same graduated filter adjustment.

Local Adjustment Brush Correction

Local adjustment brush correction refers to Lightroom's ability to correct a specific area of an image without affecting other areas, much like traditional photography's darkroom burn and dodge practice. Adjustment brush correction does far more than just making an image darker or lighter. It provides brushes that can be loaded with a variety of adjustment attributes, including: exposure, brightness, contrast, saturation, clarity, sharpness, and color tinting. Imagine this: You can apply color locally so that images are tinted with specific hue and saturation values that can be used to modify illumination problems such as mixed lighting conditions.

Local Adjustment Brush Keyboard Shortcuts

Open local adjustments: **K**
Show/hide pin: **H**
Decrease/increase brush size: **[/]**
Decrease/increase feather of the brush: **Shift + [/ Shift +]**
Commit a brush stroke and/or start new: **Enter**
Delete selected pin (brush stroke): **Delete**
Enable Erase mode: hold down **Alt / Option**

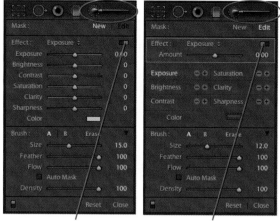

FIGURE 10.12 The adjustment brush tool has three segments: Mask, Effect, and Brush, plus two edit modes. The left Panel illustrates the slider mode, and the right Panel illustrates the button mode.

Adjustment brush options slider mode

Adjustment brush options button mode

Clicking the brush tool icon on the Develop Module's local adjustments toolbar (or pressing K) will reveal the feature options. Click the brush again to hide these options and return to the standard Develop Panel (**FIGURE 10.12**).

When the adjustment brush is clicked, the local adjustments become active. The controls available are divided into three basic areas: Mask, Effect, and Brush. Mask defines with visual clue whether you are working in a "new" brush or "editing" an active brush (**FIGURE 10.13**).

Effect defines the seven areas of adjustment as well the availability of a pull-down menu for saving local adjustment presets (**FIGURE 10.14**).

The third segment deals with brush controls (**FIGURE 10.15**). A and B brushes can be conveniently set up separately for specific size, feather, flow, and density. The brush can be active in an Erase mode by holding down the Option (Mac) / Alt (Windows) key to eliminate areas of the adjustment as you paint over the image. The auto mask feature can be toggled on or off using the check box.

FIGURE 10.13 The Mask segment of the Adjustment Brush alerts the user to the current state of adjustment. New or Edit is highlighted as an indicator.

FIGURE 10.14 The Effect segment has selections for the specific adjustment as well as a pull-down menu for saving preset local adjustments.

FIGURE 10.15 The Brush segment of the Adjustment Brush feature allows for creating characteristics for the brushes. By identifying an A or B brush, you can paint with specific effects and switch between them without setting up a brush each time.

Brush Characteristics

The brush size, feather, flow, and density need to be set before applying the correction.

- Size specifies the diameter of the brush tip in pixels.
- Feather controls the soft-edged transition of the brush. No feather equals an extremely hard edge brush, which is probably not useful in most situations. You will want to perform smooth transitions more frequently then not.
- Flow refers to the rate of application of the adjustment.
- Density controls the amount of transparency in the stroke, similar to opacity.
- Auto Mask, when enabled, can help confine the brush strokes to an area of similar color. When disabled, the adjustment that is painted on will migrate to other image areas.

Experiment with a variety of adjustments to get a feel for all the different variables that can influence the combinations of effects.

A dodge and burn example would have you painting the adjustment in at a positive brightness effect for the shadows and a negative exposure effect for a bright sky. This brush-based local correction tool does a fantastic job with dodging and burning.

Applying Adjustments with a Brush

NOTE

More than one type of adjustment can be specified at a time.

Click the adjustment brush tool in the Develop Module toolbar to select it, or press K. The Mask mode should appear with the word New highlighted. Select the type of effect adjustment you want to make by choosing one of the seven from the pull-down menu:

- Exposure establishes the image brightness overall primarily affecting the entire Histogram.
- Brightness adjusts image brightness, mainly affecting midtones.
- Contrast adjusts the difference between the highlights and shadows.
- Saturation changes the intensity of the color.
- Clarity: Plus adjustments add depth to an image by increasing local contrast. Negative adjustments blur and soften details.
- Sharpness enhances edge definition to bring out details in the image.
- Color applies a tint to the selected area. Select the hue and saturation by double-clicking the color patch to the right of the Effect listings.

Specify the options for adjustment brush A: Size, Feather, Flow, Auto Mask, and Density, and so on. Suggested starting points: Size = 15, Feather = 100, Flow = 100, Auto Mask = Enabled, and Density = 100.

When you're ready to apply a local adjustment brush, place the mouse pointer on the image area you want to correct and view the brush size. The plus icon (+) in the center of the circle indicates the insertion point, and the circle identifies the brush size. If you have set a feather amount, the brush appears as two concentric circles. The distance between the inner and outer circle represents the feathered amount (**FIGURE 10.16**).

Click and drag in the image to start the process of applying an adjustment brush stroke to the area you want to correct. When you release the mouse button, a target point or pin will appear on the image where you first inserted the brush stroke. In the Adjustment Brush Panel, the Mask mode changes to Edit, and the effect sliders become accessible to refine the adjustment. To view the mask created by the brush stroke, park the mouse pointer momentarily over the insertion point pin (**FIGURE 10.17**).

Additional brush strokes can be applied that will add to the current correction area. To erase a correction in an area, hold down the Option (Mac) or Alt (Windows) key to begin erasing with the brush.

To adjust the amount of correction applied to the entire area, click on the insertion point pin, and a double arrow will appear. Keep the mouse button down and move the mouse pointer to the left to decrease or to the right to increase the adjustment settings. This is sometimes called *scrubbing*.

To refine separate correction settings, click on the pin. The detailed adjustment sliders are available in the right Panel, and changes can be applied to the selected insertion point pin.

To create a totally new correction mask or brush stroke, select the New option in the Panel next to the Mask header.

FIGURE 10.16 When the local adjustment brush is set up and inserted into the image area, the brush icon shows the size as the inner circle. The second circle indicates the feather distance set for the brush.

FIGURE 10.17 The three images show the result of increasing the exposure of the foreground information while leaving the background untouched. The adjustment mask can be revealed by parking the mouse pointer over the local correction target pin.

No adjustment

Local adjustment brush insertion point/target

Brush mask revealed by parking the mouse pointer over the insertion point target

Exporting Images from Lightroom

Up to this point we have explored the workflow from the perspective of importing, editing, and processing your images. At some point, of course, you will want to share your images with clients, friends, and family. Lightroom has three modules for sharing your images: Slideshow, Print, and Web. But for external editing of the images in Photoshop, sending images via email, or burning images to a CD/DVD, you will need to export the image out of Lightroom. The Export function seamlessly facilitates this process.

In this chapter, I look exclusively at the Export dialog and the process of repurposing your images for screen, print, and email. Exporting images from Lightroom is mostly uncomplicated, but it does involve some basic questions about how Lightroom is to handle file formats, color space preferences, and bit depth information on the export side.

Color Information Management

To be sure, Lightroom up to this point has been managing the color information under the hood. You have not been asked any questions, in any dialogs or preferences settings, about anything related to your color space preferences. Lightroom's native color space is what's called *ProPhoto RGB*. This is a very large color space that allows you to have the most potential color from your image captures. One way to think about color spaces is as an inverted funnel with ProPhoto RGB at the top, representing the widest end of the funnel. Next down would be Adobe 1998, and then sRGB at the pointy bottom of the funnel.

Lightroom also honors any pre-tagged color information that was imported. If you set your camera to shoot JPEG or Tiff files, and your camera's color space is set to sRGB, Lightroom respects (keeps) the color capture source tag embedded in the file throughout the workflow. On the other hand, if you are shooting in the Raw format, Lightroom places these images in its native working color space of ProPhoto RGB, with an auto tone curve applied. The auto tone curve is applied because a Raw file is a linear-based capture (lacks contrast) and needs some tone adjustment to look visually pleasing.

One more thing related to color that you need to be clear about. If you have imported images into Lightroom that you had previously scanned from film (legacy files, pre-digital captures), these images more than likely have color information related to the capture of the scan as well. For example, say you scanned a color negative, and the scanner was set to capture the image information in Adobe 1998 color space. In this case, Lightroom would honor this color information as well. In other words, unbeknownst to you Lightroom has been efficiently managing the color space associated with any files that have been imported from a variety of different workflows.

Exporting Images

To start exporting images from Lightroom, move to the Library Module (by pressing G). Select a single image or a series of images that you would like to export. Once your choice is selected, click the large Export button in the left-hand Panel of the Library Module or click File > Export (**FIGURE 11.1**).

The Export dialog box appears, where Lightroom provides a straightforward, common-sense approach to the exporting workflow (**FIGURE 11.2**).

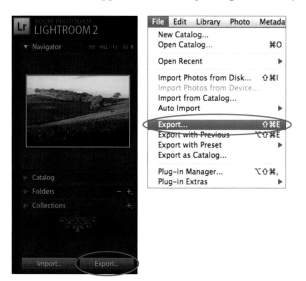

FIGURE 11.1 Use either the Export button or the File menu's Export command to start the process of exporting images from Lightroom.

FIGURE 11.2 Start at the top of the Export dialog and work your way down through each of the seven parts to establish the correct settings for your export.

Exporting Files to Disk or CD

At the top of the dialog, the first thing Lightroom tells you is how many images are selected for export and how the files are to be handled for export. By default, Lightroom exports images to your hard disk. If you need to

export to a CD or DVD, you can change the option from the pull-down menu (**FIGURE 11.3**). If you select the CD/DVD option, Lightroom walks you through the process of burning the files to a writable CD or DVD.

In this example I am working on a vineyard book. The publisher has requested Tiff files with a color space of Adobe 1998, 8 bits, at a resolution of 300 PPI (pixels per inch). Let's walk through the process and discuss the options.

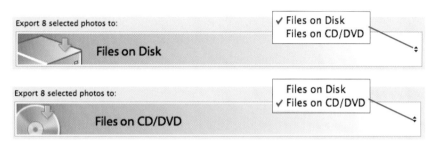

FIGURE 11.3 Lightroom's two choices for Export are available at the top of the dialog.

Export Location

You need to choose an export location (**FIGURE 11.4**). For this example, I have created a folder on my desktop called Vineyard_project_files. This is the identified location for the export.

FIGURE 11.4 The Export Location choices are important to correctly identify where your images are to be exported.

File Naming

The File Naming Panel is where you specify how the images will be named as they're exported. Pick an appropriate naming scheme for your export. In my case, vineyard_book is the Custom Text with the Custom Name - Sequence numbering applied In the Template box (**FIGURE 11.5**).

FIGURE 11.5 The File Naming Panel is where you choose a naming template to use for exporting images. The example filename is helpful for previewing how your filenames will appear after export.

File Settings

The File Settings options are extremely important to the export process. This is where you identify the file format, the color space required, the bit depth, and compression (if any) for the file(s) (**FIGURE 11.6**). For example, when specifying the amount of compression for JPEGs, drag the quality slider or enter a value between 0 and 100 in the Quality box. Smaller quality numbers will discard data to make the file smaller, which is great for emailing but not something you want to do if you are going to be printing from the file. Too much compression will degrade the image by throwing out file information to make the file smaller (see the JPEG file compression discussion in Chapter 1).

FIGURE 11.6 File Settings is where you pick the file type, color space, bit depth, and compression.

The available options are for five file formats: PSD, Tiff, DNG, JPEG, and Original. My example is set up for the Tiff format, as specified by the publisher. Using the other formats available works the same, though each would be chosen according to specific workflow requirements. An example would be using the export to produce JPEG files for a Web project or for emailing. The Original file format selection exports a copy of the file (not the original) to a destination of choice.

Image Sizing

The Image Sizing options require you to define a width and height for export (**FIGURE 11.7**). If you choose JPEG, PSD, or Tiff as your file format, you can specify the image size. If left unchecked, Lightroom retains the base resolution of the file to build the export, meaning the original pixel dimensions of your camera capture. For example, my Nikon D300 captures at 4,288 x 2,848 pixels.

FIGURE 11.7 The Image Sizing Panel determines the dimensions and resolution in which your images will be exported.

▼ Image Sizing
☐ Resize to Fit: Width & Height ☐ Don't Enlarge
W: 640 H: 640 pixels Resolution: 300 pixels per inch

The Resize to Fit option sets a maximum size for the width or height of your images. This can be helpful when you need to export specific image sizes for the Web, and for electronic submissions to a contest where pixel size is defined.

The Resolution setting will depend on what the exported file will be used for. Exporting the image file for print, Web, or an email attachment each probably requires different resolutions. For screen display, the resolution is usually 72 PPI (pixels per inch), and for printing the resolution can range from 200 to 300 PPI. Printing resolutions are quality based as well and depend on the printer and paper technology used (offset press, inkjet, thermal dye, or photo chemical). Refer to the service provider or the printer manual to determine the resolution versus quality standards to obtain the best results.

Output Sharpening

The amount of sharpening Lightroom applies to your exported images is based on the output media and output resolution you specify (**FIGURE 11.8**). Output sharpening is performed in addition to any sharpening that was applied in the Develop Module.

FIGURE 11.8 Output Sharpening can be applied on export. Sharpening is based on how aggressively you would like Lightroom to sharpen.

By specifying for paper type, either Matte or Glossy, you cause the sharpening amount to be automatically regulated to account for the different surfaces. A matte surface requires more aggressive sharpening than glossy does, because ink on matte paper is diffused into the rougher texture of the surface and therefore needs a bit more sharpening to create detail contrast. I recommend that sharpening be the last part of the workflow because it depends on the type of output selected, and it's not a good idea to sharpen on top of the sharpening already done in the Develop Module. So pick your spot to sharpen. Lightroom has three places it applies sharpening: the Develop Module, the Print Module, and the Export Module.

Metadata

Select how you want the export to handle metadata associated with the exported images (**FIGURE 11.9**).

- Minimize Embedded Metadata: Choosing this option means including only copyright metadata fields in the exported image. DNG files do not have this option available.

- Write Keywords As Lightroom Hierarchy: You probably don't need to use this option in an export unless a stock agency you're working with needs the use of your keywords.

- Add Copyright Watermark: This option adds a copyright watermark if a copyright tag is present in the IPTC metadata field for copyright protection. This watermark appears in the lower left-hand corner of your image and can be useful in protecting your image from being copied on the Web. Personally, I find watermarking distracting when looking at images, but you be the judge and determine what works best for you.

Post-Processing

So what do you want to do after the export? You can specify certain actions to be performed when Lightroom is finished exporting your images to disk or CD/DVD. One thing I'm interested in is seeing the images in the Finder (Mac) or Windows Explorer to make sure they are properly processed and ready to go. Other choices include opening the images in other applications for more external editing. I'm more inclined to use the export features here when processing images for a specific purpose, rather than as the export bridge to an external editing program (**FIGURE 11.10**). If your objective is to move an image to Photoshop to do some external editing, I find it better to use the Lightroom Edit in Photoshop feature to transport the file to the external application.

FIGURE 11.10 The Post-Processing selections deal mainly with what you want to do with the images after export.

Saving Export Settings as a Preset

Having spent the time to carefully set up an export, you might want to save the export settings as a preset so that you don't have to re-enter them next time (**FIGURE 11.11**). Click the Add button in the lower left-hand corner of the Export dialog to save as a preset. The saved preset then becomes part of the dialog's Lightroom Presets. Lightroom's preloaded presets include ones for creating exports for burning JPEGs to a DVD/CD, exporting DNGs, and exporting images for email.

FIGURE 11.11 You can save export settings specific to a workflow as a preset. In this case, I created a preset for the vineyard project images.

Exporting Images to Photoshop

Lightroom is great, but it can't do everything. That's why it integrates external image editing so well with Adobe Photoshop. Lightroom opens Camera Raw files directly in Photoshop. However, for other external editors that cannot read Raw data, Lightroom must send either Tiff or PSD copies of Camera Raw and DNG files. Having Photoshop's pixel-pushing power is a handy complementary asset to your digital darkroom that can take your

images to the next level. The photographer's toolbox benefits from Photoshop, and you should reach for it when you have exhausted all of Lightroom's global image and local adjustments features.

Now is where I focus on working with Photoshop to provide another avenue of image enhancement and compositing. To perform any type of image compositing, which means editing and combining multiple images in the same document, you will need to rely on Photoshop's strength as a pixel-based image-editing application. Remember: Lightroom's approach is non-destructive because of its metadata instruction editing and only applies adjustments you make when the image is exported. Photoshop, on the other hand, if you're not careful, can be *highly* destructive because it does not have any limitations built into its controls for image adjustment.

You may ask what is the point of additional editing in Photoshop now that we have local corrections in Lightroom? Photoshop can provide the following elements specific to a photography workflow:

- Making and saving selections based on highlights, midtones, shadows, and luminosity
- Working with multi-layered image documents
- Replacing backgrounds and skies
- Creative image compositing
- Smart Object layers
- Panoramic image stitching
- Layer alignment and blending features
- High dynamic range (HDR) image processing
- Adding text information to image files
- Creating effects with layer blending options
- Diffusion filter effects
- Selective focus emulation and blurring
- Image transformations
- Perspective control
- Extensive retouching and restoration

Lightroom provides a direct path to external editing in Photoshop built into the workflow. Using Lightroom's external editing link, the application provides a file management structure to complement working in Photoshop and then returns the edited files back to Lightroom's database. I call this *round tripping*.

Lightroom External Editing Preferences

In Chapter 4 I take a look at setting Lightroom's preferences for external editing in Photoshop. The external editing preferences specified the file format (PSD or Tiff), the preferred color space, bit depth, and compression (Tiff option only). The options you specify in Lightroom's External Editing preferences are also used by Photoshop when you save Raw files from Lightroom in Photoshop.

To review these settings again:

1. Choose Lightroom > Preferences (Mac) or Edit > Preferences (Windows).
2. Click the External Editing tab.
 - File Format: PSD is the choice I use in this chapter.
 - Color Space: ProPhoto RGB
 - Bit Depth: 16-bit files maintain finer distinctions in tone and color, whereas 8-bit images are smaller and have extended smaller range of tone.

Photoshop Preferences and Color Settings

To make Photoshop files completely compatible with this workflow, you need to visit Photoshop's Preferences and Color Settings to ensure smooth sailing. Launch Adobe Photoshop CS3 and Choose Photoshop Preferences (Mac) or Edit > Preferences (Windows) (**FIGURE 12.1**).

FIGURE 12.1 Adobe Photoshop CS3's Preferences dialog.

In Photoshop CS3's Preferences dialog select File Handling and go to the File Compatibility segment. From the Maximize PSD and PSB File Compatibility pull-down menu, choose Always. Click OK to close the dialog with the new settings to maximize compatibility (**FIGURE 12.2**).

FIGURE 12.2 File Handling in Photoshop CS3 needs to be set to Always Maximize PSD and PSB File Compatibility to ensure that Lightroom and Photoshop are completely integrated and will work harmoniously.

One more bit of housekeeping is required. In Adobe Photoshop CS3, click Edit > Color Settings (**FIGURE 12.3**).

In the Color Settings dialog that appears, in the Working Spaces segment, choose ProPhoto RGB as your RGB choice (**FIGURE 12.4**). As I mentioned earlier, ProPhoto RGB is the native working space of Lightroom; it's best to have the two programs on the same page when dealing with Raw files. Doing so eliminates most color mismatch warnings when working between the two applications. Now Photoshop and Lightroom are in sync for Raw processing files.

FIGURE 12.4 The Photoshop CS3 Color Settings dialog box with ProPhoto RGB selected.

FIGURE 12.3 In Photoshop CS3 navigate to the Edit menu and select Color Settings.

Working in Lightroom you can access Photoshop as the external editing application in three ways:

- The most direct and easiest approach is to use the keyboard shortcut; Command + E (Mac) / Control + E (Windows).
- In any Lightroom Module (except the Web Module) right-clicking an image brings up a contextual menu with the choice Edit in Photoshop (**FIGURE 12.5**).
- Click Photo > Edit in. The Photo menu is available in both the Library and Develop Modules.

Right-click an image

FIGURE 12.5 Right-clicking an image accesses the contextual menu for Edit in Photoshop in all Modules except Web.

Seamless Integration

Adobe Photoshop Lightroom, Adobe Camera Raw, and Adobe Photoshop CS3 are fully integrated to process Raw and DNG file formats. When accessed for external editing from Lightroom to Photoshop CS3, these formats are directly transported for editing. You get a free ride, without passing through so much as a dialog. An added bonus is that all your global and local corrections in metadata are automatically applied during this transfer process.

Your image opens in Photoshop in your preferred external editing file format, the one you chose in Lightroom's file-handling preferences (PSD/Tiff). When you finish working on the file in Photoshop CS3, click File > Save, and the file is placed back into the Lightroom catalog as a new file format (PSD/Tiff) and shows up next to the original file in the original folder. The original Raw file is never edited and remains there untouched.

The External Editor Round-Trip Process

When you open an image in the external editor (Photoshop), the newly created file is automatically re-imported into the Lightroom catalog when the file is saved in Photoshop. It's now time to explore the Lightroom process for external editing of JPEG, Tiff, and PSD file formats. Select a JPEG, Tiff, or PSD image for external editing in Photoshop. Press the keyboard shortcut, Command + E (Mac)/ Control + E (Windows). The Edit Photo dialog appears (**FIGURE 12.6**).

FIGURE 12.6 The Edit Photo dialog has three choices. What you choose depends on how you want to proceed with your edit process workflow.

You need to choose one of the following:

- Edit a Copy with Lightroom Adjustments: Applies any Lightroom adjustments you've made in the Library Quick Develop or the Develop Module to a copy of the file that opens in Photoshop for editing. When opening a Raw file from Lightroom, this is the only option.

- Edit a Copy: Edits a copy of the original file without Lightroom adjustments. This creates a duplicate file and opens a copy in Photoshop.

- Edit Original: Edits the original file without Lightroom adjustments. When opening a JPEG or TIFF original file from Lightroom in Photoshop, any changes made will be permanent because no copy was produced. This could be a bad choice if you happen to save the file. My suggestion is do a Save As and rename the file if you're going to edit from this choice.

The Stack with original checkbox is available with the first two choices. It is a good idea to have the Photoshop-edited file reside in the catalog folder, stacked with the original file for comparison. I call this round-tripping the file.

Next click the Edit button.

If you prefer, the images can be unstacked, and the original files and edited PSD files moved to a new folder(s) or another location to adapt to your workflow. Adding a new folder and the drag-and-drop file-management process we explore in Chapter 7 can facilitate this process.

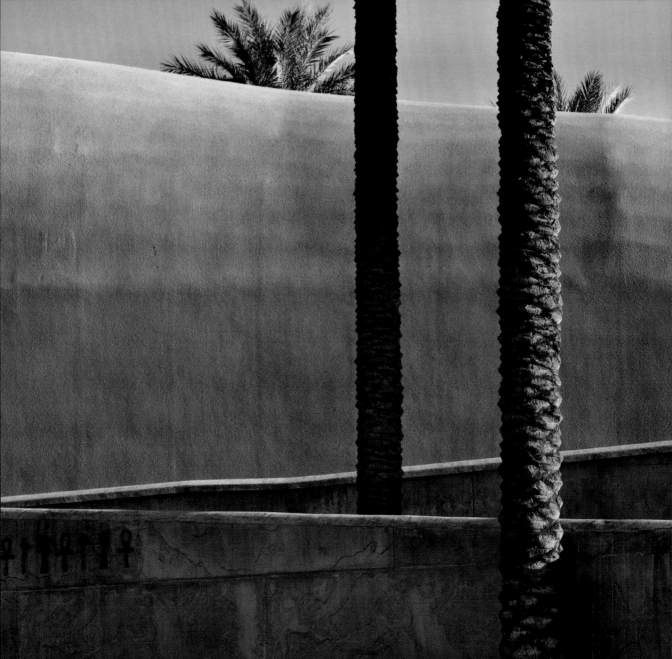

ADOBE PHOTOSHOP:
THE DIGITAL DARKROOM

Simply Photoshop

I have had the pleasure to explore and work with Adobe Photoshop every day since 1992. The program is so huge and massively deep that even on my best days getting my head around all the tools and capabilities can be a challenge. Today's features in Photoshop CS3 automate many of the processes that used to take hours of manual layer masking. Photoshop isn't cheap. But it is a worthwhile investment from the perspective of a photographic workflow.

If you're new to Photoshop and intend to use it to enhance your digital photography, you would do well to get some training, take an intensive workshop, or find books that walk you through learning the application (such as *Photoshop CS3: Visual QuickPro Guide* by Elaine Weinmann and Peter Lourekas, Peachpit Press, 2008). If a thing is worth doing, as they say, it's worth doing well. Left to your own devices, Photoshop can swallow you up in your quest to find that perfect tool.

As always with Photoshop, there is an "Oh wait, there's more" theme. There may well be six different ways to do the same thing! As digital programs director for the Santa Fe Photographic Workshops for the past 14 years, I can say I have seen as many different approaches to the instruction of Photoshop as there are instructors. Today digital capture, image processing, and sharing images online is mainstream, and the objections of traditionalists are fading in importance. My approach in this chapter is to identify the key nuggets in the complementary supporting relationship between Lightroom and Photoshop. My objective is to impart the photography techniques I have observed and learned without digging too deeply into Photoshop's closet. I only scratch the surface, but in doing so I provide a look at the Photoshop tools that can maximize the workflow.

Here I explore assembling panoramic images and creating overlapping squares to increase the megapixel size of your capture. Photoshop supports the emerging High Dynamic Range (HDR) imaging technique as a way to expand the exposure range of your digital SLR, and the use of multiple image elements in the same document. These three capabilities, among others, are completely integrated into a Lightroom to Photoshop workflow.

Assembling Panoramic Images in Photomerge

For my first example I have imported a series of images into Lightroom that were taken with the Photoshop's panoramic Photomerge feature in mind. To make the image processing and assembly in Photoshop easy, when capturing a scene the images should overlap on their adjoining edges comfortably by around a third or a quarter. Pre-visualize the scene and look to see how you will assemble it for viewing. Think carefully about choosing a vertical (portrait) or horizontal (landscape) orientation for the camera position. Portrait captures provide more information from top to bottom and require more frames to extend the width of the image during a capture series. On the other

hand, landscape captures require fewer frames to extend the width of the image. A wide angle lens in the range of 17 mm to 55 mm works great for this type of photography.

A sturdy tripod and bubble level is always a good thing to carry for this type of photography, but they're not completely necessary. The amazing Photomerge feature has fantastic layer alignment and layer blending technology. One note about tripods if you do intend to use them. Some manufacturers have created attachments that correct for the distortion and perspective problem inherent with the changing angle of the sensor plane during vertical or horizontal captures along the same plane. Such a tripod attachment works by rotating the captures around what is referred to as the *nodal point* of the lens rather than from the sensor's exposure plane. The nodal point of a lens is the point inside where light paths cross before they are focused on the sensor. See the appendix for panoramic tripod resources.

Panoramic photography does not always need to consist of long, skinny images that require huge amounts of wall space to exhibit. Reducing the number of frames to assemble down to even two is a great way to get an expanded view of the scene. Many of the panoramic frames I create are assembled from as few as two and as many as five images.

One last little nugget, try shooting in manual mode with your digital SLR to maintain consistent exposure throughout the frames recorded. For landscapes, try to work with an aperture of f8, f11, or f16 to create maximum depth of field and sharpness. Measure the exposure for the scene at the beginning, middle, and ending frames and average the exposure for capture, so that blending radically different sky exposures doesn't become a problem.

All right, let's get going:

1. Import your sequence of images into Lightroom's Library Module via the Import button.
2. In the Library Module, press G key to view the Grid view.
3. Navigate to the folder where the series of images are located (**FIGURE 13.1**).
4. Select all the frames you will assemble as a Panoramic.
5. Click Photo > Edit in > Merge to Panoramic in Photoshop. This will launch Photoshop and present the dialog box for Photomerge.
6. In the Layout segment, click Reposition Only.
7. In the Source Files segment, check to make sure these are the images to be assembled, check Blend Images together, and then click OK (**FIGURE 13.2**).

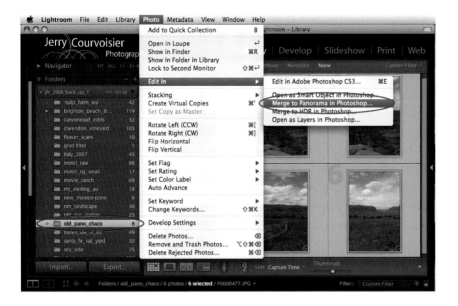

FIGURE13.1 In the Library Module, locate and select all of the images for the panoramic.

FIGURE 13.2 The Photoshop Photomerge dialog contains the choices for layout (1) and blending of the source files (2) to be assembled into the panorama (3).

Now the processing magic begins, and the power of this Photoshop feature crunches the image data, aligning similar image information and then blending all six files together seamlessly. What really amazes me is the auto masking of the image information, which is merged but separated in individual layers (**FIGURE 13.3**).

FIGURE 13.3 A Photo-merge image produced in Photoshop. The masking in the layers was auto-matically created during the assembly process.

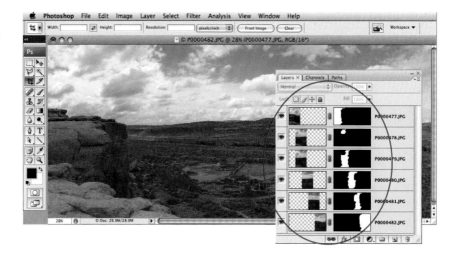

If you select the Auto feature instead of the Reposition Only in the Photo-merge dialog, the image will be auto corrected and assembled without the separate layers generated. Feel free to experiment with different Photomerge features to get a feel for how it works. You may find that you don't need all the extra gear to produce panoramics.

In the next example, four images were photographed in a sequence in which two were captured from left to right and the next two were captured by mov-ing the camera vertically, to produce a square (**FIGURE 13.4**).

FIGURE 13.4 This 649MB, 16-bit file was created in Photoshop's Photomerge from four overlapping Raw digital camera captures of a public mural at a Santa Fe bus stop.

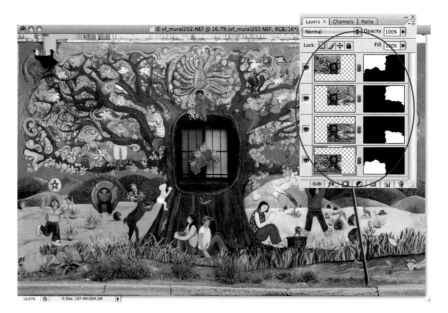

Multiple Images as Layers from Lightroom to Photoshop

Another automated feature that Lightroom and Photoshop share is the ability to open multiple images as layers in Photoshop. This can happen when two or more images are chosen in the Library Module Grid view. In the following example two images are selected, both containing the same red hut but in two different positions (**FIGURE 13.5**). The example illustrates the ability of Photoshop to match up images with similar image information that have not been photographed in the panoramic style discussed earlier. What is significant is that you can, in effect, increase the megapixel size of your camera by combining frames using these automated features. I won't bore you with tales of the old days of Photoshop when we had to construct such files manually.

Because both images in the layered document have a similar feature, they can be processed in Photoshop by clicking Edit > Auto Align Layers. The result is an expanded canvas to accommodate both of the similar image elements (**FIGURE 13.6**).

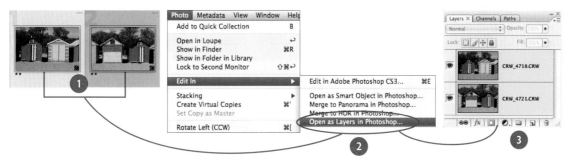

FIGURE 13.5 1) Two images with the same red beach hut. 2) Selected for Edit in > Open as layers in Photoshop. 3) After processing they land in Photoshop as two independent image elements within the same file.

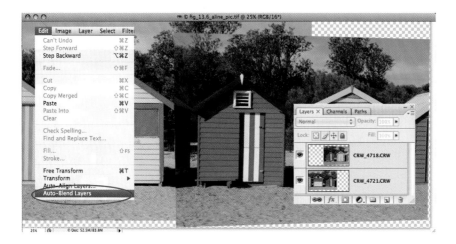

FIGURE 13.6 Two layers selected and processed using the Photoshop's Auto Align feature. The images overlap but appear to have slightly different exposures.

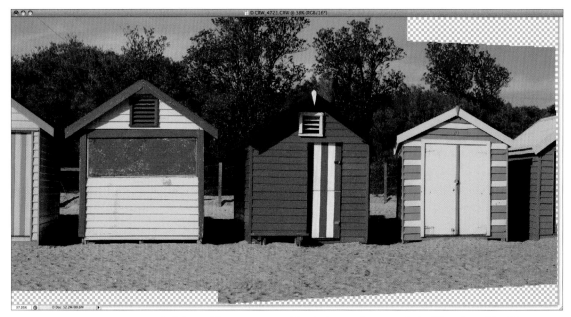

FIGURE 13.7 The image is now blended to perfection with the Edit > Auto-Blend Layers feature. Cropping is the only thing left to do.

The slightly different exposures produced from the layer alignment feature can now be corrected via Edit > Auto Blend Layers. The resulting image will be corrected for the density difference problems, and an auto mask will be applied to blend the two images together perfectly (**FIGURE 13.7**). The only thing left to do is to use the crop tool to eliminate the ragged edges because the image was a hand held shot. Click File > Save to save this new image in Lightroom's catalog.

Quick Compositing Separate Image Elements

Another example where the Edit in Layers connection feature can be appropriate is when compositing two or more separate image elements together. The way this works is really complementary between the two programs and can speed up the workflow process. Opening Photoshop, navigating to the separate file folders to open each one, and then manually stacking them in the Layers palette is a real time sink. In this example, I target two images in which I want to combine the sky from one with an image that doesn't contain a sky of any substance.

In the same operation as before in Lightroom, select the images to be layered together in a single document by clicking Photo > Edit in > Open as Layers in Photoshop. Here, the images of the chaco wall and sky are combined with a few easy steps in Photoshop (**FIGURE 13.8**).

Layer visibility turned off

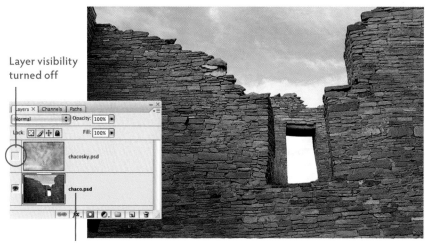

Target layer highlighted in yellow

FIGURE 13.8 This document contains two image elements in a layers stack in Photoshop. Clicking the eyeball for the sky layer turns off the layer's visibility. Highlighting the bottom layer allows you to work specifically on the targeted layer.

With the top layer visibility turned off (click the top eyeball in the first column) and the bottom layer highlighted, use the quick selection tool in the Photoshop toolbar to make the work of selecting the sky and window speedy. Use the tool to paint inside the sky area of the image to select it. Enable the Auto-Enhance feature in the options bar for this tool. This will minimize the jagged and blocky selection boundary. Auto-Enhance automatically flows the selection further towards image edges and applies the smooth edge refinement.

The selection will grow as you paint the sky. Next, with the Shift key held down to add to the current sky selection, paint again with the quick selection tool the area of the sky inside the window. When finished, you have a clean selection of both the sky and the window. The marching ants, as they are called, march around the selected areas (**FIGURE 13.9**). This selection is not a difficult one to make because of the extreme tonal value differences and the high contrast edge to select. But with a bit of practice using all the selection tools Photoshop has to offer, some of the most challenging selections will become really easy.

FIGURE 13.9 Use the Photoshop quick selection tool to obtain the selection of the sky and window areas. The yellow line illustrates the selected area where the new sky will replace the old one.

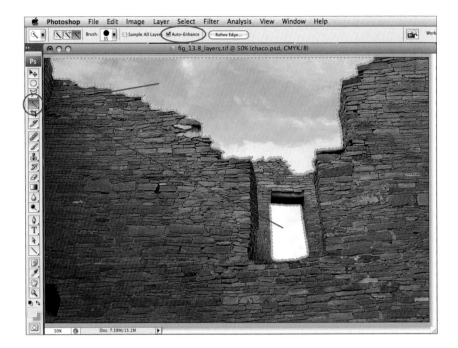

Now with the area selected, simply turn on the sky layer's visibility eyeball and highlight the sky layer by clicking on the top layer. The section is still active, and the only thing now showing is both the selection and the new sky. Click Layer > Layer Mask > Reveal Selection (**FIGURE 13.10**). This operation will use the selection as a vehicle for the creation of the new layer mask. The new layer mask generated by Photoshop from the selection will reveal the new clouds in the selected area (white).

FIGURE 13.10 The new sky on the top layer is revealed in the selected area using Photoshop's layer mask feature. Black areas hide, and white areas reveal the underlying image information.

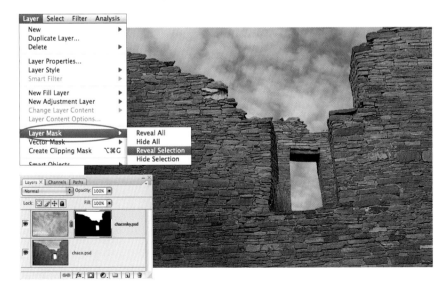

Understanding Bit Depth

Bit depth identifies how much color data is available for each pixel in an image. The more bits of information per pixel, the more available colors.

For a grayscale image, the bit depth measures how many unique shades are available. In an 8-bit image, there are 256 shades between black and white. Images with higher bit depths encode more shades. Most color images from digital cameras have 8 bits per channel, meaning a total of eight 0s and 1s. 24-bit color images have 8 bits each for red, green, and blue. This comes to 2^8, or 256 different RGB combinations for each primary color. When all three primary colors are used at different value combinations, the palette of color becomes 16,777,216 colors.

To obtain these high-quality images, most digital SLR cameras have higher bit-depth options, allowing you to achieve good shadow detail and maintain good color saturation. The definition of a high-bit image relates to how 10-, 12-, 14-, and 16-bits-per-pixel images are handled in Photoshop. A JPEG file only has 8-bit images, whereas the Raw data format can record in 10, 12, 14, and 16 bits per pixel, depending on the sensor quality. In Photoshop, an image that is above 8 bits but below 16 bits is processed in 16-bit mode, even though it is not a true 16-bit image. (HDR can extend this range to 32 bits with limited adjustment options; see the next section for more on HDR).

Take advantage of working with extra bit depth files in Photoshop to achieve more distinct variations in tone and reduce image destruction. Good Photoshop practice, if you're using the Raw format, is to apply your tone adjustments, such as highlight, midtone, and shadow, before converting to 8 bits.

High Dynamic Range (HDR)

High Dynamic Range (HDR) imaging permits photographers to capture a larger range of tonal detail from a series of image captures, rather than using the limited range of a single image capture. A digital SLR camera is capable of capturing a limited amount of tones in a single image. Characteristically, we surrender elements in an image when we capture it. Example: A scene with bright, backlit clouds in the background and some landform in shadow is beyond the dynamic range of capture. If you expose for the clouds, the landform becomes a dark silhouette. If you set the exposure to capture detail in the landform, the brighter clouds are blown out, and detail is lost. This is because our eyes are much more sensitive to the range of light within a scene than the digital sensor is.

The solution is to take more than one capture and *bracket* the exposures. The merge-to-HDR Lightroom-to-Photoshop feature enables the photographer to combine a series of bracketed exposures into a single image which encompasses the tonal detail of the entire series.

Warning: The bracketing technique does not work with subjects in motion and is primarily for still-life and landscape photography. Any motion will become blurred, and ghosting will occur. The registration of the bracketed images can become a problem for this type of image processing.

Start with the camera on a steady tripod. Set the camera for Raw file format capture and bracket five stops on the capture. One normal exposure, two on the underexposed side (–1, –2) and the two on the overexposed side (+1, +2). This should give you plenty of room for merging all the tones in the scene. Bracketing unleashes a whole new range of lighting possibilities, which many have steered clear of in the past for technical reasons. You can bracket exposures manually, but many digital SLRs also have an auto feature to do this function. Check your camera manual for auto bracket specifics.

Beware: There is a bit of a tradeoff with bracketing. Trying to expand the tonal range will come at the expense of decreased contrast in some tonal areas as well as reduced saturation of the image. Still, learning to use merge-to-HDR in Photoshop CS3 can help you make the most of your dynamic range under some problematic lighting situations while still balancing this tradeoff with contrast.

Photoshop generates an HDR file by using the EXIF information (camera metadata) from each of the bracketed exposures to determine the shutter speed, aperture, and ISO settings. It then uses this data to evaluate how much light came from each image area. Because this light has different intensities, Photoshop creates the HDR file using 32 bits (creating a large file) to describe each color channel as opposed to the usual 8 or 16 bits (see nearby sidebar on bit depth). Down sampling from the large 32-bit image to the 16- or 8-bit image is like getting better results from a broader survey of information. The more samples in a survey, the better the data collected.

Processing HDR Images

First, select the series of bracketed exposure images in the Lightroom Library Module Grid view. Make sure you've taken at least three exposures, although as I mentioned five or more is recommended for the best possible precision. More exposures allow the HDR algorithm to better approximate how your camera deciphers light into digital values.

In Lightroom, click Photo > Edit in > Merge to HDR and click OK (**FIGURE 13.11**).

Your images will appear in the Photoshop Merge to HDR dialog with the exposure values (EV) listed with the thumbnails on the left-hand Filmstrip. (You uncheck a box to eliminate individual images from the merge.) The merged results appear in a 32-bit image. You can adjust the overall tones with the Set White Point Preview slider. Small nudges on the control slider go a long way, so don't be too aggressive with this adjustment. I look to adjust the white point on the Histogram to where the white highlights have a bit of detail. You will find that the image becomes darker when maintaining the detail in the highlights (**FIGURE 13.12**).

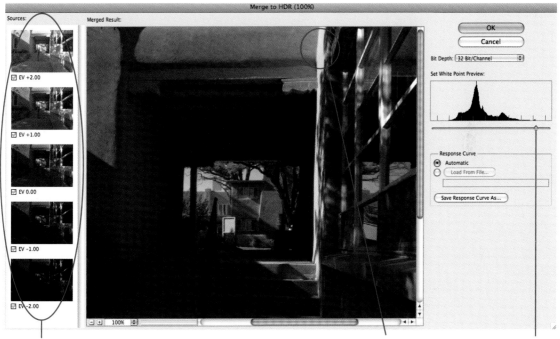

Selected images for HDR processing Highlight detail Set the white point

FIGURE 13.12 The Merge to HDR dialog box shows the selected images on the left. On the right is the Set White Point Preview slider.

Click OK to merge the selected, bracketed images and white point into the 32-bit image. This image will appear in Photoshop after processing with good highlight detail, but may look really dark and lack contrast over all.

In Photoshop, click Image > Mode > 16 bit (or 8 bit) (**FIGURE 13.13**).

FIGURE 13.13 Reduce the image from the very large 32 bits to a more manageable 16 bits using Image > Mode > 16 bits.

The process of converting the 32-bit image to 16 bits brings up the HDR Conversion dialog. This dialog has four elements: Exposure and Gamma, Highlight Compression, Equalize Histogram, and Local Adaptation (**FIGURE 13.14**). Depending on how the image is capture and processed, you may not need to use all the controls to adjust the image. The Local Adaptation Method of adjustment is the one I use most often when experimenting with such image processing.

Additional information about FIGURE 13.14:

1) Exposure and Gamma is the default option. Adjust the exposure to get the desired brightness and gamma. If you prefer an image with more contrast, lower the gamma. For less contrast raise the gamma.

2) Change the HDR Conversion method to Highlight Compression. Just by selecting this choice, the image will darken and the highlights will exhibit detail.

FIGURE 13.14 Conversion process: 32 bits to 16 bits.

3) Change the HDR Conversion method to Equalize Histogram, allowing Photoshop HDR to do the math to average out the Histogram values. Some images undergo a significant improvement in contrast when this is applied.

4) Change the HDR Conversion Method to Local Adaptation. This is where you can adjust the tone mapping, placing points on the curve and moving these to season the image to taste. Try a visually pleasing S-shaped curve to enhance the image. Once you're happy with the curve, adjust the radius and threshold sliders to make sure there are no halos in the photo.

FIGURE 13.14 Conversion process: 32 bits to 16 bits.

The radius controls the mask blur, whereas the threshold decides what gets blurred and what doesn't. (Poorly converted HDR images have a glow around the contrast transition edges areas of contrast.)

When you finish the conversion, your disappointment that the image information lacks contrast and color saturation will be realized. But move on the next step and click OK to convert.

Now use the normal adjustment layers to improve the contrast with levels or curves and saturation globally as well as locally on the processed file (see Chapter 14 for more). Again, the object here is to deal with extreme dynamic ranges that cannot be recorded in a single frame, using an automated solution provided by Photoshop (**FIGURE 13.15**). I have found many photographers using this in creative ways as well because it provides a new element to the toolbox that was not available in the past. Overprocessing the file in HDR can lead to some interesting effects.

FIGURE 13.15 Comparison of the HDR-processed file and the adjustments made after the processing with adjustment layers for contrast and saturation.

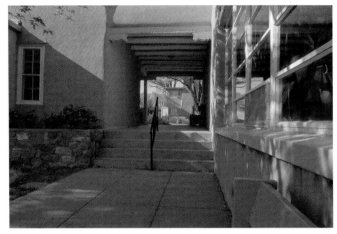

HDR processed from five bracketed frames

Processed file improved with adjustment layer corrections

Smart Objects

Photoshop has a unique type of layer called a Smart Object layer, which is like a virtual copy or version within a Photoshop document. Smart Layers can be transformed (scaled, skewed, or distorted) without directly editing any image pixels (here is where I'd like to mention that helpful word *non-destructive* again). You can even edit a Smart Object as a separate image, even after placing it in a Photoshop document. Smart Objects can contain Smart Filter effects, which permit the non-destructive application of filters to images so that later you can adjust or eliminate the filter effect. Lightroom links the workflow directly to Photoshop, making it easy to create a Smart Object image.

Select an image from Lightroom's Grid view and click Photo > Edit in > Open As Smart Object in Photoshop. You will then be transported directly to Photoshop. The Photoshop layer will have a small icon as a visual clue that it is a Smart Object (**FIGURE 13.16**).

Click the Smart Object icon in the Photoshop layer to bring up the image in the Adjustment dialog. This is internally linked to the Photoshop document. Even as an image element within a stack of layers in a Photoshop document, Smart Objects can be adjusted independently, and the Photoshop document will be updated when the adjustment or transformation is completed. Smart Object adjustments can be can be revisited as many times as you feel the need to update the layer in relation to the other images in the document.

FIGURE13.16 The icon in the layer image thumbnail means this is a Smart Object. Clicking the icon in the layer launches an adjustment dialog.

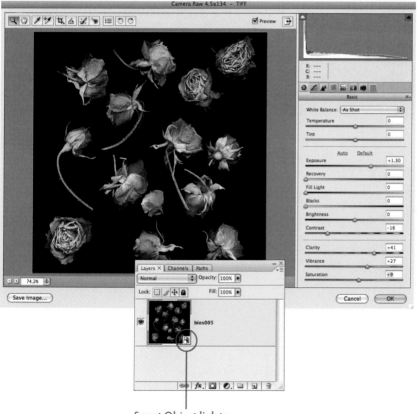

Smart Object link to independent adjustment

Photoshop Adjustment Layers

Using adjustment layers is a flexible method to make adjustments in Photoshop without permanently altering the pixels in the image. The color and tonal modifications are contained within the adjustment layer, which acts as a filter through which the underlying image layers are displayed. The benefit to using adjustment layers is that the editing is not permanent until you actually flatten all the layers within the image. You can

even save the image with all its adjustment layers as a working Photoshop document (PSD), return to it, reopen it, and all the changes made to the adjustment layers will still be there for you to alter, remove, or modify.

I know this all sounds a bit familiar, but Lightroom's local adjustments are limited to seven specific adjustments, whereas Photoshop offers 17 adjustments. When you include the 26 layer blending and opacity options, your reach is pretty extensive. I don't explore all these options in detail, but I do hope to help you gain an understanding of how to use adjustment layers in Photoshop. I focus on a few of the various color and exposure adjustment techniques, with a few creative concepts thrown in to get you started.

New users of Photoshop tend to make adjustments to their images using the appropriately named Image > Adjustments menu. Too be sure, you will find a plethora of image-adjustment tools there (**FIGURE 14.1**).

FIGURE 14.1 Adjustment tools in Photoshop's Adjustments menu. These "embedded adjustments" are directly applied to the currently active layer. Avoid using these whenever possible and use the adjustments from the Layers palette instead.

All the adjustments that come from this menu are what I call *embedded adjustments*. The adjustment is applied to whatever layer is currently active. These adjustments are certainly very potent, but every time you apply them you can permanently alter the information of the image. For example, once a change is made, old information is eliminated and new information added. If you should save the document and then reopen it, there is no recovery but to start over. Some would argue that Photoshop does have the History feature,

which records all the steps you have preformed on a file, and you can scroll back in time to eliminate the adjustments, but you can only do so as long as the file remains open. Using an adjustment layer has the advantage that you can come back at any time and make changes, even after the file has been closed and reopened.

It's a good idea to take advantage of "flexibility" when it's offered, and to use the potential of the application to your advantage.

To make adjustments to a portion of your image, select that section in Photoshop. If you make no selection using the adjustment layer, it will be applied to the entire image. This is the difference between local and global adjustments.

Adjustment layers are accessed from two places within Photoshop (**FIGURE 14.2**).

- The Layers menu.
- The Layers palette (click on the adjustment layer icon, which looks a like a yin-yang symbol).

FIGURE 14.2 Accessing the adjustment layers from the either the menu or Layers palette icon.

I prefer to use the yin-yang icon as the most convenient access. By clicking the yin-yang, you eliminate the step of passing through the New Adjustment Layer dialog every time you use the tool from the Layers menu. Because adjustment layers also contain a masking component, they can utilize a selection- or brush-based element for fine-tuning image corrections.

Creating Selection-Based Adjustment Layers

To illustrate I use a photo of the Cactus Lodge Motel sign. I created adjustments based on selections. Photoshop has a variety of selection tools to choose from, and these are easy to use in cases where the edges are well defined (such as architectural features, sharp horizon lines, and graphic elements). The objective here is to highlight areas of the sign to illustrate some basic selection concepts and adjustments.

When using masking features, selections do *not* need to be perfect. The mask modification with the paint brush will take care of any imperfections. So please be loose, and don't become overly burdened by getting the selection exactly right. Just loosely isolate the area(s) you want to change. Don't use the feather adjustments from the Select menu to try and finesses the selection. It's just not required, because the mask is what you will learn to manage.

I'm going to use the simple polygonal lasso selection tool to isolate the angular sign elements for adjustment (**FIGURE 14.3**). This is a simple tool in which you click on points in the image to anchor the selection. It's like having gum struck on your shoe after you click on the first point to anchor the selection.

FIGURE 14.3 Enable the polygonal lasso from the toolbar by selecting it from the fly-out drawer.

Clicking at each of the four corners and ending at the same starting point will quickly grab the rectangle-shaped sign. If you make a mistake and you anchor the point in the wrong spot, press Delete to loosen the anchor and click on a new point to anchor in the correct spot. If you need to go back further then one anchor, pressing the Delete key again and again to take away anchor points (**FIGURE 14.4**).

FIGURE 14.4 The polygonal lasso uses anchor points to make the selection. It's great for straight-line selections.

The selection tools in Photoshop are always improving, and it's now quite easy to make loose selections that can be improved using a few simple techniques in the masking process. The new quick selection, the magic wand,

and the lasso tool are extremely easy to get the gist of. In my example of the motel sign, the polygonal lasso and a magic wand were the only tools used in selecting the sign components. The magic wand is useful when selecting areas of similar color or tone value. When you click the wand in an area, it selects (by searching out) similar colors as part of the selection. In the motel sign example, the blue cactus element is an easy magic wand selection. When you finish creating the selection, the marching ants appear indicating that it is currently active. You use the selection as a way to create the adjustment layer mask (**FIGURE 14.5**).

FIGURE 14.5 Once the selection from the magic wand is active, marching ants will appear. The adjustment layer will use the selection to create the mask.

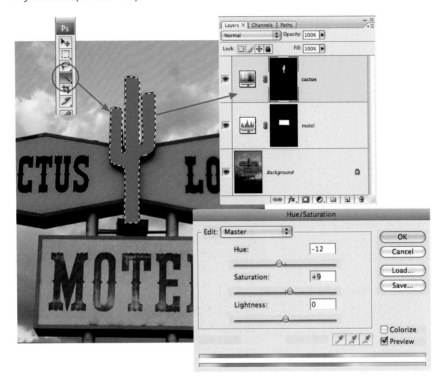

Click the layer adjustment yin-yang and select hue saturation. This automatically creates the masked area from the selection in the adjustment layer. Adjust the hue control slider in the dialog by moving it to the left to make the cactus element within the sign a more pronounced shade of blue. Say OK to the Hue/Saturation dialog and observe the layer palette. If you click the adjustment layer eyeball, it turns the hue saturation adjustment off. Click again to re-enable the adjustment.

After clicking OK in the adjustment dialog the new adjustment layer will appear in the Layers palette above the background layer. The adjustment layer has a layer visibility eyeball in the first column that can be toggled on

or off by clicking directly on the eye icon. Next to the eyeball icon are two additional thumbnails: the layer adjustment thumbnail (levels, curves, photo filter etc) and next, the layer mask thumbnail. The adjustment layer orientation within the layer stack is important to understand. The adjustment layer only affects all layers below the adjustment. If an adjustment is positioned between two layers, it affects only the one below it and has no influence on the one above it. If you care to remove the adjustment layer, drag and drop it on the trash can icon at the foot of the Layers palette.

Review the before and after images of the Motel sign in **FIGURE 14.6** to see how the basic selections were used to create the masking for the individual adjustment layers, and I hope you will see that I have left the lights on for you.

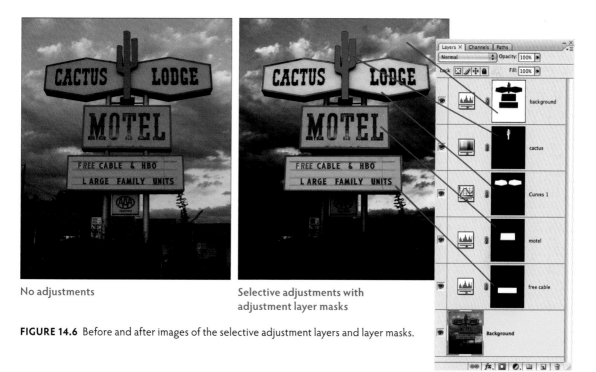

No adjustments

Selective adjustments with adjustment layer masks

FIGURE 14.6 Before and after images of the selective adjustment layers and layer masks.

Brush-Based Adjustment Layers

Because the adjustment layer is in combination with a layer mask, you have some flexibility in that you can locally "erase" away the adjustment in the image. Do so by using the brush tool to paint with black in the adjustment layer mask. By painting in varying brush opacities (in other words, shades of gray), you lower the effect of the adjustment specific to where gray is applied to the mask.

Masking and Brush Tips in Photoshop

Access the brush tool from the Photoshop Tool bar or press B on the keyboard. To paint on the layer mask, just click on the adjustment layer mask and paint with the brush; as you lay down your brush strokes, the paint will fill in the layer mask. Black paint hides the effect of the adjustment; white paint reveals it; gray is a percentage of the mask density. By changing the brush opacity percentage in the brush options bar at the top of the Photoshop interface, you can achieve precise control over the amount of adjustment opacity in specific areas. Darker grays will reduce and lighter gray values will increase the adjustment.

To see the mask without the image information, hold down the Option (Mac) / Alt (Windows) key and click the adjustment layer mask; repeat to hide the mask. Having the ability to see the mask enables you to make touch-up adjustments with the paintbrush tools. To disable the mask completely, Shift-click the mask, and an X will appear across it; repeating the operation enables the mask again.

Brush Size
While the brush is active on the toolbar, place the mouse pointer in the image area and use the [(left bracket) to decrease and the] (right bracket) to increase brush size.

Hardness
While the brush is active on the toolbar, use Shift + [to increase softness, and Shift +] to increase hardness in 25 percent increments.

Paint a Straight Line
Hold down Shift for a constrained line (vertical, horizontal, or 45 degrees).

Paint or Vector between Points
Click once at one point, hold down Shift, and click again at another point to paint a straight line between the two points

Brush Opacity
Use the number pad to set opacity: 2 = 20 percent, 66 = 66 percent.

Press the X key to switch between painting with foreground and background colors (black and white).

Brush Reset
Right-click the brush icon in the Options bar and choose Reset from the pop-up menu.

When using brush-based adjustment layers, my approach has me making the adjustment without a selection. From the yin-yang I select an adjustment, focusing my attention only on the area I want to change, and make the correction. I then apply the adjustment by clicking OK in the Adjustment dialog. At this point the adjustment (levels, curves, hue saturation, and so on) globally affects the image because there is no masking (black or gray) applied.

My immediate next step is concealing the adjustment with black by inverting the current state (white) of the layer mask. First, highlight the adjustment layer and then invert the white mask to black by pressing Command + I (Mac) / Control + I (Windows). Then use an appropriately sized brush to paint with white or gray to apply the correction locally to the image.

This approach lets me make the adjustment with my attention only focused on the area ultimately to be corrected. Applying the adjustment and immediately inverting the adjustment layer mask to black hides the adjustment and allows me to paint in the adjustment with white or values of gray to apply the correction. The built-in flexibility of the adjustment layer also lets me revisit the adjustment to increase or reduce the effect or change the opacity of the brush to a low percentage value and build up the adjustment with successive paint strokes. When using small percentages of brush opacity, each time a stroke is applied it becomes an additive process of applying the adjustment at a percentage density within the mask.

Let's look at a practical example where this technique comes in handy. In the image of the Great Sand Dunes, I explore paint-based adjustment layers. The original exposure looks a bit flat and dark, and the dunes have a blue magenta colorcast (**FIGURE 14.7**). So let's set the magic in motion and access the curves adjustment layer to first adjust the blue sky. As I create the modified S curve adjustment for the sky, the sand dunes turn bluer and pinker. My only focus at this point is the contrast and color of the sky.

The curves adjustment layer is applied globally first, but the sky is the emphasis of the adjustment.

Maintaining the position of the black and white pins (triangles, one in each corner) in the curve prevents the highlights within the image from becoming blown out or the shadows from becoming blocked up.

Now I need to change the adjustment layer white mask to black so that I can hide the adjustment (black) from the underlying image. Command + I (Mac) / Control + I (Windows) inverts the white mask to black.

Next select the Brush (B) from the toolbar. Increase its size and reduce its hardness. (Check out the sidebar, "Masking and Brush Tips in Photoshop.")

FIGURE 14.7 The original image before the correction for the low level of ambient light.

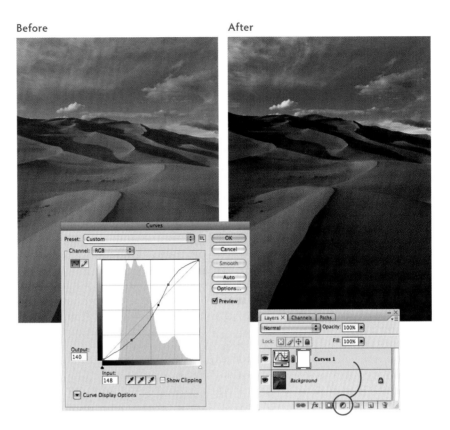

Larger, softer brushes allow for smooth transitions when painting on the image. The soft edge of the brush enables smooth transitions as I paint in the local adjustment to the clouds (**FIGURE 14.8**).

You may want to isolate separate adjustment layers and utilize the opposite, or inverse, of a mask as selection when adjusting the foreground versus the background. The use of multiple adjustment layers enables complete flexibility in fine-tuning your images. When working with the layer mask feature, if you want to create a selection from the mask you just made, or any other one for that matter, hold down Command (Mac) or Control (Windows) and click directly on the mask; the white information on the mask will immediately turn into the marching ants.

Next, to inverse the selection use Command (Mac) / Control (Windows) + Shift + I. Or use the menu Select > Load selection (**FIGURE 14.9**). The Load Selection dialog lets you select a mask to load and invert it by checking the appropriate box. Now access the Photo Filter adjustment layer to effectively adjust the sand without influencing the sky.

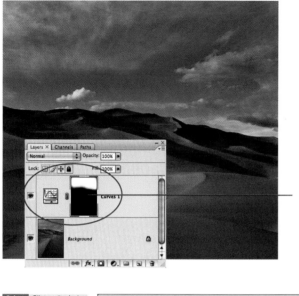

FIGURE 14.8 Inverting the adjustment layer mask from white to black. After inverting, painting with a white soft brush reveals the adjustment locally to the sky.

White is revealing the local adjustment within the mask

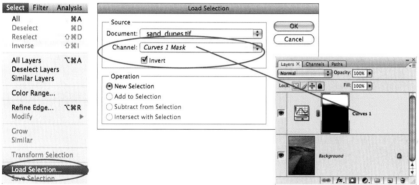

FIGURE 14.9 Using the menu option Select > Load Selection presents a dialog for selecting the curves mask and inverting the selection at the same time.

Don't limit yourself to a single adjustment layer. You can have as many as you like; each one will stack on top of the next when making consecutive edits (**FIGURE 14.10**). This can be helpful when you fancy one curve adjustment to correct the image globally and then use another adjustment to locally correct a selected area within the image. Remember, complete flexibility is what adjustment layers are about. There are no commitment issues until you flatten the image. But if that still remains a problem, just duplicate the file and flatten the copy.

TIP

A sure sign that you have mastered your way around the Layers pallete is when you use keyboard shortcuts for navigating the layer stack. Combine the bracket keys ([or]) with Option/Alt to select the layer above or below; Use Command/Control to move your selected layer up and down.

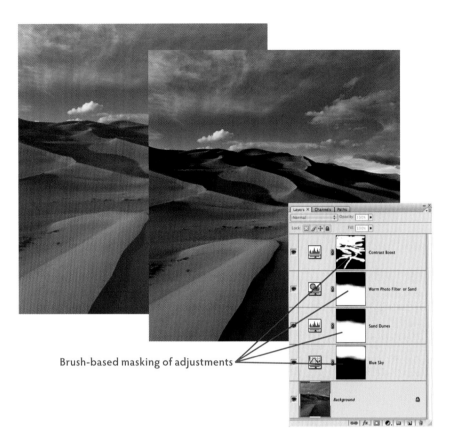

FIGURE 14.10 Multiple adjustment layers with locally masked corrections can significantly improve your workflow and the way you work intuitively with Photoshop.

Brush-based masking of adjustments

Fine-Tuning Your Mask Adjustments

Yes, I gave you permission to be sloppy and loose in making selections and painting in your local corrections. I will explain now some often overlooked, fundamental approaches to feathering the transition edge and expanding and contracting your masking (selections). You can work directly on the mask by holding down Option (Mac) / Alt (Windows) and clicking the mask thumbnail. This brings up to full view the mask on the screen. Eliminate any problem areas of the mask with a touch-up brush (white to reveal or black to hide a specific area). To return to the image view, repeat the same keystroke and click on the mask.

If you have created a mask that looks too sharp, and your adjustments take on the look of a cut-and-paste correction, that can easily be fixed by blurring the edge. Select the adjustment layer and click Filter > Blur > Gaussian Blur. Pick a low value for Radius to blur the edge (**FIGURE 14.11**). Zoom the image to 100 percent while you blur the edge to see the change in real time. Remember, you are blurring the mask layer, not the image layer. Slightly blurring the edge can in most cases help with the transition zone edge transfer.

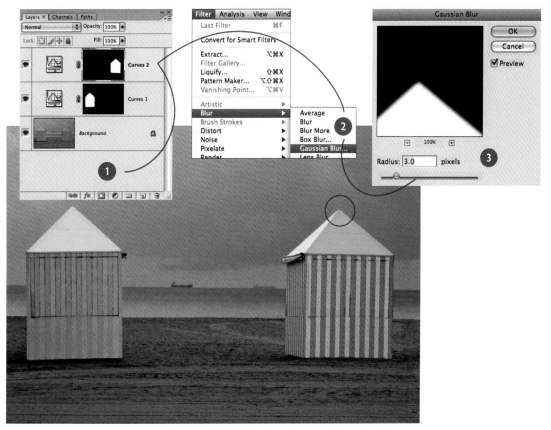

FIGURE 14.11 To feather the edge of the mask: Highlight the adjustment layer (1), click Filter > Gaussian blur (2), and set a small radius for the Gaussian blur (3).

To expand or contract the edge of your mask (selection), zoom to 100 percent, blur the adjustment layer mask ever so slightly with the Filter > Blur > Gaussian Blur. Then Press Command (Mac) / Control (Windows) + L to bring up the Levels dialog with a Histogram of the mask. Move the middle, midtone control slider to the left to expand the edge of the mask, and to the right to contract it. An important point: By using the keyboard shortcut for the Levels adjustment does not bring up an adjustment layer, but rather an "embedded adjustment," targeting only the mask content, not the image. This technique of using the levels middle control slider to expand or contract the edge of the mask will gently control the edge transition within the mask.

CHAPTER FIFTEEN

Multiple Raw
Image Processing

Because of the limitations of single frame capture when shooting
JPEGs and Tiffs, you may find yourself disappointed when try-
ing to capture the full range of tones available within the scene
photographed. Remember: more depth of information is sup-
ported by the Raw file format.

Taking advantage of the processing power of High Dynamic Range (HDR) has limitations as well (see Chapter 13 for more). HDR limitations are frequently encountered when you are capturing scenes that have motion or when you lack a stable tripod to bracket the exposure effectively. HDR is great for architecture, interior/exterior views, and still lifes with broad ranges in contrast and tone. Placing multiple images together using Photoshop's Layer Align feature is also great, but if the wind is blowing and leaves are shaking in the trees you will soon realize the futility of using that process in those situations.

Here I look to take advantage of the Raw file format with its depth of data when processed at high bit. Before I embark on expanded Raw development processing, I encourage you pay special attention to exposing properly for the digital frame in the first place and monitoring your Histogram for optimized exposure. Poorly exposed images will not benefit much from this expanded processing technique. You may be able to salvage an operator error exposure problem, but do not expect a high-quality image from extreme under- and overexposed captures.

You can simply process the same file once for specific highlight detail, ignoring the shadows, and then process it again for the shadow information. A third and forth processing of the same file can enhance midtones, clarity, and color saturation, detailing specific image areas that will benefit from image composite masking. This is conceptually the same as the image compositing I explored earlier (Chapter 13) when replacing the sky in the Chaco wall image, except this time I process it differently for the composite masking.

Raw and the Paint with Light Process

When multi-processing a Raw image file, take advantage of the best interpretation of a scene's tonal range and color. Let's walk through the process of working with this "paint with light" process. Developing the file requires using either the Lightroom Develop Module and exporting the images processed to Photoshop for the image composite masking process, or using Photoshop to open the file and processing the image in Adobe Camera Raw on the front end before working with the image in Photoshop. Either way, you are using the ACR processing engine to develop the image file again and again for specific detail, whichever program you're in.

This part of the book is about using Photoshop, so I will open the file directly from the application. Note that using Photoshop to navigate to and open the file will require you to ultimately re-import the file into Lightroom, because you bypass the round-tripping process by using Photoshop exclusively.

Many types of single Raw exposures can gain from this multi-processing-of-a-single-image technique. When images are processed for highlight information and then again for shadow information, combining the two images in Photoshop can certainly expand the range of values available. Images can be overprocessed as well for specific adjustments, such as color to introduce a low- or high-intensity change to be added with selective masking.

As an example, I will work with the image I photographed on an overcast and rainy fall day in the Tuscany wine region. I can smell the rain and the freshness of the air, but I would like to process this image to bring out more detail, color in the clouds, and a bit more contrast as I remember it.

In Photoshop, open a Raw file that can be enhanced with an expanded tone range correction. The Adobe Camera Raw dialog box appears, which has all the same features and adjustments for exposure and color that you have used in Lightroom.

Process the first image for highlight detail. Move the exposure control slider down to −0.50 or lower depending on the image information. Minus 0.50 represents a reduction of the overall exposure down about a half-stop (**FIGURE 15.1**). Watch the highlight detail and make sure the highlights don't become too dark. After this adjustment, click Open to process the adjustment into Photoshop. Leave the file open and proceed to the next processing stage.

FIGURE 15.1 The processing for the highlight detail in this illustrated example has the exposure slider moved to −0.50.

Highlight detail processing

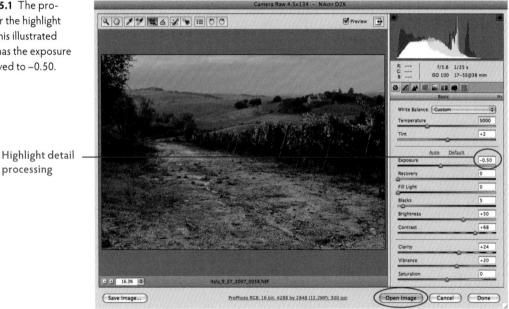

Return to the same original Raw file and open the image up again and process the image for shadow detail. When the ACR dialog box appears, use the exposure control slider to open up the shadow information. In this case, I turned up the exposure value to +0.75 to achieve the brighter effect. Ignore the fact that the highlight information will blow out. The objective is to brighten up the image overall to provide more shadow detail. Click Open to move this image into Photoshop (**FIGURE 15.2**).

FIGURE 15.2 By reprocessing this Raw file for shadow detail, it becomes the lighter image.

Shadow detail processing

Now bring the two processed images together into one file. Because they are processed to the same resolution, they are identical files and can be stacked in layers within Photoshop. *Pin registration* is the traditional term used to describe the exact match of both of these images.

Create a composite layered image. Use the title bar to drag and arrange the images in the workspace so you can see both together. Press V to enable the move tool and hold down Shift key as you drag one image on top of the other (**FIGURE 15.3**). There is no rule about which file should reside on top or bottom. Normally I drag the image requiring the least amount of change to the top, so in this instance I dragged the dark image on top of the lighter one. Dragging and dropping results in a stacked layers file with the dark image on top of the lighter image.

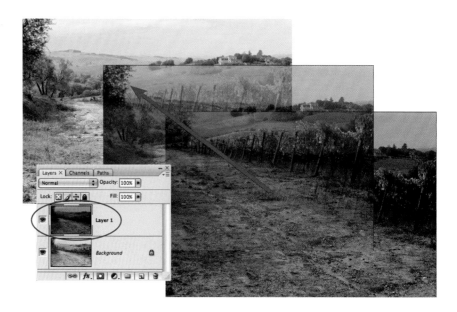

FIGURE 15.3 The images can be easily assembled into one document by dragging and dropping one on top of the other with the move tool. Hold down Shift as you drag and drop to place the image in the exact center of the destination.

Highlight the destination layer for the mask by clicking on it. The simple way to add a layer mask is to click on the layer mask icon at the bottom of the Layers palette (the rectangle with a circle inside it). This generates a Reveal All (white) layer mask on the active layer (you can also click Layer > Layer Mask > Reveal All). At this point, all the image content of the top layer is showing because the layer mask is white (**FIGURE 15.4**). (Remember: White reveals, black conceals.) Now paint with a soft black brush to mask off the current layer to reveal the underlying brighter image detail.

FIGURE 15.4 When the layer mask icon at the bottom of the Layers palette is clicked, it creates a layer mask in the highlighted layer.

When painting with solid black you will create a 100 percent mask. Painting in your adjustments with a low-opacity brush (20 percent) enables you to build up the reveal slowly to evaluate the process as you paint. Different opacity brush strokes allow greater flexibility when enhancing the image (**FIGURE 15.5**). The masking here is not completely black but rather subtle shades of gray to reveal the lighter areas of the underlying image at different percentages of lightness. I like to think of this as painting with light at the end of my brush.

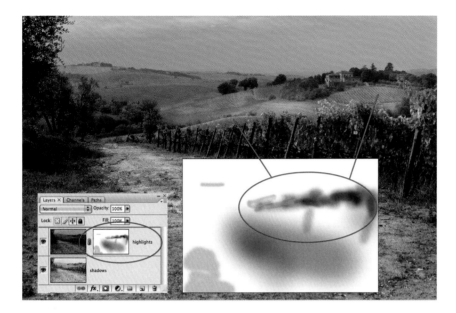

You can add another processed Raw image for a color boost adjustment using the same processing and drag and drop technique as before. The processed image from the same Raw image file was set to a different white balance. Tungsten white balance was used to add a bit of blue information to the sky and pump up some of the greens by adding a little blue with a low opacity brush (**FIGURE 15.6**).

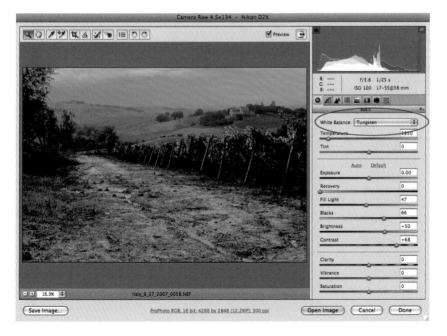

FIGURE 15.6 Reprocessing the Raw file, in this case for a tungsten white balance, provides just the right amount of blue to locally brush on to the image using low opacity brushes.

Combining all three different processings of the original Raw file helped modify the image for highlights, shadows, and color. This composite can then be flattened to allow the adjustments to be rendered into the document (**FIGURE 15.7**).

FIGURE 15.7 This is the final adjusted image using the technique for multi-processing the Raw image file. The layers show the masking required to produce the result.

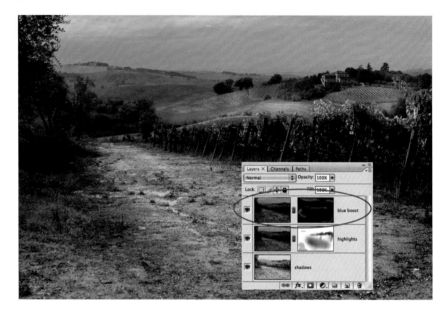

Okay. Now, one last look at the before and after result (**FIGURE 15.8**). The original image was very low in contrast and lacked color intensity and detail. By reprocessing it for the information I wanted to visually enhance, I was able to use layer masking to combine the best of the three different versions of the same Raw image. Note that you can't do this with a JPEG file because it lacks Raw's depth of data.

Raw and Smart Object Layers

A modification to this technique of multi-processing would be to process Raw files as Smart Object layers. With this variation to the processing, the layer image information can be modified in the ACR again and again and will dynamically update the current Photoshop Document (PSD) with any changes made. This is something to think about and experiment with to further expand the available tools for your photography. When Smart Objects are used and placed into a document, the reprocessing of the Raw file is always available for adjustment by clicking on the Smart Object icon in the high-lighted layer. Whereas in the step-by-step technique discussed earlier, the processing was once and only once to achieve the brighter, darker, or color effects. But the control was in the masking density differences.

FIGURE 15.8 The Image on the bottom is how I, in my mind's eye, remember the day in a Tuscan vineyard. The contrast and detail are improved, and the highlight areas now hold the image together.

Before

After

Layer Blend Mode Magic in Photoshop

In Photoshop's Layers palette, there are 25 blend modes to choose from in the pull-down menu, but when it comes to image editing in Photoshop, I would promote really only five of these for photographic images: Multiply, Screen, Overlay, Color, and Luminosity. These are the ones I use most in my day-to-day work. Develop a little background on how and when to use these, and they will become valued tools to make your editing more efficient.

By default, the Normal blend mode is active (**FIGURE 16.1**). Using blending does mean you need to have at least two layers in the stack to effectively intermingle the effects produced by the blending process.

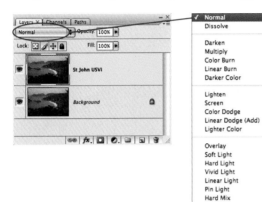

FIGURE 16.1 The blend modes accessed from the pull-down menu in the Layers palette have 25 possible choices.

Cycle through the list of 25 layer blend modes using the Shift plus (+) or Shift minus (-) keyboard shortcut when the move tool (V) is active. That will have you moving up and down the list to quickly view the effect of each blend. You will see that there are blends that darken the image and blends that lighten it, blends that both lighten and darken at the same time to boost contrast, and blends that affect either the color or luminosity values of an image.

The modes I have suggested for use are defined by Adobe's user guide as:

- **Multiply** looks at the color information in each channel and multiplies the base color by the blend color. The result color is always darker. I think of Multiply as placing two images of the same slide together, creating double the density.
- **Screen** looks at each channel's color information and multiplies the inverse of the blend and base colors. The result color is always lighter. I think of Screen as a giant spotlight that illuminates everything.
- **Overlay** multiplies or screens the colors, depending on the base color. The base color is not replaced, but mixed with the blend color to reflect the lightness or darkness of the original color. I like to think that Overlay is about boosting the colors and contrast.

- **Color** creates a result color with the luminance (brightness) of the base color and the hue and saturation of the blend color. This preserves the gray levels in the image and is useful for coloring monochrome images and for tinting color images. I think of Color as throwing a tint of a selected color over the image canvas, but this color protects the texture details and luminosity.

- **Luminosity** creates a result color with the hue and saturation of the base color and the luminance of the blend color. This mode creates the inverse effect of Color mode.

Multiply

Let's experiment with the first one: Multiply. The sky above the bay off the island of St. John in the before image below could be a bit more interesting, and the blue water could be a little darker.

TIP

All the blend modes within the Layers palette can also be controlled with the opacity control slider.

I click Layer > Duplicate, creating a new duplicate layer above the background image. Then I use the pull-down menu in the Layers palette to set the blend mode to Multiply. When the Multiply blend mode is applied, observe the increase in density overall. To control the effect of the Multiply blend you can turn down the Layers palette opacity slider or create a layer mask to locally mask off the areas, preventing the Multiply blend enhancement. Varying the percentage of opacity in the brush options controls reveals shades of gray within the mask (**FIGURE 16.2**).

FIGURE 16.2 Creating a duplicate layer and applying the Multiply blend mode along with a layer mask to locally control the increased density enhancement.

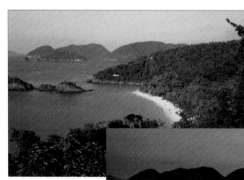

Before

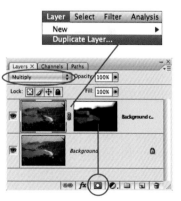

Multiply blend with a local correction layer mask

After

Screen

The next image (of Puye cliff dwellings) to blend has some pretty dark shadows (**FIGURE 16.3**). The Screen blend mode can lighten the information when blending two images together. I like to think of this as the "super dodge" tool for selectively increasing the shadow information when these dark pixels are isolated on a new layer to be blended. Click Select > Color Range to bring up a dialog, click Shadows in the pull-down menu, and click OK. This produces a marching ant selection of shadow information (dark pixels) within the image. Now wasn't that easy!

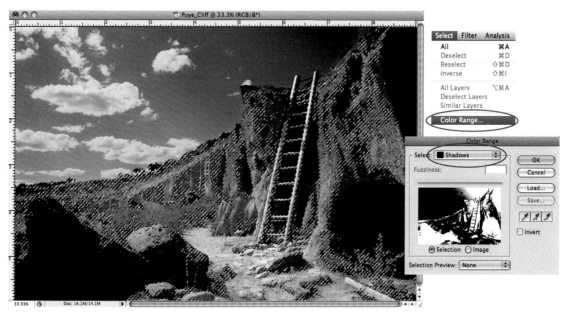

FIGURE 16.3 The color range selection is useful for targeting a specific range of color or tone to calculate the values selected. In this case the focus is the shadows.

Once Photoshop creates the shadow selection, I move the content of the selection up to a new layer and then use the Screen blend mode to lighten all the shadow pixels. With the selection active, click Layer > New > Layer Via Copy. This moves the content of the selection to a new layer (**FIGURE 16.4**).

Now that the shadow information is on a new layer, select Screen from the Layers Blend mode pull-down menu. The shadow areas will become extremely bright, so turn down the opacity slider to 10 or 15 percent to control shadow brightness. No layer masking is required, only blending of the selected content. You can select the eraser tool (by pressing E) from the Photoshop toolbar to eliminate any areas on layer one that do not need to be part of the Screen blend (**FIGURE 16.5**). Placing the eraser tool in the image area and dragging with the mouse button down erases pixels from layer one.

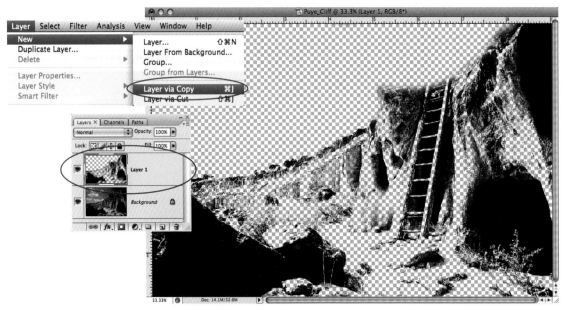

FIGURE 16.4 New > Layer Via Copy isolates only the shadow pixels on a new layer for blending with the Screen mode.

FIGURE 16.5 With the selection content for the shadow information isolated on Layer 1, the Screen blend mode is applied specifically to the shadow pixel information with opacity set to 15 percent.

Overlay

Moving on to the third blend mode Overlay. This blend mode applies both Multiply and Screen at the same time. With this blend effect, dark areas become darker and light areas become lighter. Anything on the layer that is 50 percent gray completely disappears from view. This blend boosts image contrast and the saturation of some colors. I'm not sure I completely understand how it produces the effect, but I like it! The best part is that you can control how much of the effect is applied to the blend with the layer opacity control slider.

In this case, I duplicate the layer just as I did earlier and apply the Overlay blend mode. Observe the before and after effect when applying this blending of the two identical images with the Overlay mode (**FIGURE 16.6**).

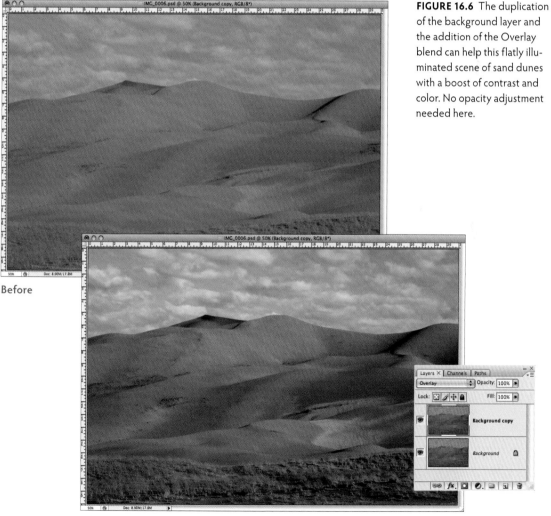

FIGURE 16.6 The duplication of the background layer and the addition of the Overlay blend can help this flatly illuminated scene of sand dunes with a boost of contrast and color. No opacity adjustment needed here.

Before

After

Color

I use the Color blend mode when I want to introduce a specific color in a layer blending process. I would encourage you to explore other adjustment layers that deal with color changes, like the photo filter or selective color or hue saturation, but Color is a very basic and fundamental blend that I use often to introduce color to an image. In the example image shown in **FIGURE 16.7**, the stonework photographed contains little color and is a candidate for some infusion of color to produce a warmer rendering of the scene.

First use the color picker to pick a color for your image. In this case, I would like to introduce a warm tone brown. Your selected color will appear as the foreground color in the color picker (**FIGURE 16.8**).

FIGURE 16.7 The image of the Chaco doors is almost monochromatic and has a cold feel to it.

FIGURE 16.8 Double-click the foreground color in the Toolbar to launch the Color Picker dialog. To select a color, click on it in the color range.

Creating a new empty layer allows the color to fill the background layer above the image (**FIGURE 16.9**).

Now click Edit > Fill and choose the foreground color in the dialog. The layer will fill completely with the foreground color and block out the underlying layer until the blend mode is changed to Color. Control the amount of color within the image by using the layer opacity control slider (**FIGURE 16.10**).

FIGURE 16.9 Create a new empty layer as a destination for the color by clicking on the new layer icon in the Layers palette.

FIGURE 16.10 Filling the layer with the selected color and using the Color blend mode adds the selected color to the image, preserving its texture and luminosity.

Luminosity

Last but not least is the Luminosity blend mode. This mode creates the inverse effect of the Color mode. There will be times when you need to create an adjustment layer with curves to introduce more contrast but also need to avoid changing the image color. This extreme color example of blurry colors illustrates the adjustment curve applied for the contrast increase. The contrast increase moves the colors to different hues and saturations. The **FIGURE 16.11** illustrates the Luminosity blending mode applied.

FIGURE 16.11 When the layer blend of Luminosity is enabled, the colors are not effected by contrast adjustment of the image.

Contrast curve adjustment

Contrast curve adjustment plus Luminosity blend mode

Photographic Effects with Photoshop

Photoshop allows you to emulate classic photographic effects without investing in camera attachments such as filters and soft focus lenses. Selective focus, for example, is a time-honored way of directing the viewer's attention. I'm a real devotee of controlling the area of focus, and I'm also of the opinion that focus is overrated. Not everything needs to be tack sharp to create interest for the viewer.

Photoshop has a powerful set of blurring filters: average blur, blur more, box blur, Gaussian blur, lens blur, motion blur, radial blur, shape blur, smart blur, and surface blur. My eyes are getting blurry just thinking about all the possibilities. My primary blur filters are Gaussian blur, for modifying and feathering my layer masking selections, and lens blur for creating selective focus and simulating shallow depth of field.

Yes it's true: Most Photoshop users immediately jump to the Gaussian blur filter as the default approach to blurring image areas. Although Gaussian blur is a great filter with many uses, it doesn't offer much in terms of control, other than the radius control slider and using layer masking to manage how selective it can be. Photoshop's lens blur filter, on the other hand, offers more control over the blurring. When you use it with an easy-to-create depth map, as you will see, you can specify how much blurring is applied to different areas of the image, giving you creative control over which areas are in focus and which are not.

There are plenty of options to work with when applying the lens blur filter, and I'm not going to bore you with exploring every one. I want you to focus, so to speak, on developing an understanding of a few features that will help bring out the best in your photography. You can use lens blur with a variety of images to bring attention to select areas of the image by fine-tuning the focus. On the downside, lens blur does not work as a Smart Filter, so I suggest working on a copy of the file or a duplicate layer.

Selective Focus with Lens Blur

The image of the rodeo rider in **FIGURE 17.1** has poor contrast, and the background is a bit distracting. The depth of field is a little too deep; the people in the stands are competing with subject.

The object here is to select the rider for an image enhancement adjustment and use the inverse of this selection to apply lens blur. To separate the rider from the background, I make a selection of the rider using the quick selection tool (see Chapter 13 for more on that tool). I save this selection within the Photoshop document as a Channel and title it rider_select (**FIGURE 17.2**). Saving the selection as a channel in Photoshop allows me to use or refine the selection at any time without having to rebuild it again.

FIGURE 17.1 This image could benefit from improved contrast and selective focus to eliminate the distracting background.

FIGURE 17.2 Select > Save Selection to name the new Channel (selection).

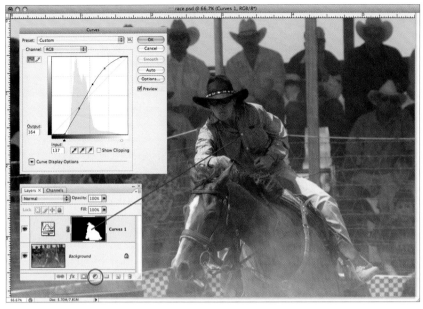

FIGURE 17.3 The curve adjustment layer uses the selection to apply the contrast correction to the selected area within the image.

I create a curves adjustment layer to modify the rider's contrast, separating out the subject of the image from the background. Photoshop uses the selection to create the mask to localize the adjustment (**FIGURE 17.3**).

Now I apply the blur to the image background with the lens blur filter. Clicking Filter > Blur > Lens Blur brings up Photoshop's rather colossal Lens Blur dialog box, with a large preview area for the image on the left and a variety of controls on the right (**FIGURE 17.4**). Feel free to experiment with these on your own images, but I think you only really need to know a few of them. In the Depth Map segment, I choose select_rider as the Source. This retrieves the saved selection from the Channels palette. I check the Invert box to allow the blur to happen on the background instead of in the saved selected area I made earlier. Turn up the radius in the Iris segment to control the amount of blur. Without the depth map source selection, there is no way to control local blur from this dialog. When None is selected under the Depth Map Source, the blur is applied throughout the image.

As you can see, increasing the contrast for the rider and blurring the background to better isolate the subject in the frame improves this image. The sense of place is preserved with the blurred cowboy hats complementing the background (**FIGURE 17.5**).

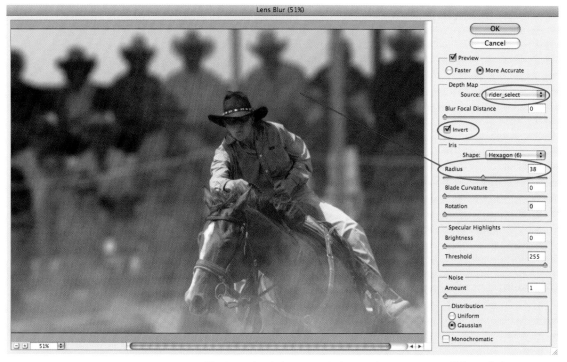

FIGURE 17.4 The Lens Blur dialog controls the Depth Map amount of blur with the image. Radius controls the amount of blur (increases as the number increases).

FIGURE 17.5 Compare the before and after images with the local contrast adjustment and the lens blur applied to the image background.

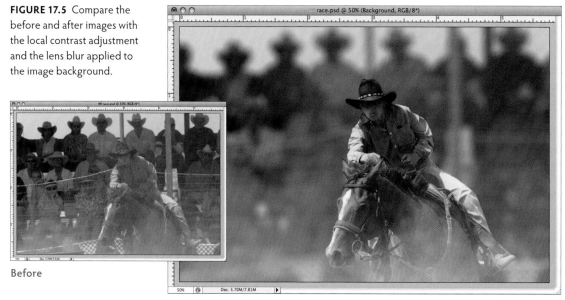

Before

After

Diffusion Effects

Photoshop can emulate many diffusion and soft focus effects that require the use of camera filters or special lenses. In my opinion, it's better to shoot the subject with correct exposure in well-balanced light and *then* apply the effect you want in Photoshop. This method eliminates the weight of extra gear and the preplanning required to attach the filter to a lens or switch a lens for a desired effect.

Photoshop's Filter menu has bucketloads of filters to choose from. I would suggest that you camp out in front of the computer and spend a whole weekend sometime, looking at all the choices on some low-resolution JPEGs (but I'm weird that way). The low-resolution JPEG images allow you to quickly view the results of the filter effects without having to watch the clock spin. Many of these filters are huge number-crunching monsters and can take quite some time to rearrange the pixels. So give yourself the gift of time and experiment to get a feel for all the potential possibilities, from lens flare to lighting effects, that are available from this application.

I have a special technique I use when I want to diffuse the high midtones and highlights, called the luminosity selection. When you see the results you may start to feel your brain synapses firing in all directions as you think of other applications for it.

Open any image to add some highlight diffusion. Wedding photographers are drawn to this because the highlights of the white dress can really accentuate the effect. In this example I use a photo of rodeo horses. Navigate to the Channels palette and press Command (Mac) / Control (Windows) as you click on the RGB layer. There you have it: an automatic luminosity selection! I have not seen this one in user manuals (**FIGURE 17.6**).

You can also explore third-party plug-ins and actions that automate a particular style or effect that you're looking for. These cost extra and can easily be found by typing **Photoshop effects** into your favorite Internet search engine.

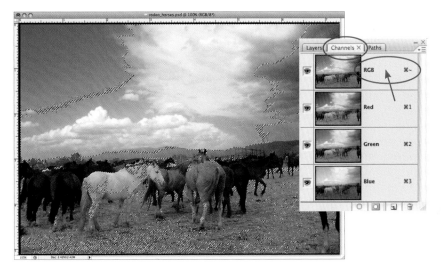

FIGURE 17.6 Click the Channels tab and press Command/Control + J. Click the RGB layer to activate the very handy luminosity selection.

FIGURE 17.7 The new layer created with the content of the luminosity selection. Note the transparency areas have a checkerboard pattern.

The luminosity selection identifies the light-colored pixels throughout the image. If you look at the content of the selection via the Levels dialog, you will find the luminosity selection is normally the pixel information starting from just left of the midtone slider to the highlights. A variety of image adjustments can be made specific to these pixels, or to the inverse (dark pixels). If used for image adjustment layer masking, this technique creates a wonderfully smooth selection mask. If you want to use the inverse of the selection (dark pixels), click Select > Inverse, and voila! The inverse of luminosity. Now with the luminosity selection active (surrounded by marching ants), I move the content of the selection up to a new layer with the New Layer via Copy keyboard shortcut of Command + J (Mac) or Control + J (Windows). You might remember this one as "jumping" the selection content to a new layer (**FIGURE 17.7**).

Now that the selection content is isolated on a new layer, I fill the layer with white. Click Edit > Fill and select white from the pull-down menu. Make sure the Preserve Transparency checkbox is selected. The result is that all the luminosity information is now white, and the image takes on a very high key appearance. *High key* can be defined as producing tones that are predominately light in value, with few or no dark or black values (**FIGURE 17.8**).

FIGURE 17.8 The Luminosity selection content is moved to a new layer, and the layer is filled with white while preserving the transparent areas.

Now click Filter > Blur > Gaussian Blur. In the Gaussian Blur dialog, push the radius control slider to modify the diffusion effect. Depending on the resolution of the image file, the control slider for the blur may require an increase or decrease of the radius values to adjust the effect visually. The layer opacity control slider may also provide some control of the effect as well (**FIGURE 17.9**). Go ahead and experiment with effects that can be produced with the luminosity selection. Filling the selection with another color after isolating it on another layer can provide some unexpected results. Develop your own approach to using the selection with adjustment layers and composite layer masking. I think just this little selection nugget alone can change the way you use Photoshop in your workflow.

FIGURE 17.9 The diffused effect can be controlled by the radius control slider as well the layer opacity percentage.

Black and White
in Photoshop

Recent years have seen a return to the popularity of black and white photography as digital capture has evolved. Many find a strong monochromatic image more dynamic, intriguing, and compelling than anything created with color.

Back in the days of black and white film, I used lens filters to control the gray-scale capture process. A red filter would darken a blue sky in varying degrees based on the filter's intensity and density. Photoshop's Channels palette, which lets you view color images as grayscale separations, strongly emulates such filter effects (**FIGURE 18.1**).

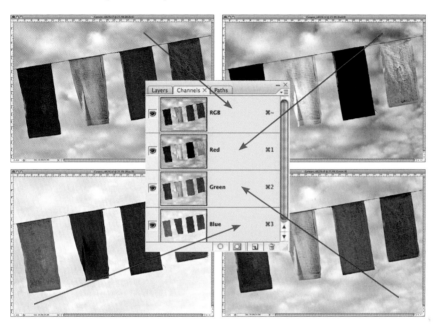

FIGURE 18.1 The different grayscale separations for the red, green, and blue information. Note how the colors are represented differently in grayscale.

The Channels palette is a powerful way to view these separations, because you can observe the tonal differences based on the color-to-grayscale conversion. Noise levels in each color channel can be quite different, for example, with the blue and green channels having the most and lease noise, respectively. The separations can provide a way to mix and match the channels for different interpretations of color as grayscale. This isn't the only way to produce black and white images in Photoshop, either. I must have come across at least ten variations over the years; it has become an evolving process as the tools have become better and better.

Seeing in Black and White

Seeing in black and white is radically different then seeing in color. It's all about tone and contrast and visually anchoring the blackest and whitest points in detail within the image. When you decide to experiment and convert your images to black and white, Photoshop provides loads of flexibility so your vision can become a reality. The difference in today's process is that

capturing the image originally in color has become an important part of the conversion process. Beginning with color information provides more options when it comes time to create the black and white image. In FIGURE 18.1 you saw the grayscale separations in the Channels palette. These can be individually copied and pasted into a layered document, and with the use of layer masking techniques specific areas can be targeted to favor one interpretation of the grayscale versus another. Another method can be used to mix the percentages of the grayscale interpretations or separations to develop the black and white. Another method employs two adjustment layers with one to take the saturation completely out of the image and a second one to radically change the hue and saturation of the colors that passed through the desaturation adjustment layer filter. This concept can provide some insight into the methods and techniques employed to create the black and white image.

Black and White Adjustment Layer Conversion

Some of the methods I've mentioned require mental gymnastics to implement. Photoshop CS3 has a new, easy-to-use Black and White adjustment layer for converting from color. The advantage to using this method of conversion is that it is a great way to visually manipulate the underlying color information and grayscale form dynamically. I could show you five or six different approaches to get the same result, but why not do it the easy way?

To simplify the process, break down the conversion to four components:

- Convert color to black and white with the adjustment layer.
- Control the image contrast with an adjustment layer curve.
- Fine-tune locally with layer blending.
- Introduce a color tone preference.

The Black and White adjustment layer is available from the Layers palette (**FIGURE 18.2**). This dialog is divided into three areas of control. The default presets provided by Adobe are in a pull-down menu at the top. These presets can provide direct conversion options based on the stored preset values or can act merely as starting points for your conversion process. You can also create and save custom presets for this adjustment, and your saved settings will populate the preset list as you develop different approaches to the process. The second area helps to modify the individual color hues for reds, yellows, greens, cyans, blues, and magentas selectively with range control sliders. The range control sliders can be moved in positive or negative percentages with limits of –200 percent (dark) to +300 percent (light). Finally, there is the Tint control checkbox for introducing color globally with hue and saturation control sliders.

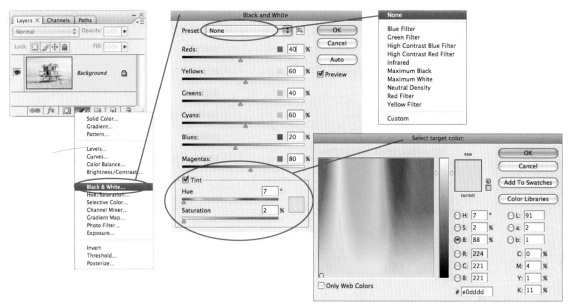

FIGURE 18.2 The Black and White adjustment layer dialog contains three areas for the conversion: Preset, individual color hue sliders, and the Tint controls for hue and saturation.

For this example, I use a colorful South Beach, Florida lifeguard station. The image has some dominant colors to help you visually grasp the process of converting this image to black and white using the adjustment layer (**FIGURE 18.3**).

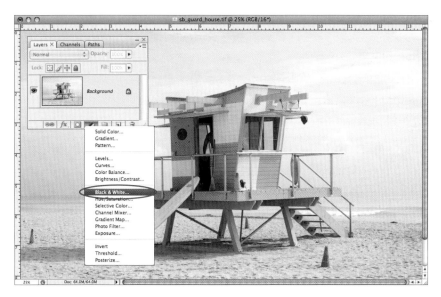

FIGURE 18.3 Access the Black and White adjustment layer from the Layers palette. This image has some colorful areas to illustrate the workings of the Black and White adjustment layer.

Access the Black and White adjustment layer from the yin-yang in the layer palette. When the dialog is presented, the image will appear in black and white, and the settings can be adjusted to develop its look and feel. A couple things to watch out for:

- Do not push the control sliders so far that you introduce posterization and noise to the continuous tone image. Experiment with pushing the control slider aggressively to the left or right to visually observe when the image starts to degrade then back off on the adjustment.

- Watch for clipping of the black or white points. Shadow and highlight clipping will occur when you push the adjustments too far and start to loose detail within these areas.

In **FIGURE 18.4** I split the black and white adjustment in half to illustrate the effects of the control sliders. The adjustments were pushed darker to accentuate the clouds and ocean (blues and cyans), and the reds, yellows, and greens were adjusted to provide a pleasing tone for the lifeguard station building.

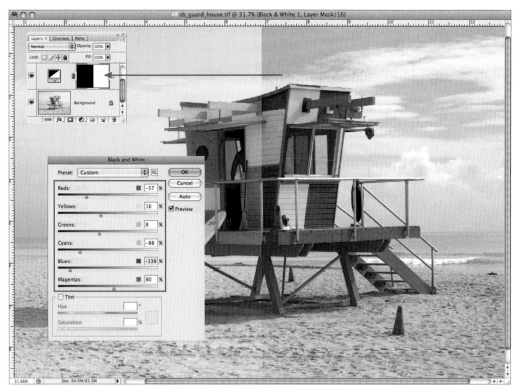

FIGURE 18.4 The split-screen comparison shows the use of an adjustment layer mask selection for one side of the image. Make the selection, access the black and white adjustment layer from the Layers palette, and apply adjustments with the color sliders.

The Black and White dialog controls are quite sophisticated and provide targeted control over which color you are adjusting within the image. The mouse pointer changes to an eyedropper as you position it over the image. Click and hold the mouse button down on an image area and the eyedropper turns to a double arrow with a pointed finger (**FIGURE 18.5**), highlighting the color chip for the predominant color at that location. Click and drag to the right or left within the image area and the color slider for the area targeted in the image will become a darker or lighter gray. This is a fantastic feature! It removes the need to worry about identifying which of the six color controls need to be adjusted to create the new gray tone value. Even someone with color blindness could potentially make some very nice black and white images from color captures using this method.

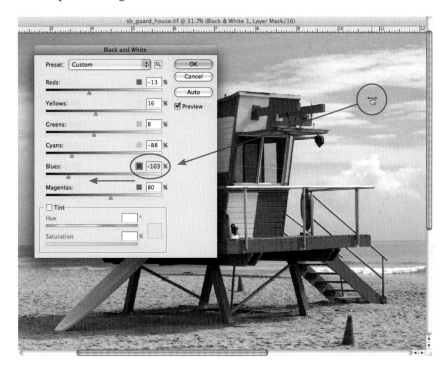

FIGURE 18.5 By targeting an area in the image with the mouse pointer, you can click and drag to change the grayscale value to be darker or lighter.

Now the contrast correction can be applied with an adjustment layer curve (**FIGURE 18.6**). Create a curve that will show a definitive difference between the highlights and shadows without clipping the extreme values.

FIGURE 18.6 Craft the adjustment layer curve so that the curve has a gentle slope to define the value differences and create a pleasing contrast.

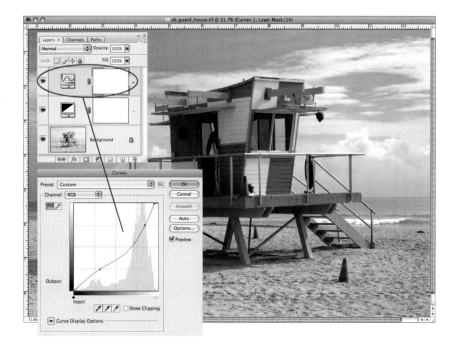

Now for some selective burning and dodging (lightening and darkening), using a special technique to enhance the gray values locally. Create a new empty layer on top of the layer stack and set the Blend mode to Soft Light. Click Edit > Fill and in the dialog set the fill at 50% Gray (**FIGURE 18.7**).

FIGURE 18.7 1) Create a new empty layer by clicking the icon next to the trash can. 2) Set the blend mode for the new layer to Soft Light. 3) Click Edit > Fill. 4) Set the content fill to 50% Gray.

Now the dodge and burn layer is set up for painting. Choose a brush from the toolbar and create an appropriately sized soft-edged brush for the area you want to work in. Set brush opacity to a low value (15 percent) and paint with black or white in the Soft Light blend layer to lighten or darken selective areas. When you use low-opacity brushes, each brush stroke builds up the effect slowly until it reaches full opacity. Now check out the completed black and white image (**FIGURE 18.8**).

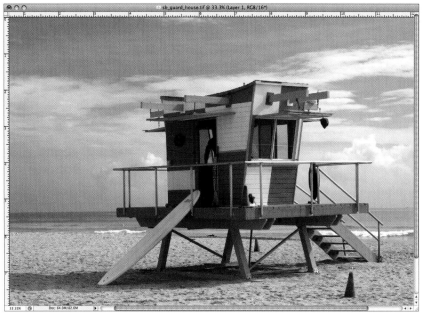

FIGURE 18.8 Before and after black and white conversion. Note the Soft Light blend layer provides the fine tuning of burning and dodging on the after image.

Before

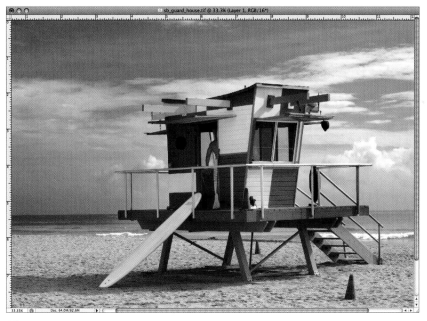

After

Let's take a final, quick look at the tone process. The palette preferred most from the traditional photo chemical darkroom would migrate to either a warm or cool tone process. But today, digital photography provides no limitations to the color tone palette you might choose. Feel free to experiment with Photoshop to produce any range of tones.

Remember, if there is a particular look and feel you have come to enjoy seeing in your images, save the tint as a preset. You have 16.7 million color combinations to choose from, so saving your choice as a preset now will streamline your workflow.

You can pick color tones throughout the application from a variety of sources, but to keep your workflow simple look to the Black and White adjustment layer to Tint control (**FIGURE 18.9**). Selecting a color from the Tint control is simply done by moving the hue and saturation sliders until you produce the desired effect.

FIGURE 18.9 The Black and White adjustment layer has an effective tint control for producing toned images. Looking at an area that contains a good representation of all the image's tonal information helps evaluate the strength of the tint to apply.

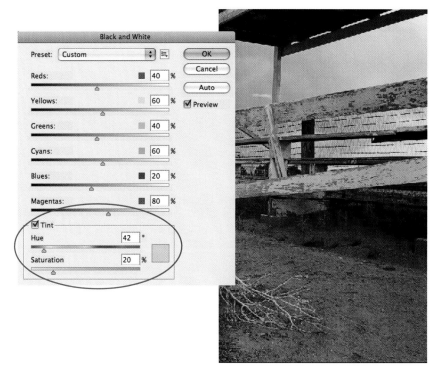

As I close out this chapter I would encourage you to enjoy experimenting in the realm of black and white and to explore the different visual aspects of this medium that toning can provide. It can change the way you look at your photography and how you transform your color images into dynamic black and whites (**FIGURE 18.10**).

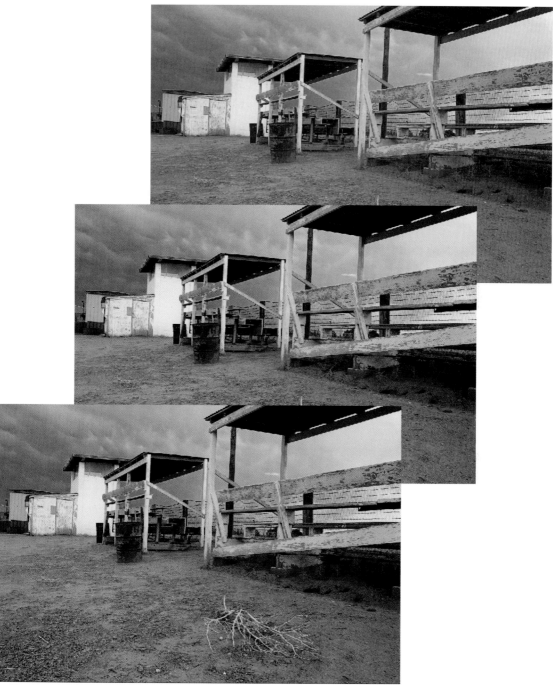

FIGURE 18.10 Comparing warm and cool tone renderings against neutral. Depending on the intensity of the color hue and saturation, these results can provide interesting responses from the viewer.

APPENDIX

Web Resources

CAMERA MANUFACTURERS
Canon: www.usa.canon.com

Fuji: www.fujifilmusa.com

Kodak: www.kodak.com

Nikon: www.nikonusa.com

Olympus: www.olympusamerica.com

Pentax: www.pentaximaging.com

Ricoh: www.ricohzone.com

Sigma: www.sigmaphoto.com

Sony: www.sonystyle.com

MAIL ORDER PHOTO SUPPLY HOUSES
Calumet: www.calumetphoto.com

B&H Photo: www.bhphotovideo.com

Freestyle Photographic: www.freestylephoto.biz

Samy's Camera: www.samys.com

Porter's Camera: www.porters.com

TRIPODS
Really Right Stuff: www.reallyrightstuff.com

Manfrotto: www.manfrotto.com

Gitzo: www.gitzo.com

PANORAMIC IMAGING RESOURCES
AGNOS: www.agnos.com

bophoto: www.bophoto.com/bracket

Jasper Engineering: www.stereoscopy.com/jasper

Kaidan: www.kaidan.com

KingPANO: www.kingpano.com

Nodal Ninja: www.nodalninja.com

Peace River Studios: www.peaceriverstudios.com

panorama-hardware.com: www.panorama-hardware.com

SENSOR CLEANING
VisibleDust: www.visibledust.com

COMPACTFLASH CARDS AND SECURE DIGITAL MEDIA

Lexar: www.lexar.com

Sandisk: www.sandisk.com

Kingston: www.kingston.com

Delkin: www.delkin.com

Hoodman: www.hoodmanusa.com

INKJET PRINTERS

Print Permanence: www.wilhelm-research.com

HP: www.hp.com

Epson: www.epson.com

Canon Printers: www.usa.canon.com

TECH INFO SITES

Digital Negative (DNG): www.adobe.com/products/dng

Latest imaging news and reviews: www.dpreview.com

Digital Photography Insights: www.robgalbraith.com

The Digital Darkroom Questions (DDQ): www.timgrey.com/ddq/index.htm

Teacher's Resources – MAC on Campus: www.mac-on-campus.com

Creative Pro: www.creativepro.com

Camera Raw: www.adobe.com/products/photoshop/cameraraw.html

Color Management – X-Rite: www.xritephoto.com

Copyright: www.copyrightalliance.org

XMP INFORMATION

http://www.adobe.com/products/xmp/pdfs/XMP_for_CreativePros2004.pdf

http://wiki.photoolsweb.com/index.php?title=Labels_and_Ratings

http://en.wikipedia.org/wiki/Extensible_Metadata_Platform

PRINT AND WEB PUBLICATIONS

Digital Camera Resource: www.dcresource.com

Digital cameras with reviews: www.dcviews.com

Digital Imaging Magazine: www.digitalimagingmag.com

A Multimedia Magazine for Photojournalism in the Digital Age:
www.digitaljournalist.org

Digital photo magazine online: www.shutterbug.com

Communication Arts magazine: www.commarts.com

An online photo magazine: www.apogeephoto.com
 www.dcmag.co.uk
 www.professionalphotographer.co.uk

Popular Photography and American Photo: www.popphoto.com

Nature Photographers Online Magazine: www.naturephotographers.net

Nature Photographer "how–to" magazine: www.naturephotographermag.com

Nature photography: www.outdoorphotographer.com

Photo District News: www.pdnonline.com

Photography and the Creative Process: www.lenswork.com

A visual magazine with imagery as the content: www.blindspot.com

The How-To Magazine for Everything Adobe: www.layersmagazine.com

For the serious amateur and professional photographer:
www.phototechmag.com

Digital Photography Magazine: www.pcphotomag.com

Digital Media Publisher: digitalmedia.oreilly.com/learningcenter

Michael H. Reichmann: www.luminous-landscape.com

AfterCapture: www.aftercapture.com

PDNedu: www.pdnedu.com

Rangefinder: www.rangefindermag.com

ONLINE BOOK PUBLISHING

Apple: www.apple.com/ilife/iphoto/printproducts.html

Asuka: www.asukabook.com

Blurb: www.blurb.com

Kodak: www.kodakgallery.com

My publisher: www.mypublisher.com

Shutterfly: www.shutterfly.com

Lulu: www.lulu.com

Picaboo: www.picaboo.com

Photoworks: www.photoworks.com

Snapfish: www.snapfish.com

ADOBE PHOTOSHOP

Adobe Forums: www.adobe.com/support/forums

Photoshop tips and techniques: www.russellbrown.com

National Association of Photoshop Professionals (NAPP):
www.photoshopuser.com

General Photoshop News: www.photoshopnews.com

ADOBE PHOTOSHOP LIGHTROOM

Adobe Lightroom team: http://blogs.adobe.com/lightroomjournal
http://lightroom-news.com

George Jardine: www.mulita.com/blog

ORGANIZATIONS AND ASSOCIATIONS

The Center: www.sfcp.org

ASMP - American Society of Media Photographers: www.asmp.org

APA - The Advertising Photographers of America: www.apanational.org

Photo Projects: www.blueearth.org

IAPP - International Association of Panoramic Photographers: panphoto.com

NAPA - North American Nature Photography Association: www.nanpa.org

NPPA - National Press Photographers Association: www.nppa.org

NAPP - National Association of Photoshop Professionals:
www.photoshopuser.com

WPPI - Wedding and Portrait Photographers International:
www.wppionline.com

Announcements of exhibitions and contests: www.absolutearts.com

National Geographic Society: www.nationalgeographic.org/photography

Aperture: www.aperture.org

The Center for Photographic Art: www.photography.org

Texas Photographic Society: www.texasphoto.org

PP of A Professional Photographers of America, Inc.: www.ppa.com

SPE - The Society for Photographic Education: www.spenational.org

PIEA - Photo Imaging Education Association: www.pieapma.org

APA, Advertising Photographers of America: www.apanational.com

ASPP, American Society of Picture Professionals: www.aspp.com

CPI, Commercial Photographers International: www.mycpi.com

EP - Editorial Photographers: www.editorialphoto.com

IAAP, International Association of Architectural Photographers:
www.architecturalphotographers.org

IAPEP, International Event Photographers: www.iapep.com

PACA, Picture Archive Council of America: www.pacaoffice.org

PMA, Photo Marketing Association: www.pmai.org

SAA, Stock Artists Alliance: www.stockartistsalliance.org

SPS, Student Photographic Society: www.studentphoto.com

WPJA, Wedding Photojournalist Association: www.wpja.com

Keyboard Shortcuts

Jerry's Top 30 Lightroom Shortcuts for the Library and Develop Modules

Function	Library (Mac/Windows)	Develop (Mac/Windows)
Module Navigation		
Go to Library Compare Mode	C / C	C / C
Go to Library Loupe Mode	E / E	E / E
Go to Library Grid Mode	G / G	G / G
Go to Library Survey Mode	N / N	—
Go to Develop Module	D / D	—
Show/Hide Panels		
Show/Hide Toolbar	T / T	T / T
Show/Hide Side Panels	Tab / Tab	Tab / Tab
Show/Hide All Panels (excl. toolbar)	Shift + Tab / Shift + Tab	Shift + Tab / Shift + Tab
Show Filmstrip	F6 / F6	
Cycle through Screen Modes	F / F	F / F
Cycle the Lights Out Modes	L / L	L / L
Solo Mode On/Off	Opt-click on Panel name/ Alt-click on Panel name	Opt-click on Panel name/ Alt-click on Panel name
Open additional Panel without closing previous	Shift-click on Panel name/ Shift-click on Panel name	Shift-click on Panel name/ Shift-click on Panel name
Zooming		
Toggle Zoom View	Z	Z
Zoom In (4 major zoom increments)	Cmd + + / Ctrl + +	
Zoom Out (4 major zoom increments)	Cmd + - (minus key) / Ctrl + - (minus key)	—
Enter Loupe or 1:1 View	Return / Enter	—
Viewing / Sorting Photos		
Select All	Cmd + A / Ctrl + A	Cmd + A / Ctrl + A
Set Rating to 0 / Remove Rating	0 / 0	0 / 0
Set Rating to	1-5 / 1-5	1-5 / 1-5
Set Rating to 1–5 and Move to Next Photo	Shift + (1-5) / Shift + (1-5)	Shift + (1-5) / Shift + (1-5)
Stack Photos	Cmd + G / Ctrl + G	—

Function	Library (Mac/Windows)	Develop (Mac/Windows)
Unstack Photos	Cmd + Shift + G / Ctrl + Shift + G	—
Create Virtual Copy	Cmd + ' / Ctrl + '	Cmd + ' / Ctrl + '
Add to Quick Collection	B / B	B / B
Clear the Quick Collection	Cmd + Shift + B / Ctrl + Shift + B	Cmd + Shift + B / Ctrl + + Shift + B
Show Library Filter Bar	\	—
Developing		
Undo Last Action	Cmd + Z / Ctrl + Z	Cmd-Z / Ctrl-Z
Redo Last Action	Cmd + Shift + Z / Ctrl + Shift + Z	Cmd + Shift + Z / Ctrl + Shift + Z
Auto Tone	Cmd + U / Ctrl + U	Cmd + U / Ctrl + U

INDEX

Symbols/Numbers

embedded adjustments, 195, 205
Equalize Histogram Method, 190, 191
Erase mode, 159
eraser tool, 217
EV (exposure values), 189
exchangeable image file format (EXIF), 58–59
EXIF (exchangeable image file format), 58–59
EXIF metadata, 58–59, 79, 89
Expanded Cells option, 109
Export button, 163, 164
Export command, 163, 164
Export dialog, 162, 164–169
exporting folders as catalogs, 93
exporting images
 to disk/CD, 164–165
 export location, 165
 to external editor, 51
 file formats, 166
 file naming and, 165
 File Settings options, 166
 Image Sizing options, 166–167
 layers and, 51
 from Lightroom, 162–169
 metadata options, 167–168
 to Photoshop, 170–175
 Post-Processing options, 168
 presets for, 169
 for printing, 51–52
 sharpening options, 167
 for Web, 52
exposure. *See also* overexposure
 adjusting with brush, 160
 adjusting with Exposure and Gamma, 190
 adjusting with exposure slider control, 134
 adjusting with graduated filter, 157
 adjusting with Histogram, 18–22, 124
 adjusting with Quick Develop, 102
 auto mode features and, 19–20
 bracketing, 188
 histogram as tool for, 18–22
 overexposure, 20, 21, 45

 quality and, 15
 tips for, 22
 underexposure, 22, 45
Exposure and Gamma method, 190, 191
exposure compensation, 20
exposure slider control, 134
exposure values (EV), 189
Expression Media, 39
Extensible Metadata Platform. *See* XMP
extensions, 42
External Editing tab, 51–52
external editor round-trip process, 175
external editors, 51, 52, 175
external image editing, 170–175
external storage, 25, 54

F
feathered-edge masks, 144
feathering, 160, 204–205
file extensions, 42
file formats
 DNG, 50, 79, 174
 DSLR camera, 14–17
 EXIF, 58–59
 export, 166
 external editing, 174
 IPTC, 59
 JPEG, 14–17, 175
 metadata, 58–59
 PSB, 172–173
 PSD, 51, 172–175
 Raw, 14–17, 174
 Tiff, 51, 175
 XMP, 59
File Handling tab, 52, 56–57
file output, 51
File Settings options, 166
files. *See also* images
 backup, 56
 bit depth, 187
 in catalogs, 56–57
 data, 77
 exporting to CD/disk, 164–165